HISTORIC TEXAS FROM THE AIR

HISTORIC TEXAS

FROM THE AIR

By David Buisseret, Richard Francaviglia, and Gerald Saxon

WITH AERIAL PHOTOGRAPHS AND
PHOTOGRAPHER'S PREFACE BY JACK W. GRAVES, JR.

University of Texas Press ☙ Austin

THE PUBLICATION OF THIS BOOK IS
IN HONOR OF JOSEPH PATRICK HEGARTY.

Requests for permission to reproduce material from this work should
be sent to:

Permissions
University of Texas Press
P.O. Box 7819
Austin, TX 78713-7819
www.utexas.edu/utpress/about/bpermission.html

♾ The paper used in this book meets the minimum requirements of
ANSI/NISO Z39.48-1992 (R1997) (Permanence of Paper).

LIBRARY OF CONGRESS CATALOGING-IN-PUBLICATION DATA

Buisseret, David.
 Historic Texas from the air / by David Buisseret, Richard Fran-
caviglia, and Gerald Saxon ; with aerial photographs and photogra-
pher's preface by Jack W. Graves, Jr. — 1st ed.
 p. cm.
 Includes bibliographical references and index.
 ISBN 978-0-292-71927-9 (cloth : alk. paper)
 1. Texas—Aerial photographs. 2. Historic sites—Texas—Pictorial
works. 3. Texas—History, Local—Pictorial works. 4. Historic
sites—Texas. 5. Texas—History, Local. 6. Texas—Descripton
and travel. I. Francaviglia, Richard V. II. Saxon, Gerald D.
III. Graves, Jack W., Jr. IV. Title.
 F387.B85 2009
 779'.99764—dc22
 2008033295

Contents

Authors' Preface

The history of a state as large and diverse as Texas is best understood in terms of its individual historic sites. From the Sabine River in the east to El Paso in the west, and from the Red River south to the lower Rio Grande Valley, Texas has hundreds of sites where important events and developments—wars, migrations, treaties, and inventions—took place. These sites include Native American rock shelters, French forts, Spanish missions, and more recent oil fields and farms. A number of these historic sites—for example, the Alamo—are world-famous, though others are known only to locals. Texans are notoriously proud of their colorful history. They study it from kindergarten through high school, and historic sites such as (again) the Alamo, San Jacinto Battlefield, and the Texas State Capitol are popular attractions for Texans of all ages.

In writing this book, however, we also wanted to be sure to include lesser-known sites such as the Alibates flint quarries or the silver mining town of Shafter. We'll wager that few Texans have even heard about, much less visited, several of the remote and little-known places we include in this book; however, their obscurity today does not diminish their importance to state history. In all, we document seventy-three locales, great and small, all across Texas. For each site, we give a brief historical background, offer related images from the past and present, and suggest sources for further reading. Some of these sites, like Big Bend or Palo Duro Canyon, are normally known as scenic rather than historic sites. Nevertheless, we show that they also have very rich histories indeed.

It wasn't too difficult to write about these seventy-three historic sites thanks to the fine research facilities we were privileged to use, and the many trips we've been able to take to sites scattered around this great state. One thing that would be virtually impossible for most people to do, though, sets *Historic Texas from the Air* apart from any other book about Texas history. As this book's title implies, we were able to view the sites from the air, and to take photographs from that unique vantage point. We then carefully integrated the information revealed by those often spectacular aerial photographs in order to shed new light on Texas history. To further assist readers, we also included additional views of the sites, including the often overlooked but important historic postcards and maps that we found in archival collections.

To our knowledge, only one other book has explored Texas from the air: *Texas—A Salute from Above* by T. R. Fehrenbach (1985). Historian Fehrenbach, though, took a different approach than ours. His pictures were mostly of recent history, including suburbs and ranches. We, on the other hand, are solely interested in what aerial photos can tell us about Texas's long history, using them to reveal aspects of that history that are not visible from the ground. Fehrenbach was assisted by four fine photographers, but we had only one, Jack Graves. He has proved to be not only a skillful aerial photographer, but also a well-informed historian, with an eye for both the facts and for the "feeling" that a photograph can convey about sites.

Fehrenbach's book was an early purchase for historical geographer Richard Francaviglia when he arrived in Texas in 1991. After many trips around Texas by air and on the ground in his role as director of the University of Texas at Arlington's Center for Greater Southwestern Studies and the History of Cartography, Francaviglia began to imagine a development of Fehrenbach's method like the one in the book that you now hold.

Another intellectual source for our work was material from three classes in the Department of History at UTA that Jack Graves took with Gerald Saxon, now dean of libraries at UTA, ten or so years ago. In his papers about Texas forts and Mexican-American War sites in south Texas and northern Mexico, Jack illustrated his work with remarkable black and white aerial photographs of the forts that he studied.

Jack's papers were thus another partial inspiration for this book, and so, too, was the arrival of Professor David Buisseret on the UTA campus in 1995. David had written the prize-winning book *Historic Illinois from the Air* in 1992. Now that he had become a Texan, we realized that a similar project would be perfect for the Lone Star State. All four of us met in 2002 to begin working out the details of the project, and were overjoyed that our vision was very similar. We realized that aerial views could help people understand Texas history from a geographical perspective. The photographs, we concluded, would have to be high resolution *color* images. In a sense, the photographs could be both maps and informative visual records of the landscape from the air. And we knew that supplementing them with real maps—either original historical maps or maps hand-drawn for this volume—would help place the photographs in geographical space.

As the project came together, we realized that it was a bit grander, and more spectacular, than we originally envisioned. It called for lots of color and a big, horizontal format. But why not? Texas's size and diversity warrant that kind of ambitious treatment. We were overjoyed when the University of Texas Press agreed with our vision: a full-color book that also contains substantive historical interpretations of dozens of sites. The book you are about to read, then, represents the vision of four people who fervently believe that history and geography are inseparable. Throughout the project, we hope to show that the texture of Texas history varies from place to place and from region to region. We hope that readers enjoy *Historic Texas from the Air* as much as we enjoyed researching and writing it. More importantly, though, we hope readers learn as much about Texas history from these pictures as we did in putting this book together.

—**David Buisseret, Richard Francaviglia, and Gerald Saxon**

Photographer's Preface

When Gerald Saxon first approached me about this project in the summer of 2002, I did not fully appreciate the wonderful opportunity or the many challenges that this "journey" would afford. It has been a great honor to work with the three authors—David Buisseret, Richard Francaviglia, and Gerald Saxon—on what is essentially a continuation of David's realization from his distant days in the Royal Air Force that aerial photography was "a field with fascinating possibilities for the historian." This book is a direct descendant of David's previous books, *Historic Jamaica from the Air* (1972, new edition 2001) and *Historic Illinois from the Air* (1992), and reflects the shared vision of the authors.

My involvement developed through a relationship formed with Gerald during three independent study classes—aerial photographic essays—he directed while I was completing a history requirement for the long-delayed completion of my BA from the University of Texas at Arlington. The first two projects documented, from the air, battle sites in southern Texas and northern Mexico of the Mexican-American War of 1846–1848, and the third project focused on U.S. military forts built on the north and central Texas frontier during 1849–1889. All three projects are currently cataloged in Special Collections at the University of Texas at Arlington library.

After several meetings to discuss our options and agree on a course of action, we developed a preliminary concept for the book and began the difficult task of deciding which historic sites to include. The possibilities in a state known for its size as much as for its rich and diverse history, seemed endless. Our list of choices would change numerous times before the project's completion.

One of the many challenges involved with any aerial photography project is capturing the "view" that the clients, or in this case the authors, are looking for. The authors' knowledge and ability to convey their vision of the various sites prior to the actual flight was critical. We developed a form for the authors to complete for each site that noted the description of the proposed photo, location, type (individual building, multiple buildings, landscape, ruins, etc.), orientation, identifying marks, other objects to be included or excluded in the photo, and remarks. In many cases the authors would make sketches and/or provide photos, maps, and drawings to help illustrate and/or define the view they were looking for. In a few instances we tried to replicate the exact view or direction depicted in an existing old photo or sketch. It was a challenging process, and I hope the reader can comprehend and appreciate the combined efforts involved.

The most difficult aspects of aerial photography are the limitations placed on the photographer by the site's fixed orientation on the ground, Mother Nature's influences, and the problems associated with shooting from a moving perch. In a studio environment, the photographer can move the subject, adjust the light, and shoot at ease from various stationary locations. For the aerial photographer, some days are perfect, some days are not, and you must adjust "on the fly" and deal with the unique situations each site and location presents. Heat, cold, wind, thermals, turbulence, smoke, haze, fog, clouds, sun, terrain, ground obstacles (towers, buildings, etc.), and FAA air space restrictions are just a few of the variables that we must deal with. On several flights we could not find the actual site on the first trip and had to do additional research and try again. Some sites no longer existed; others were just not impressive

from the air and were eliminated from the final list. We also experienced the usual difficulties that plague personal flight, including weather delays, weather cancellations, and equipment problems.

I took the majority of the aerial photographs in this book between 2004 and 2006. However, several repeat flights were required due to weather problems and/or circumstances on the ground during the original flights that made it impossible to get good photographs. Some of these, and flights to a few additional sites, were not rescheduled until after the original draft of the book was completed in 2007 and early 2008. In all, I photographed 111 sites, some multiple times, to obtain the final 73 used in the book. It took 39 individual photo flights totaling 81.2 hours of flight time and covering approximately 7,846 miles. An additional 10 commercial flights totaling 4,840 miles and 9 road trips totaling 2,760 miles were required to complete the project, bringing the total distance traveled to 15,446 miles. I flew in fixed-wing aircraft—Cessna 172 Skyhawks—for travel and photo flights in outlying areas, and Schweizer 300 and Robinson R22 helicopters for photo flights in the congested metropolitan areas of Dallas/Fort Worth and Houston.

I took a total of 4,176 individual photographs using a 35mm Canon EOS 1-N with either a Canon 70–200mm 2.8L zoom lens or a 24–85mm wide-angle lens. I mostly used Kodak Professional Extachrome transparency film, E100VS, but on a few occasions I used Fujifilm Fujichrome color reversal film, Velvia 100F. Thanks go out to my good friends Perri Hughes and Stephen Miller at Barron Photografix LTD in Fort Worth, who handled all film processing and gave valuable advice when needed.

There are a few pilots who can safely fly and take good photographs at the same time, but I'm not one of them. Even though I've been a fixed-wing pilot since I graduated from high school, I always take along an experienced pilot to fly the plane while I concentrate on photography. I do not have my helicopter rating, so a pilot is a must when shooting from a helicopter. Most of the photographs were taken "low and slow," from 300 to 800 feet above the ground and at speeds of approximately 60–70 knots in the helicopters and 90–100 knots in the fixed-wing aircraft, making the necessity for a seasoned pilot a critical safety issue.

I was fortunate to have a great friend and mentor, Lt. Col. Francis (Frank) X. Cantwell, USAF Ret., with me on just under half the photo flights. Frank's piloting skills and stamina were instrumental in getting many of these photographs done safely and on schedule. He was a pleasure to have along, and it would have been difficult to complete the project without his help—thanks, Frank. Thanks also to pilots Jim Payton, Jordan Wagnon, and Peter Kendig, who were with me on numerous flights, and to those pilots I met and flew with only once: Suzy Azar, Gilbert Barth, Bill Brady, Patrick Davis, Domenick Galindo, Adan Garcia, Kim Hanley, Chris Newby, and Fernando Rodriguez. I would also like to thank State Marine Archeologist Steven D. Hoyt, of the State Historical Commission, for information regarding *La Belle* and his assistance in locating the actual site.

Again, thanks to David, Richard, and Gerald for the privilege of working with them on this book. The project was a unique opportunity to combine my interests in history, aviation, and photography into what I hope will be an enjoyable book. This was a once-in-a-lifetime experience and an unforgettable way to see the great state of Texas.

—Jack W. Graves, Jr.

HISTORIC TEXAS FROM THE AIR

1

THE LAND

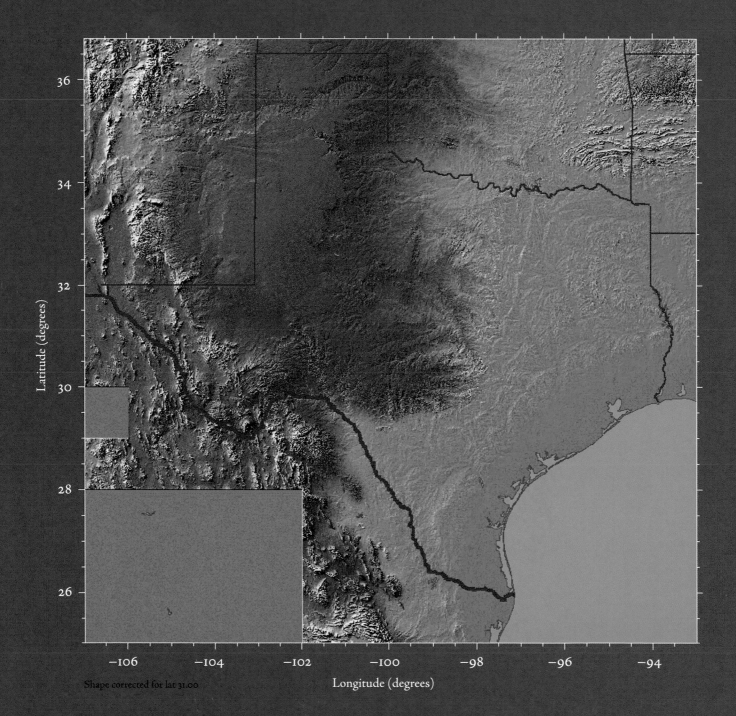

Shape corrected for lat 31.00

INTRODUCTION

Perhaps the best place to begin *Historic Texas from the Air* is with a view of the state from a space satellite. From more than a hundred miles up, Texas appears as a vast and varied portion of the earth's crust. To help us make sense out of the image, Johns Hopkins University Applied Physics Laboratory has effectively used false colors to enhance the appearance of topographical features.

The challenge of depicting large geographical areas was very effectively tackled more than seventy years ago by Erwin Raisz, a geographer at Harvard University. In the 1930s, Raisz produced maps that set new standards for the monochrome depiction of terrain by using a skillful system of shading to show topography. This detail showing Texas comes from the sixth edition of Raisz's *Landforms of the United States*, published in 1957. With extraordinary skill, Raisz was able to clearly show even the detailed features of this huge area.

Raisz's map captures the general slope of the land from northwest to south-

Satellite image of Texas, Johns Hopkins University Applied Physics Laboratory (April 2005),
http://fermi.jhuapl.edu/states/maps1/tx.gif.

east, sharply delineating the central lobe of high ground, just to the east of which is a line of major cities: Fort Worth, Waco, Austin, and San Antonio. To the east of this line is a series of plains, prairies, and timbered land, including what Raisz calls the "Eastern Cross Timbers" between Fort Worth and Dallas and the "Coastal Dark Prairie" along the Gulf. West of the line of towns lies what is now called the Hill Country, which Raisz describes as the "Central Mineral Region," the "Lampasas Plains," and the "Comanche Plateau." Farther west are the remoter plateaus and high plains, bordered on the southwest by substantial mountains.

Perhaps the weakest part of Raisz's maps is their delineation of rivers, which is why we also offer a simplified explanatory map. Much of our story will concern the many Texas rivers as they flow across the state and into the Gulf of Mexico. We hope that readers will use both maps and the satellite image as a way of reflecting on the influence that the geography of Texas has exerted on the history of many of the sites that follow.

Terry G. Jordan with John L. Bean, Jr., and William M. Holmes. *Texas: A Geography*. Boulder: Westview Press, 1984.

D. W. Meinig. *Imperial Texas*. Austin: University of Texas Press, 1969.

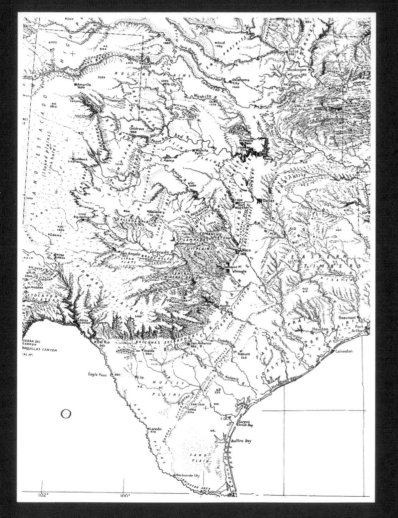

Detail of map by Erwin Raisz, Landforms of the United States
(Cambridge, Mass.: E. Raisz, 1957).

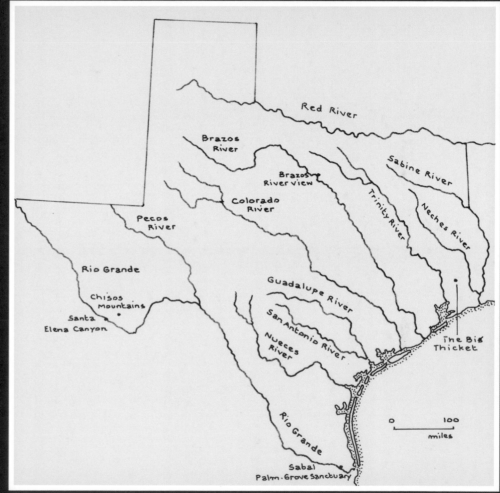

Map to show Texas hydrography and sites of chapter 1.

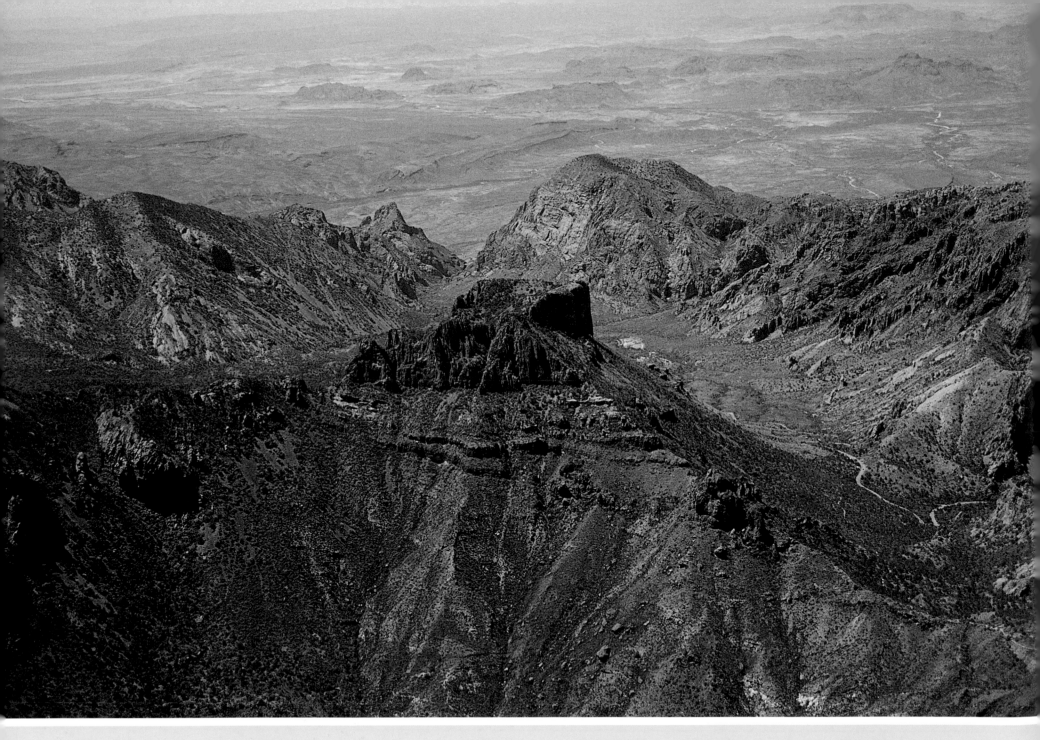

Aerial photograph of the Chisos Mountains, 11 April 2005, midday, looking west.

HISTORIC TEXAS FROM THE AIR

Geology: Chisos Mountains, Big Bend National Park

In the topography of western North America, the Chisos Mountains appear as a southern extension of North America's largest mountain chain, the Rocky Mountains. The Chisos Mountains stretch from the Rio Grande on the Mexican border in the southwest up to Panther Junction in the northeast. The Chisos are mainly volcanic in origin and are relatively young; hence they remain extremely rugged, as our aerial photograph shows. Their Spanish name means "ghosts," and they do indeed have a rather ethereal look, as they are sometimes shrouded in mist and clouds. They are the third tallest mountains in Texas (7,825 feet at Mt. Emory), and seem to be the result of three successive uplifts, notably in Cenozoic times about 70 million years ago.

The Chisos are rich in minerals and are known for their great variety of plant and animal life, including many species apparently stranded this far south at the end of the last ice age about 10,000 years ago. The Chisos Mountains rise from a desert floor, but are well-watered at their cooler forested summits, where precipitation is more plentiful. The trees growing in the upper elevations include Arizona pine, Douglas fir, Arizona cypress, and quaking aspen, though the areas in which these ice age relics can flourish are limited.

These mountains have been inhabited over time by a number of different peoples. The earliest seems to have been the Chisos Indians, who occupied the area before the 1550s and were replaced during the eighteenth century by the Mescalero Apaches, who were in turn slowly pushed out by the Comanche. The variety of habitats in this area, from fertile river valleys to high mountains, coupled with the changes in weather conditions, meant that these native peoples moved from place to place using a variety of skills to survive, including cultivation of crops in the lowlands and hunting of animals and birds in the upper regions. Today the Chisos form part of Big Bend National Park, established in 1944 by President Franklin Delano Roosevelt, and including, in part, land set aside by the state of Texas from 1933 onward.

John Jameson. *The Story of Big Bend National Park*. Austin: University of Texas Press, 1996.

Ross A. Maxwell. *The Big Bend of the Rio Grande*. Austin: University of Texas Press, 1968.

"Mount Emory" from William Emory, Report on the United States and Mexican Boundary Survey, 3 vols. (Washington, D.C.: U.S. Department of the Interior, 1857–1858).

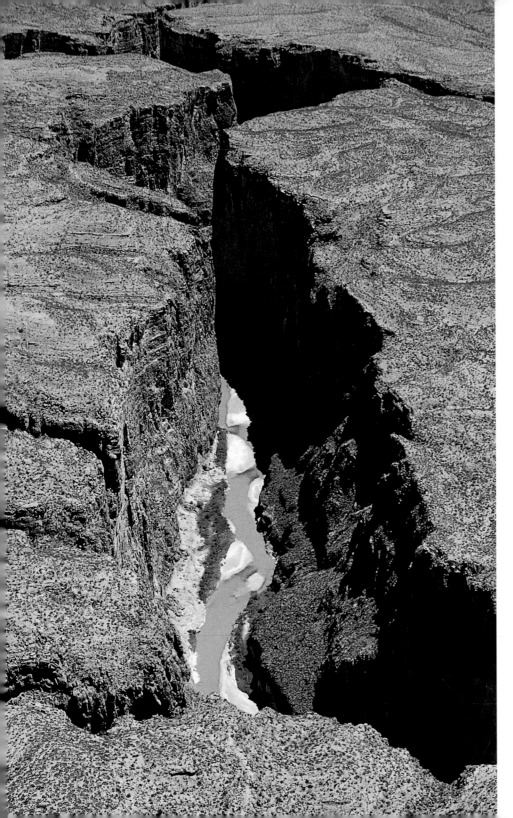

Geology: Santa Elena Canyon, Big Bend National Park

We normally think of the Big Bend area as a remote, pristine, scenic national park, but in fact it has been home to people for thousands of years. Many Indian tribes hunted here, and in the nineteenth century, European settlers eked out a marginal living from such activities as the harvesting of wax from the candelilla plant, scattered mining enterprises and some ranching. In the twentieth century, the very limitations that had kept the human population thin—open spaces, desert climate, and sparse vegetation—became a magnet for people seeking temporary escape from the sprawling urban centers.

This view of the Santa Elena Canyon at the southern edge of the national park shows the formidable nature of the terrain. The canyon cuts deeply into a limestone plateau, with rugged mesas on the Texas side of the border, and the Sierra Ponce on the Mexican side. This canyon was a redoubtable obstacle to exploration. It thwarted an expedition by Governor Pedro de Rábago y Terán, who had to divert his party around it in 1747, and it remained unexplored for more than a century afterward. Santa Elena Canyon is shown on a map by the United States and Mexican Boundary Survey in 1856, but on most maps of the period it appears only as the unnamed but topographically defined border between the United States and Mexico. The first scientific expedition through the canyon was conducted by Texas geologist R. T. Hill in 1899.

We now appreciate the Big Bend both as a geological wonder and as a superb example of the variety of the Chihuahuan desert landscape. As in

Aerial photograph of Santa Elena Canyon, 11 April 2005, midday, looking northwest upstream.

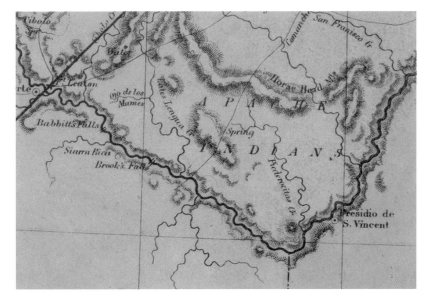

Santa Elena Canyon is unnamed on this map from C. S. Richardson's New Map of Texas including Part of Mexico *(Philadelphia: Charles Desilver, 1861), but appears as the border between the United States and Mexico. Virginia Garrett Cartographic History Library, Special Collections, University of Texas at Arlington Library [henceforward "Garrett Maps, UTA Library"].*

all desert areas, the sparse vegetation leaves the bedrock geology exposed for all to see. Fossils found in the park include huge seashells, the largest flying dinosaur (pterosaur), and a horned dinosaur. The park's spectacular volcanic features make it an outstanding geological laboratory; it is also a habitat for diverse wildlife, including plants and animals remarkably adapted to life in the desert-mountain-riverine setting.

Nancy Alexander. *Father of Texas Geology, Robert T. Hill.* Dallas: SMU Press, 1976.
Clifford B. Casey. *Mirages, Mysteries and Reality: Brewster County, Texas, the Big Bend of the Rio Grande.* Hereford, Tex.: Pioneer Book Pub., 1972.
Arthur R. Gómez. *A Most Singular Country: A History of Occupation in the Big Bend.* Santa Fe: National Park Service, and Provo: Charles Redd Center for Western Studies, Brigham Young University, 1990.

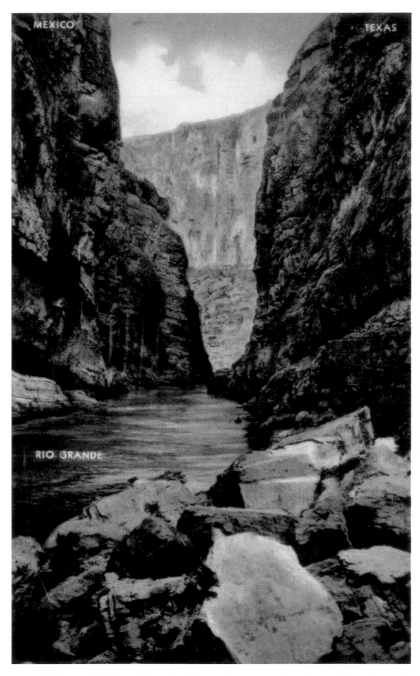

Postcard showing the "Santa Helena [sic] Canyon," ca. 1920. Jenkins Garrett Texas Postcard Collection, Special Collections, University of Texas at Arlington Library [henceforward "Garrett Postcards, UTA Library"].

Hydrography: Brazos River, Palo Pinto County

Like most Texas rivers, the Brazos winds its way across varied habitats in its southeastward flow to the Gulf of Mexico. From its headwaters in the southern Texas Panhandle, the Brazos River crosses the ranch-studded rolling plains, traverses the rugged western Cross Timbers, and enters the plains in the rich Blackland Prairie near Waco. From there, it meanders to the Gulf through some of the state's densest forests and richest farmlands. When the Texas and Pacific Railway was built through this area in 1881, it occupied a portion of the Brazos River valley, as seen in the lithograph from *Texas: Her Resources and Capabilities* (1881). The lithographer shows the river flowing wide and placid between tall cliffs; the railroad hugs the base of the cliffs as it parallels the river.

Our aerial photograph shows a more or less typical stretch of the river in Palo Pinto County. Although we are tempted to think of rivers and their surroundings as natural, this modern-day view reminds us how much Texas and its rivers have changed in the last two centuries. With increased farming and ranching activity in the nineteenth century, the landscape surrounding the Brazos River began to change, as Anglo settlers replaced nomadic Indians. When these new settlers began to control fires and graze cattle, they inadvertently encouraged the spread of brush such as mesquite and cedars, which dominated large areas by 1900. Because the thick, moisture-absorbing roots of native grasses were disturbed by the heavier growth, the soil held less water and yielded more runoff. Consequently, the Brazos became more temperamental. Flooding increased during rains, but the opposite effect occurred in drier times; instead of flowing virtually year-round, the Brazos now stopped when the rains ceased. Because much of the natural vegetation had been removed, the altered land also surrendered more of its soil to the Brazos River during heavy rains, as it was not held in place by the roots of plants. Instead of its formerly clear flow, the river was sometimes almost brick red in color as it carried huge loads of sediment that formed sandbars when the water receded again.

With improved stewardship and land management techniques in the past seventy years, the Brazos has regained a bit of its earlier character. In more placid times, the waters are blue and relatively clear. However, during periods of heavy flow, the Brazos looks like a huge red serpent weaving its way through the dark green brush.

Ty Cashion. *A Texas Frontier: The Clear Fork Country and Fort Griffin, 1849–1887.* Norman: University of Oklahoma Press, 1996.

John Graves. *Goodbye to a River: A Narrative.* New York: A. Knopf, 1960.

John Graves, with photographs by Wyman Meinzer. *Texas Rivers.* Austin: Texas Parks and Wildlife Press, 2002.

A. C. Greene. *A Personal Country.* New York: A. Knopf, 1969.

Verne Huser. *Rivers of Texas.* College Station: Texas A&M University Press, 2000.

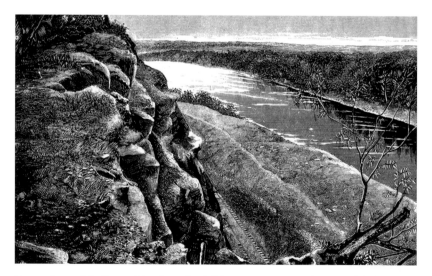

Image of part of the Brazos River from South-Western Immigration Company, Texas: Her Resources and Capabilities *(New York: Slater, 1881), Special Collections, University of Texas at Arlington Library.*

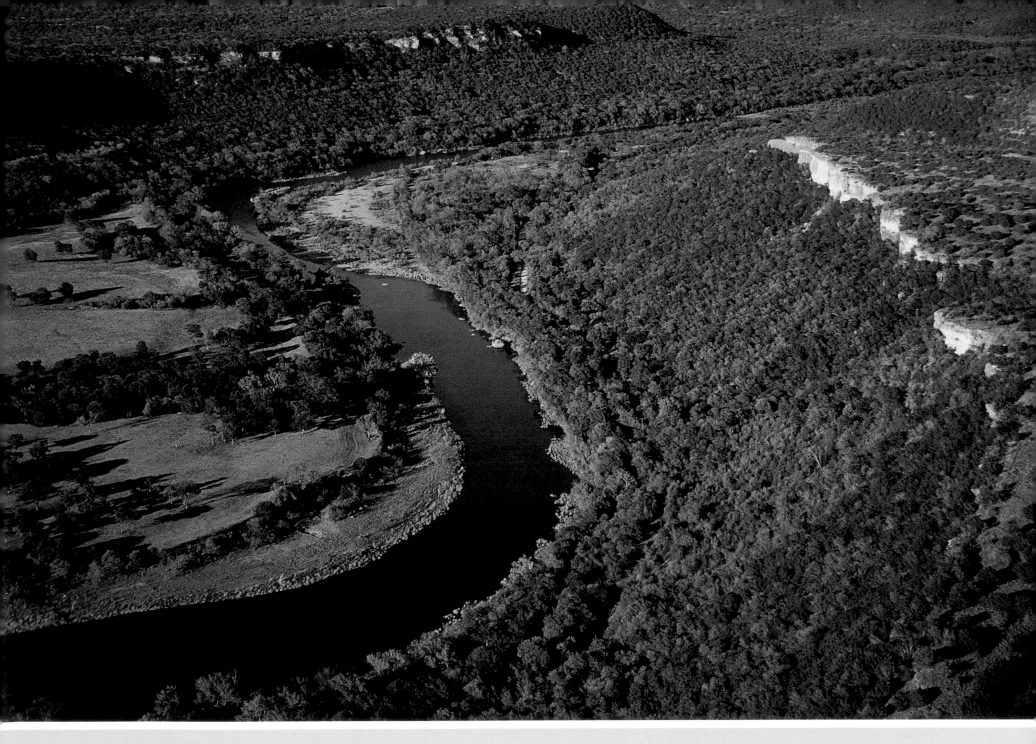

*Aerial photograph of the Brazos River, 11 April 2005, early evening,
looking north from downstream at Flint Bend.*

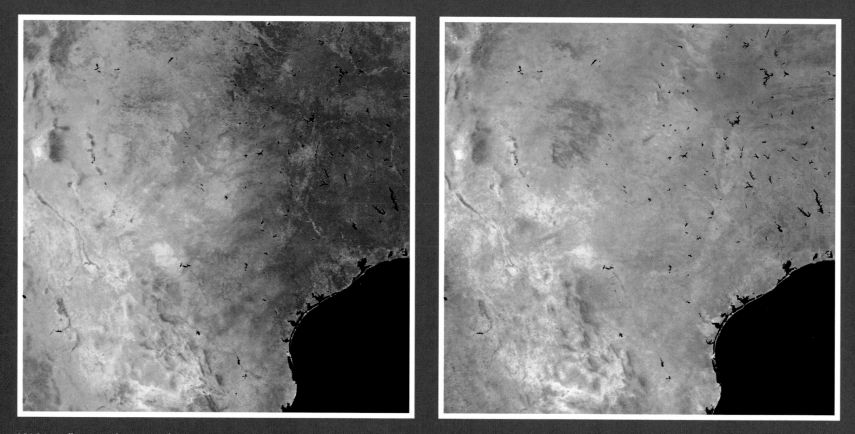

NASA satellite true-color images of Texas in spring and fall 2000 reveal fluctuating wet/dry patterns, http://synergyx.tacc.utexas.edu/Spotlight?Texas_drought/drought_ss2000.html. Courtesy the Center for Space Research, University of Texas at Austin.

Climate: Images of Drought and Hurricane

One of the most remarkable features of Texas urban geography is the close proximity of two great cities, Dallas and Fort Worth. Now, indeed, they have practically merged together into what is called the "Metroplex," but for many years, in defiance of geographers' "central place theory," which normally finds smaller communities dispersed to profit from interaction with the countryside, and only one large city developing to serve a large area, they coexisted and prospered together. That is because they lie along the major east-west division of the state; Dallas looks to the well-watered east, with its cotton and other agricultural crops, for its prosperity, while Fort Worth relies on the drier west, with its cattle ranches, wool production, and other livestock enterprises.

This contrast is dramatically illustrated by our two satellite images, which show Texas (and part of Oklahoma) in April and then in September of 2000, a year of fierce drought. In the spring, the true-color image shows a green area of lush vegetation extending virtually as far as the Hill Country, and south into much of the coastal plains. But in the image taken in the fall, drought conditions have pushed far into east Texas; even the Piney Woods look a distinctly paler green. The fall image is also interesting because it shows so well the great man-made lakes on which Texas now depends for water. On the right, a hundred or so miles up from the coast, are four (black-looking) lakes, diminishing in size from east to west; these are Toledo Bend Reservoir and Lakes Sam Rayburn, Livingston, and Conroe. The very large lake to the north of them on the edge of the greenish area is Lake Texoma, on the Oklahoma border. Many of the state's lakes are too small to be identified on an image like this, but together they have hugely changed living conditions in Texas, allowing for a remarkable expansion of the population. Note, incidentally, how both images show vegetation along the course of the Rio Grande in its highly drought-resistant valley.

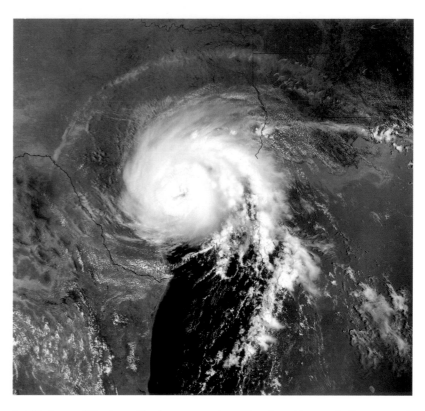

Satellite image of Hurricane Claudette over southern Texas, http://www.redtailcanyon.com/itema/14526.aspx.

Of course, Texas is also known for its exposure to both tornadoes and hurricanes. The latter have played a particularly important role in Texas history, as we shall note when we talk about Indianola, Rockport, and Galveston. Since the advent of satellite imagery, it has become possible to generate extraordinary images of these huge storms, like this one of Hurricane Claudette just after landfall. There is some evidence that such hurricanes may become even more destructive as the temperature of the Gulf of Mexico slowly rises.

George W. Bomar. *Texas Weather*. 2nd ed. Austin: University of Texas Press, 1995.
Donald R. Haragan. *Blue Northers to Sea Breezes: Texas Weather and Climate*. Dallas: Hendrick-Long Pub. Co., 1983.

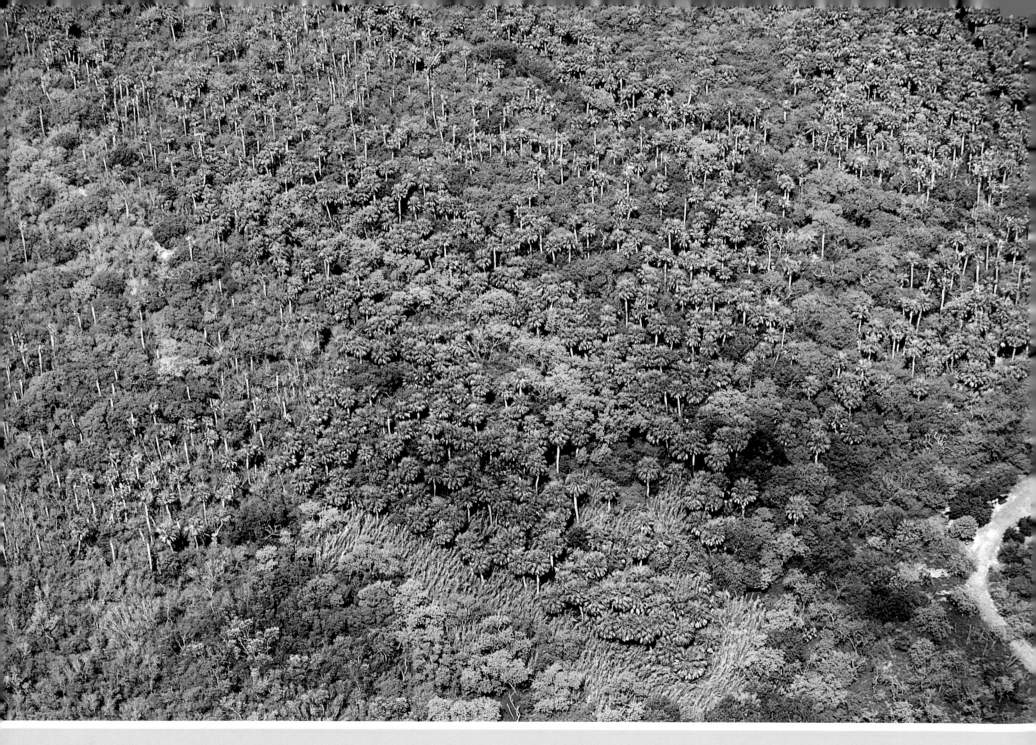

Aerial photograph of part of the Sabal palms, 27 May 2006, mid-morning, looking north.

Vegetation: Sabal Palms, Brownsville

Texas is remarkable for its numerous longstanding and large-scale vegetative features. Some, like the Big Thicket, may have equivalents elsewhere in the United States. But others which depend ultimately on an unusual soil type and climate conditions, like the Cross Timbers, do not seem to have many counterparts. The map shows that the Cross Timbers is a double belt of trees, which was known to the Indians and later identified by the Spaniards as the "Monte Grande," that slopes down into Texas from Oklahoma and even farther north. Even though it has been broken up by building in the past century or so, this natural feature still persists. Our map from 1853 shows the Cross Timbers region too far to the west, but otherwise gives a good impression of its shape.

Another type of distinctive and persistent vegetation is the trees which, though now apparently out of place, have survived from previous (ice) ages. We have already mentioned the Arizona pine, the Douglas fir, the Arizona cypress, and the quaking aspen on the Chisos Mountains; to these we should surely add the lost pines of Bastrop, the palmetto groves of Luling, and the palms at the mouth of the Rio Grande. Of these, the Sabal palms proved especially photogenic from the air. The Sabal palm (*Sabal texana*), while common in adjacent Mexico, is at the northernmost extent of its range here, because it cannot tolerate cold weather. Some of Texas's palm trees, such as those in San Antonio and Austin, are not native, but these isolated and distinctive Sabal palms at the mouth of the Rio Grande were noted by the early Spanish explorers, and they continue to thrive today. As early as 1524, the Spaniards had noted the Sabal palms, sited at the mouth of the "Rio La Palma."

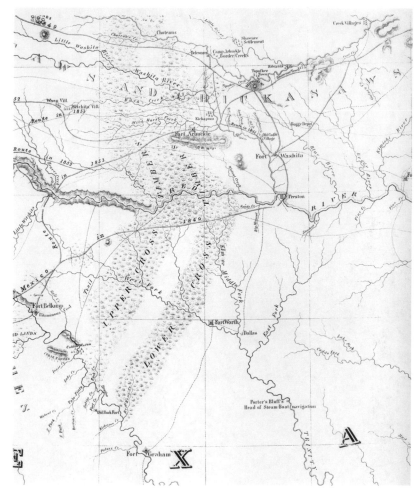

Detail to show the Cross Timbers, from Randolph Marcy, Map of the Country between the Frontiers of Arkansas and New Mexico *(New York: Ackerman Lith., 1853). Garrett Maps, UTA Library.*

Texas Parks and Wildlife Department. "Ecoregions of Texas." http://www.tpwd.state.tx.us/huntwild/wild/birding/pif/assist/pif_regions/ (accessed 9 May 2008).

Richard Francaviglia. *The Cast Iron Forest.* Austin: University of Texas Press, 2000.

Vegetation: The Big Thicket, near Kountze

Southeast Texas's Big Thicket once included two million acres of densely packed vegetation that prevented settlement for most of history. The boundaries of the Thicket have never been exactly defined, but most agree it begins in southern Polk and Tyler counties and ends below Sour Lake. As Campbell and Lynn Loughmiller write in *Big Thicket Legacy*, "The heart of the Thicket lies within the broad 'V' formed by Village and Menard Creeks, which originate within a mile of each other in Polk County on the north, and the rivers they feed into, the Neches on the east and the Trinity on the west." The Thicket contains the broadest variety of plants of any area in the United States and this, coupled with the numerous streams, swamps, bogs, and creeks and the thick undergrowth, made travel through the region almost impossible.

The earliest people to come to inhabit the Big Thicket were the Indians—the Caddos to the north and the Atakapans to the south. Like others after them, they came to hunt bear for meat and tallow and to meet at the mineral springs in the region. Anglo settlers arrived in the nineteenth century, building their cabins in the wilderness and eking out an existence by hunting bear and deer and growing corn, sweet potatoes, and sugar cane. Late in the century and early in the twentieth, more settlers came, following the railroads and timber companies. Today the descendants of these early settlers still live in the small towns in and around the Thicket, including Kountze, Sour Lake, Honey Island, Batson, and Saratoga.

Human development assaulted the land, and by the 1920s, much of the wilderness had been destroyed. The Big Thicket Association formed in

Geraldine Watson of Silsbee, Texas, helped lead the fight to save the Big Thicket, 1972. Fort Worth Star-Telegram *Photograph Collection, Special Collections, University of Texas at Arlington Library [henceforward "Photograph Collection, UTA Library"].*

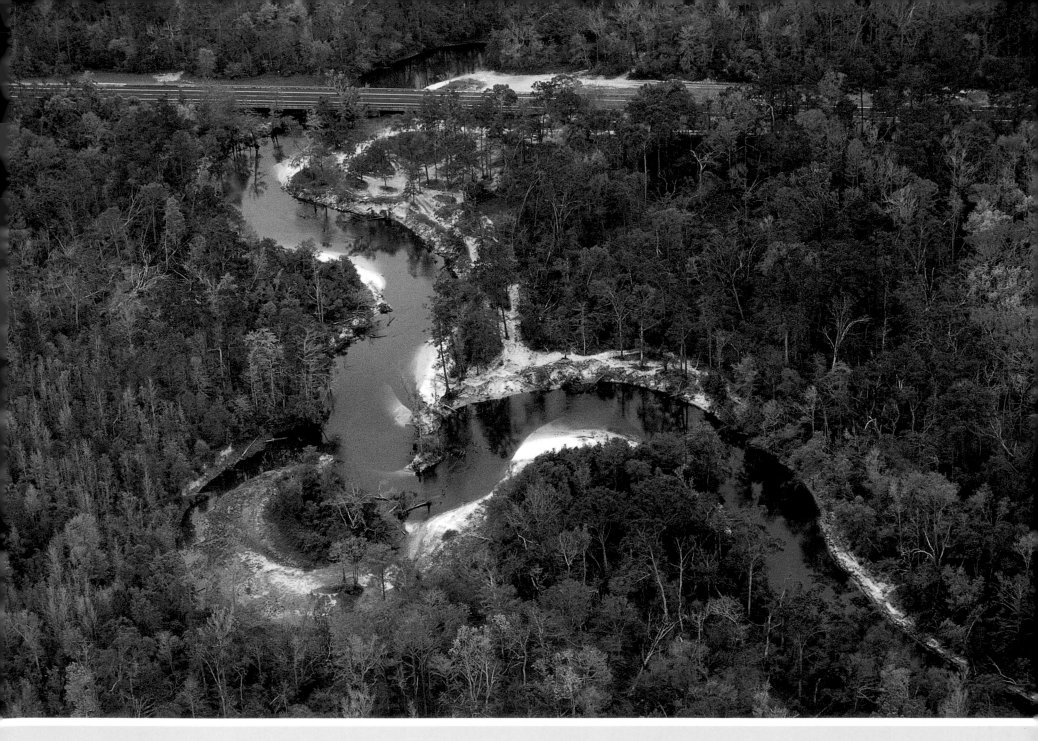

Aerial photograph of the Big Thicket, 12 April 2006, mid-afternoon, looking northeast from downstream at Village Creek.

1964 to fight for the Thicket's preservation as a unique botanical region. In 1974, Congress authorized the creation of the 85,000-acre Big Thicket National Preserve. President Gerald Ford signed the bill into law. The preserve consists of twelve protected units scattered through Hardin, Liberty, Polk, Tyler, and Jasper counties.

This photo of Village Creek just east of Kountze shows Big Thicket's dense and diverse vegetation, even today. Without walking through the Thicket, one cannot appreciate the variety of plant life that can be found there. In fact, the Thicket is something of a "biological island" with many species that cannot be found anywhere else within several hundred miles. Only in this region do desert cactus and palmetto, tumbleweed and tupelo, bald cypress and yucca, and mesquite and magnolia all share the same space. Gordon Baxter, a southeast Texas radio personality and author who writes about the Big Thicket in general and Village Creek in particular, found spiritual meaning in the region, writing about "Village Creek, where I brought my sons and daughters in turn, and let them learn the lessons of beauty and of courage and to hear God's peace." The residents of the Thicket still feel this deep connection to their land.

Francis E. Abernethy, ed. *Tales from the Big Thicket*. Austin: University of Texas Press, 1966.

Gordon Baxter. *Village Creek*. Bryan, Tex.: Shearer Publishing, 1981.

James J. Cozine, Jr. *Saving the Big Thicket: From Exploration to Preservation, 1685–2003*. Denton: University of North Texas Press, 2004.

Glen Sample Ely. *The Big Thicket of Southeast Texas: A History, 1800–1940*. VHS. Austin: Forest Glen TV Productions, 1998.

Pete A. Y. Gunter. *The Big Thicket: An Ecological Reevaluation*. Denton: University of North Texas Press, 1993.

Campbell and Lynn Loughmiller, eds. *Big Thicket Legacy*. Austin: University of Texas Press, 1977.

The southeast Texas town of Sour Lake is nestled on the edge of the Big Thicket, as seen in this early twentieth-century postcard. Garrett Postcards, UTA Library.

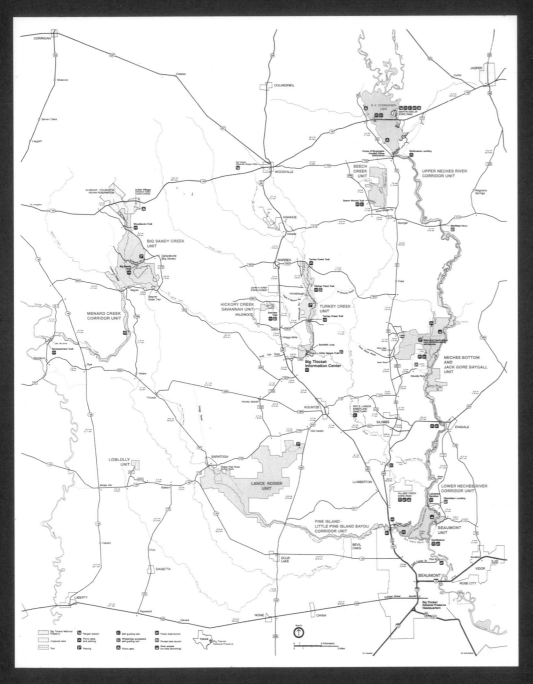

Map of Big Thicket National Preserve, ca. 1997, National Park Service, U.S. Department of the Interior, http://www
.nps.gov/bith/planyourvisit/maps.htm.

2

THE INDIAN PRESENCE

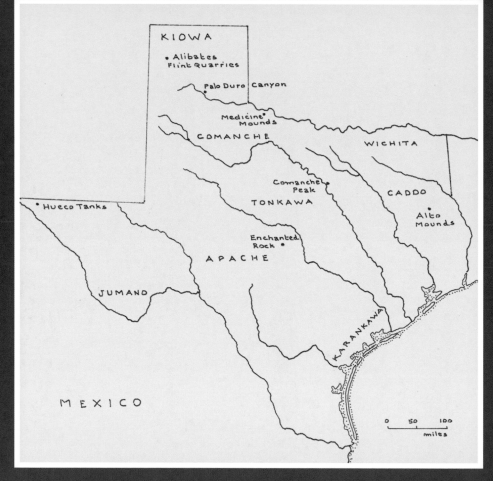

Map to show approximate locations of various Indian groups in Texas, and the sites of chapter 2.

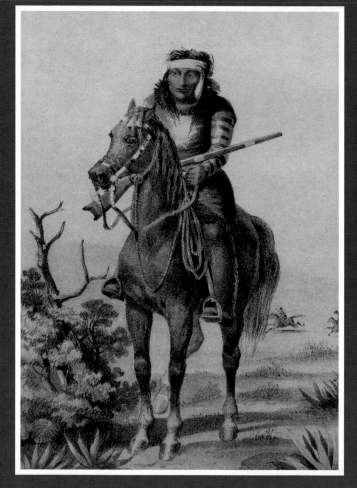

Lipan mounted warrior from William Emory, Report on the United States and Mexican Boundary Survey, 3 vols. (Washington, D.C.: U.S. Department of the Interior, 1857–1858).

INTRODUCTION

This chapter follows logically from the previous one, for the great variety of geographic environments in what would become Texas attracted many different indigenous peoples. These Indians, as we shall for convenience continue to call them, often ranged far across the area, so that our attempts to describe the places where they generally lived will only be approximate.

Perhaps the most sedentary group was the Caddo confederacy, which included subgroups such as the Hasinai, the Nacogdoches, the Ais, and the Adais. They lived mainly in the eastern Piney Woods, where they constructed large round huts and also at least one set of earthen mounds, as pictured. They cultivated a wide variety of plants, including beans, squash, and corn; hunted game; and fished in the region's rivers and marshes. It has also become clear, in recent years, that they masterfully worked both clay and stone. They were not only sedentary, but also largely peaceable, and it was their misfortune that the early European settlers lumped them together with much more aggressive tribes, generally showing the same hostility toward all "Indians."

A little to the west, in the Blackland Prairie, lived the Tonkawa and Wichita and their subgroups, such as the Waco. These Indians cultivated some plants, but were less sedentary than the Caddo, living in tepees and organizing seasonal hunts that often ranged over large areas. They are said to have been remarkable for their extensive use of tattoos. On the coastal plains to the south lived the Karankawa, who received bad press from European commentators. An unsettled people, they gathered seasonal fruit, hunted game, and fished from their dugout canoes. They were sometimes described as cannibals; certainly they seem fiercely to have resisted conversion by the Spanish missionaries.

To the west, especially in central and western Texas, lived the numerous Comanche tribes. Having become expert horsemen, they were almost completely nomadic, living in tepees and hunting bison from which they derived food, shelter, and clothing. Many of the sites sacred to them appear in this book, including Comanche Peak, Enchanted Rock, and the Medicine Mounds. In the high plains their neighbors were the Kiowa; both of these peoples ranged over the land of the Alibates flint quarries and Palo Duro Canyon. Beyond the Kiowa lived the terrifying Apache people, who sometimes joined other Indian groups at Hueco Tanks in order to find water.

Finally we should mention the Jumano people, who for a time lived along the valley of the Rio Grande. They were sedentary, often living in adobe houses and cultivating the rich river bottoms. But they also ranged far afield in order to hunt bison, and so combined the features of various other Indian peoples whom we have been describing. All of these indigenous peoples proved to be alarmingly vulnerable to European diseases, a weakness that allowed them to present only an attenuated resistance to the European invaders.

Eventually, the Indian peoples were theoretically cleared from the land coveted by the Europeans, whether by force or fraud. It has however become clear of late that some of the early European settlers in Texas seem to have intermarried with Indian peoples, in spite of orders for native peoples' expulsion. Moreover, roaming tribes like the Apache and Comanche sometimes took white women as captives. One way or another, interracial combinations seem to have been more common than was once realized.

Terry Jordan. "The Anglo-American Mestizos and Traditional Southern Regionalism." In *Culture, Form, and Place: Essays in Cultural and Historical Geography*, edited by Kent Mathewson. Baton Rouge: Geoscience Publications, Dept. of Geography and Anthropology, Louisiana State University, 1993.

William W. Newcomb. *The Indians of Texas: From Prehistoric to Modern Times*. Austin: University of Texas Press, 1969.

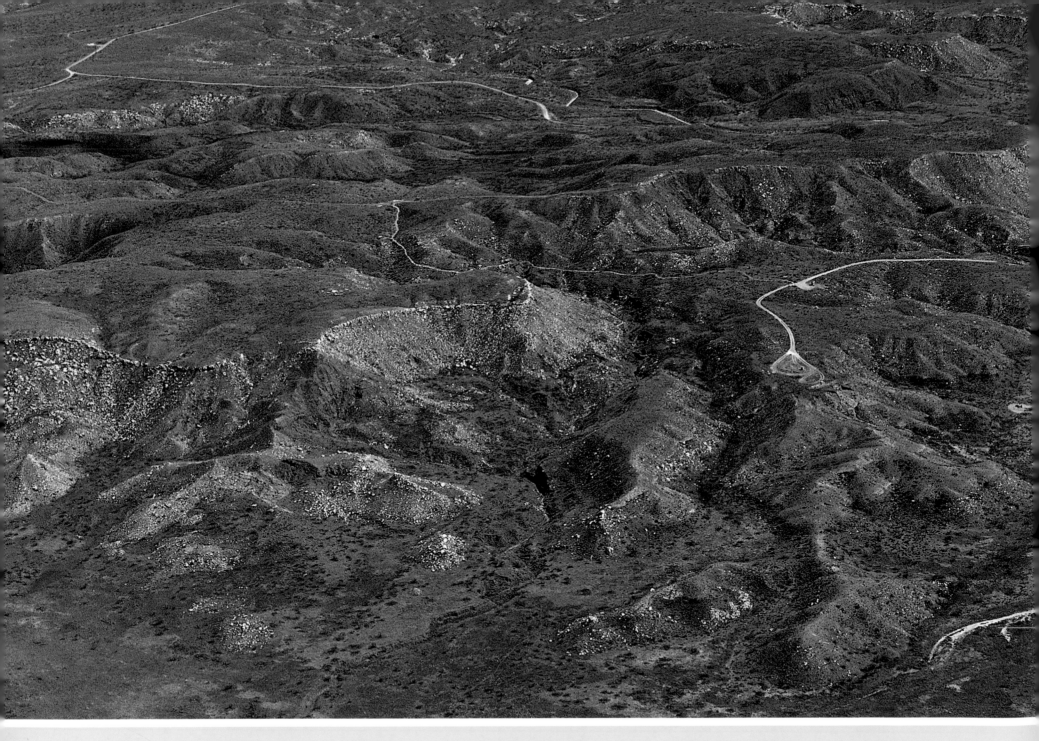

Aerial photograph of Alibates quarries, 19 April 2005, mid-morning, Canadian River drainage in Potter County.

Alibates Flint Quarries, vicinity of Amarillo

This is one of the oldest sites featured in this book, in terms of human use. The Alibates flint quarries are located in the High Plains, not far from Amarillo, where the Canadian River cuts through dolomitic rock from the Permian age (about 260 million years old). Dolomite normally consists of grayish calcium magnesium carbonate, but here the dolomite is agatized—that is, rich in silica. The hard flint found here often varies in color from white to maroon, but can also be yellow, red, brown, or blue. Typically, the flint is banded, meaning it features various colors arranged as layers. Flint often washes out of the rock and is deposited as gravel in the nearby Canadian River valley. Outcrops where the resistant rock protrudes from the ground are a major source of this flint.

Although it requires more skill and labor, digging often unearths large pieces of flint that can be worked into a variety of tools. Humans have been gathering flint from the entire area for at least 10,000 years using two methods: either by finding cobbles and smaller pieces in streambeds and scattered about, or, as the name "flint quarries" suggests, by mining flint from the surrounding rock. The area is honeycombed with thousands of small pits, which are often found just below the canyon rim; these are likely evidence of the first mining operations. In the quarries, the flint

seems to have been extracted with stone hammers and wooden wedges, and the larger quarries were probably developed by what archaeologists call the Panhandle Aspect peoples, who built slab-house villages in the period from about AD 1150 to 1450.

The complexity of these archaeological sites associated with the Alibates flint quarries suggests that this may have been the earliest area to be mined in Texas; the majority of fine stone tools circulated by native peoples in a large area came from the Alibates site, which occupies several square miles. In fact, the high-quality flint apparently found its way to Indian peoples up to a thousand miles away. In addition to being Texas's first mining area, the Alibates quarries appear to have been the center of a very early trading network. This may well be Texas's oldest continually utilized site, since the flint from this area was valued for arrowheads and spear points well into the historical period, when Europeans arrived in the sixteenth century.

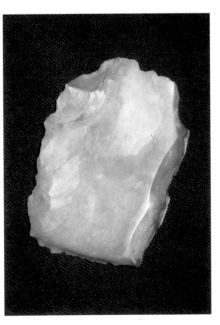

Photograph of flint artifact found in West Texas. Photograph by Jack Graves.

Conger Beasley, Jr. *Alibates Flint Quarries National Monument.* Edited by Derek Gallagher. Tucson, Ariz.: Southwest Parks and Monuments Association, 2001.

H. Mewhinney. "Alibates Flint Quarry." *Texas Parks and Wildlife,* August 1965.

Panhandle Geological Society. *Alibates Flint Quarries: Alibates Indian Ruin, Santa Fe Trail, Sandford Dam.* Amarillo, Texas, 1963.

Enchanted Rock, Fredericksburg

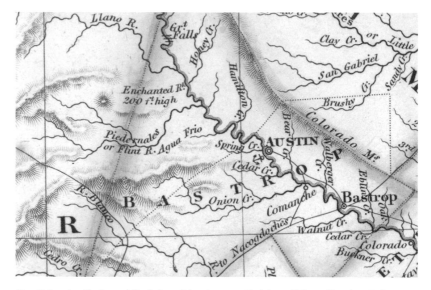

Detail showing Enchanted Rock from John Arrowsmith, Map of Texas *(London: J. Arrowsmith, 1844). Garrett Maps, UTA Library.*

Geologically speaking, Enchanted Rock is the oldest of the sites featured in this book. It is composed of granite dating from the Precambrian age, making it more than 800 million years old. Enchanted Rock is the upper portion of a huge batholith that formed when liquid magma cooled slowly under the earth's surface. The rock was once deep below the surface, but slowly emerged millions of years ago as the area rose and erosion removed the younger rocks above it. The singular feature resembles a huge whale surfacing from the depths. Although it rises only about 400 feet above its surroundings, Enchanted Rock is one of Texas's most spectacular geological features, and was soon marked on early maps like the one by British mapmaker Arrowsmith (see image). Its humped shape and pink color distinguish it from the surrounding brush-covered landscape. Adding to this rock's mystery is the fact that it sometimes glistens at night (likely the result of water droplets in indentations) and creaks and groans as its surfaces expand and contract.

As its name implies, Enchanted Rock has inspired a rich folklore. Probably named by Spaniards who were aware that the Tonkawa and Comanche regarded it with a mixture of awe and fear, Enchanted Rock is associated with legends from at least three cultures—Native American, Spanish, and Anglo-American. The Indians associated it with loss—some researchers claim the Indians considered it haunted by the spirits of warriors who lost battles there, or by the spirit of an Indian woman who jumped to her death after witnessing such a battle. Some Spaniards thought that the glistening rock was composed of silver or iron. One tale features a Spanish soldier (Don Jesús Navarro) falling in love with an Indian woman (Rosa). When she was brought by her tribe to the rock to be sacrificed, Navarro rescued her. During the period of the Texas Republic, Captain John Coffee Hays is said to have held off Comanche raiders single-handedly at the rock until they fled, convinced that the rock's spirits had empowered him. In Anglo-American legends, perhaps inspired by early Spanish accounts, Enchanted Rock was touted as the site of mineral riches. Although a small amount of gold has been mined in this part of the central Texas mineral belt, the country is not actually very promising for the prospector. Still, legends persist and may explain Enchanted Rock's enduring fame as both a natural wonder and a "haunted" place rich in history and folklore.

Martin D. Kohout. "Enchanted Rock Legends." *Handbook of Texas*. Vol. 2, p. 865. Austin: Texas State Historical Association, 1996.

Stephen M. Kotter and Linda A. Nance. *Archaeological Assessments at Enchanted Rock State Natural Area, Gillespie County, Texas*. Austin: Prewitt and Associates, 1980.

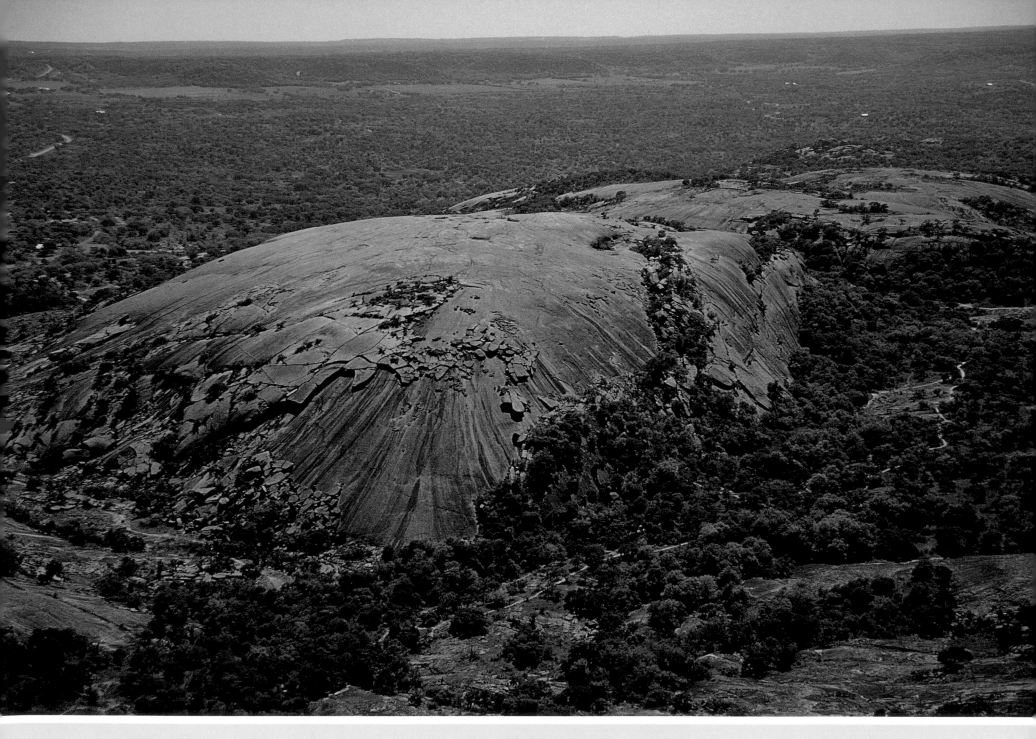

Aerial photograph of Enchanted Rock, 10 April 2006, mid-afternoon, looking northwest in southern Llano County.

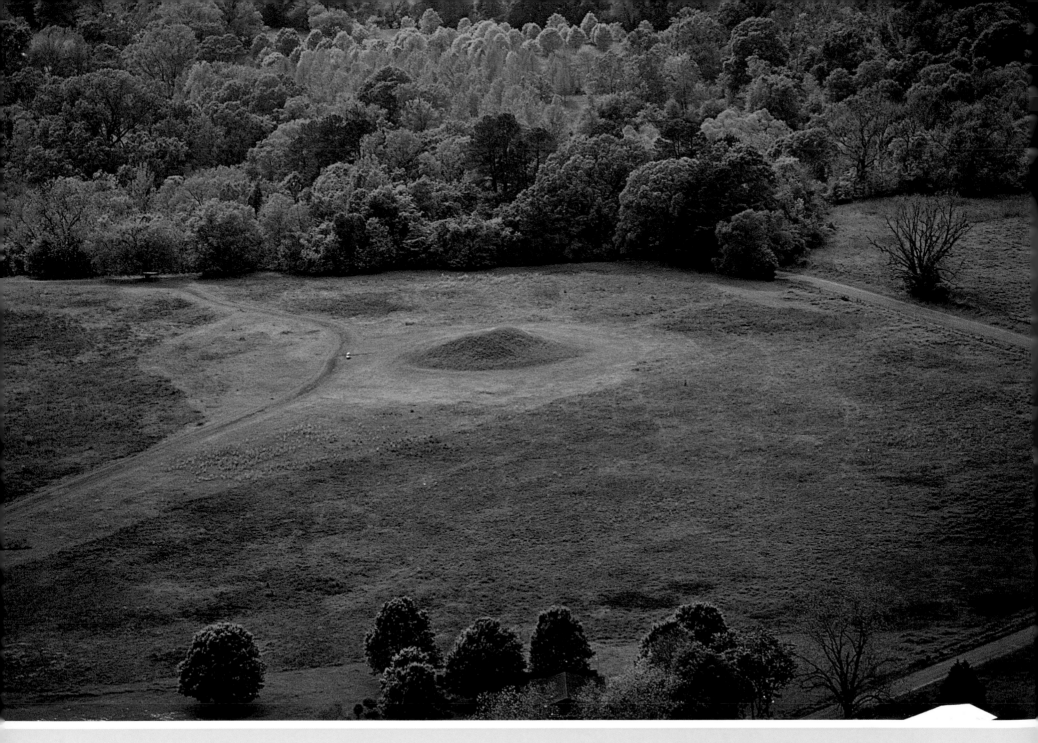

Aerial photograph of Caddo Mounds, 12 April 2006, mid-afternoon, looking west in Cherokee County.

Caddo Mounds, Alto

In the United States, the term "mounds" is used to characterize many Indian sites of the Midwest and of the Mississippi River valley. Some have geometrical shapes, and others represent animals: buffalo, turtles, and so on. Although many of these earthworks have been destroyed in the course of economic development, many others survive, including particularly spectacular examples in Ohio and Illinois. The site at Alto, Texas, includes a group of three such mounds, apparently constructed by the Caddo in about AD 900. These seem to be the most southwesterly surviving mounds, even though the remnants of a large village alongside the upper Trinity River near present-day Arlington have proved that substantial groups of Caddo also lived farther to the west.

Two of the three mounds at Alto were capped by communal buildings, while the third was used for burials. The Caddo would have lived in their beehive-shaped dwellings all around the mounds, cultivating corn, hunting game (with bow and arrow), and producing their elegant and distinctive pottery. They also formed part of a trade network that extended far up the Mississippi valley and eastward to the Appalachian mountains; they were in general a peaceable and sedentary people, unlike their neighbors to the south and west.

The Spaniards must have known of the mounds, since their *camino real* passed not far away. The first European text to mention the mounds seems to be by Athanase de Mézières, who in August 1779 described one of the mounds as "rather a monument to the multitude than to the industry of its individuals." The Texas Parks and Wildlife Department established a historic park at the site in 1974; this site now includes an exhibit about the Caddo and a reconstruction of a traditional Caddo dwelling.

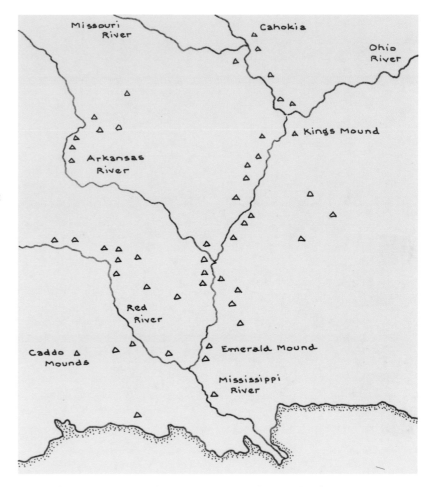

Map to show some major mounds in the Mississippi valley. Note how far to the west the outlying Caddo Mounds are. Map generated from Time-Life Books, Mound-Builders and Cliff-Dwellers *(Alexandria, Va.: Time-Life Books, 1992).*

Herbert Bolton, ed. *Athanase de Mézières and the Louisiana-Texas Frontier 1768–1780.* 2 vols. Cleveland: Arthur H. Clark, 1914.

Timothy K. Perttula. *The Caddo Nation: Archaeological and Ethnohistoric Perspectives.* Austin: University of Texas Press, 1992.

F. Todd Smith. *Caddo Indians: Tribes at the Convergence of Empires, 1542–1854.* College Station: Texas A&M University Press, 1995.

Comanche Peak, Granbury

On 7 March 1846, William Shorey Coodey, president of the National Council of Cherokees, announced to a council of Comanches and other Indians meeting high atop Comanche Peak that Texas had become a state in the American union, and was no longer an independent nation. This news meant the Native Americans in the region would now be dealing with U.S. officials rather than with those from Texas. The site Coodey chose to announce this important change was Comanche Peak, one of the most significant landmarks to Indians in the region. The peak dominates the broad central valley of the Brazos River, and is four miles south of current-day Granbury, the county seat of Hood County. The so-called peak is not really a peak at all, but rather a long north-south mesa shaped like an exclamation point. Its highest point is 1,230 feet above sea level.

Before Anglo-American settlers pushed into the region in the two decades before the Civil War, the area was home to the Comanches. In the nineteenth century, a band of Comanches called the Penatakas, or Honey Eaters, roamed the Texas plains just west of the Cross Timbers between the headwaters of the Brazos and Colorado Rivers. Comanche Peak, known to the natives as "Que-Tah-To-Yah," or "rocky butte," was both a spiritual site and a meeting place for the Comanches.

According to Comanche oral tradition, the peak or butte was an easily recognizable landmark on the plains, and became a stopping place for Comanche parties after raids into Mexico. The Comanches would meet at the peak to celebrate a successful raid, store supplies, and hold sacred ceremonies. In addition, they used the vantage point that the peak afforded over the Brazos valley to watch for encroaching settlers and military threats. From here, they could send smoke signals to warn of any impending danger. Of course, the peak offered no protection against the immigration of Anglo settlers onto the plains of Texas, which led the government to dislocate the Comanches and other Native Americans. In the 1867 Medicine

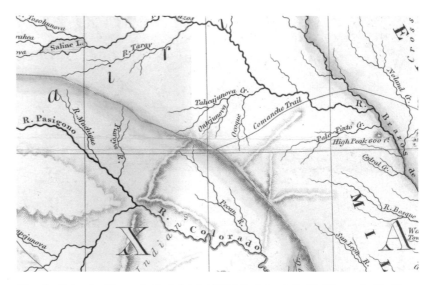

Map detail showing Comanche Peak, labeled "High Peak 600 ft.," with "Comanche Trail" marked northwest of the peak, from John Arrowsmith, Map of Texas (London: J. Arrowsmith, 1844), Garrett Maps, UTA Library.

Lodge Treaty, the United States established a reservation for the Comanches in southwestern Indian territory between the Washita and Red Rivers. Despite the treaty, some Comanches refused to stay on the reservation, and raided Texas well into the late nineteenth century.

Comanche Peak has been in private hands since 1847 when John F. Torrey, a former soldier in the Texas Revolution, acquired the property and several decades later built a log cabin on it. Since the Comanches' removal, the peak that bears their name has been used for dances, picnics, hunting, and ranching. While the sacred peak still dominates the region, the Comanches for whom it was so important have all but disappeared; most of their descendents live in Oklahoma.

C. L. Hightower, ed. Hood County History in Picture and Story, 1978. Fort Worth: Historical Publishers, 1978.

Vance J. Maloney. The Story of Comanche Peak, Landmark of Hood County, Texas. Glen Rose, Tex.: Vance J. Maloney, 1970.

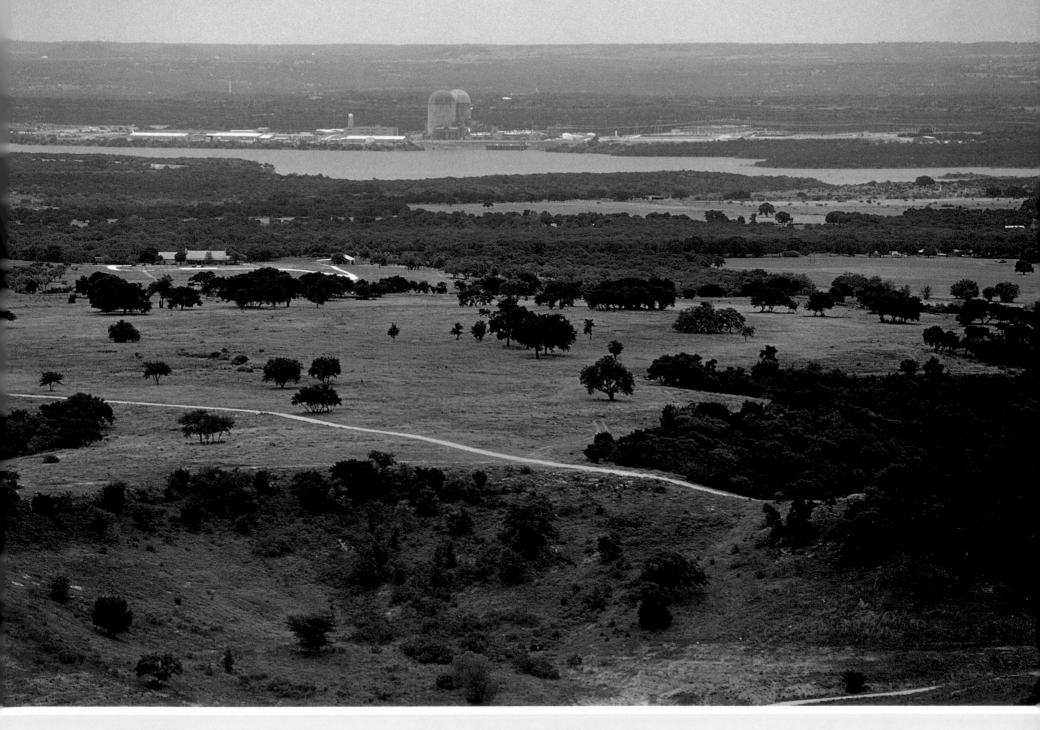

Aerial photograph of Comanche Peak, 28 July 2005, mid-afternoon, looking west toward the nuclear power plant.

Medicine Mounds, Hardeman County

Sketch of Medicine Mounds from the ground (Richard Francaviglia).

Rising from the plains of Hardeman County, the Medicine Mounds have long been landmarks in northwestern Texas. They appear on numerous nineteenth-century maps, and are mentioned in frontier journals and travel accounts. Although the hills collectively called the "Medicine Mounds" rise only a few hundred feet above the surrounding plains, the flatness of the rest of the landscape here enables them to be seen at least ten miles away. From other elevated sites, the Medicine Mounds can be seen for up to forty miles. In contrast to man-made features like the Caddo Mounds, the Medicine Mounds are natural.

From the air, the geological structure of the Medicine Mounds is easy to understand. The site consists of four almost evenly spaced, conical hills aligned in a northwest to southeast configuration. All are composed of sedimentary rock that resists weathering. Of the four mounds, the tallest (which is located farthest northwest) is called Big Mound (and sometimes Medicine Mound); its flat summit is 1,744 feet above sea level. Because the plains surrounding the mounds lie about 1,400 feet above sea level, even the tallest mound only rises about 300 feet above its surroundings. The other mounds, successively lower in elevation southeastward, are called Cedar Mound (1,712 feet), Third Mound (1,640 feet), and Little Mound (1,600 feet). Our aerial photo looks northwest from the lowest to the tallest mound and beautifully shows the mounds' alignment. It also reveals the reddish color of these features and the cedar and other vegetation that help define the character of the mounds as islands in a sea of grass.

Today the Medicine Mounds are surrounded by ranch lands and grain and cotton fields. This is a result of the settlement of the area by Anglo-American farmers and ranchers since the 1860s. However, the landscape had a different appearance when the Comanche Indians used to occupy the area, and the mounds marked the location of a nearby buffalo trail. The Comanches consider the two tallest mounds—Medicine Mound and Cedar Mound—to be sacred sites. These were, and still are, the sites of vision quests—multiday spiritual searches in which young men would commune with the spirit world. The medicinal plants that grow here were and are used in various Comanche health and healing ceremonies.

In numerous areas of central and west Texas, natural topographic features of importance to native peoples have been altered and even destroyed as sources of stone and gravel (for example, Santa Anna Peak). The Medicine Mounds have escaped this fate. Once in danger of losing their character to nearby development, the Medicine Mounds were purchased by the Summerlee Foundation of Dallas as a site worthy of preservation. Their preservation remains an important issue, as these natural features are still sacred to the modern Comanche population.

Nancy Kenmotsu. *Archaeological and Documentary Research at Medicine Mounds Ranch, Hardeman County, Texas.* Austin: Texas Historical Commission, 1994.

Bill Neal. *The Last Frontier: The Story of Hardeman County.* Quanah, Tex.: *Quanah Tribune-Chief,* 1956.

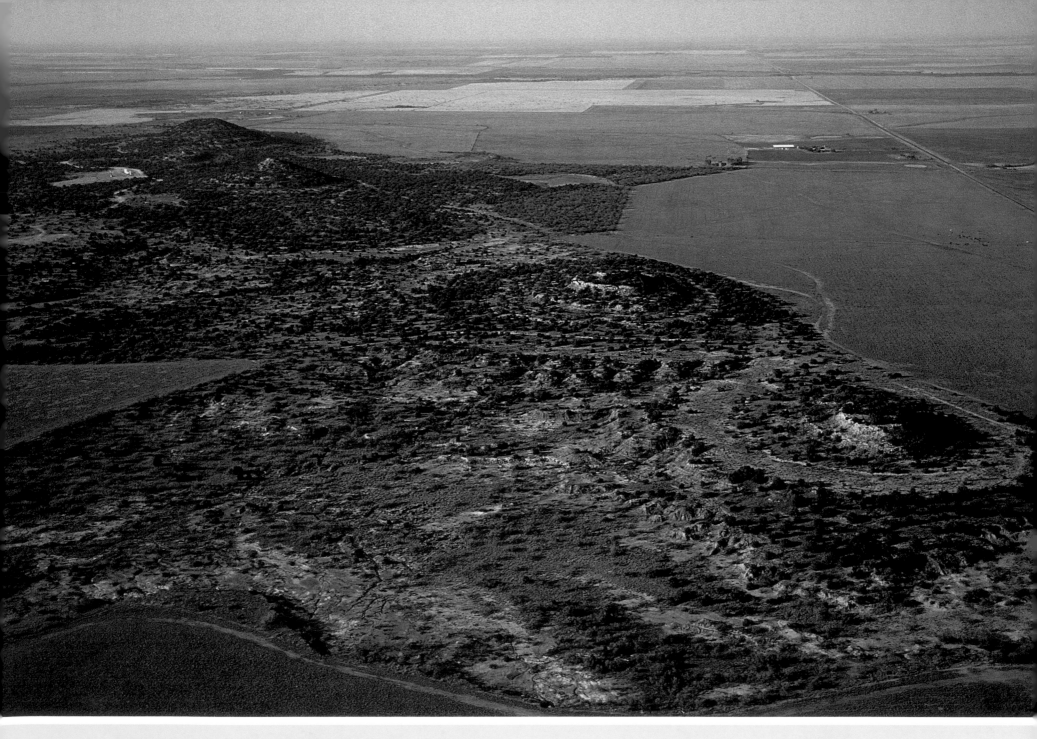

Aerial photograph of Medicine Mounds, 7 October 2006, late afternoon, looking north.

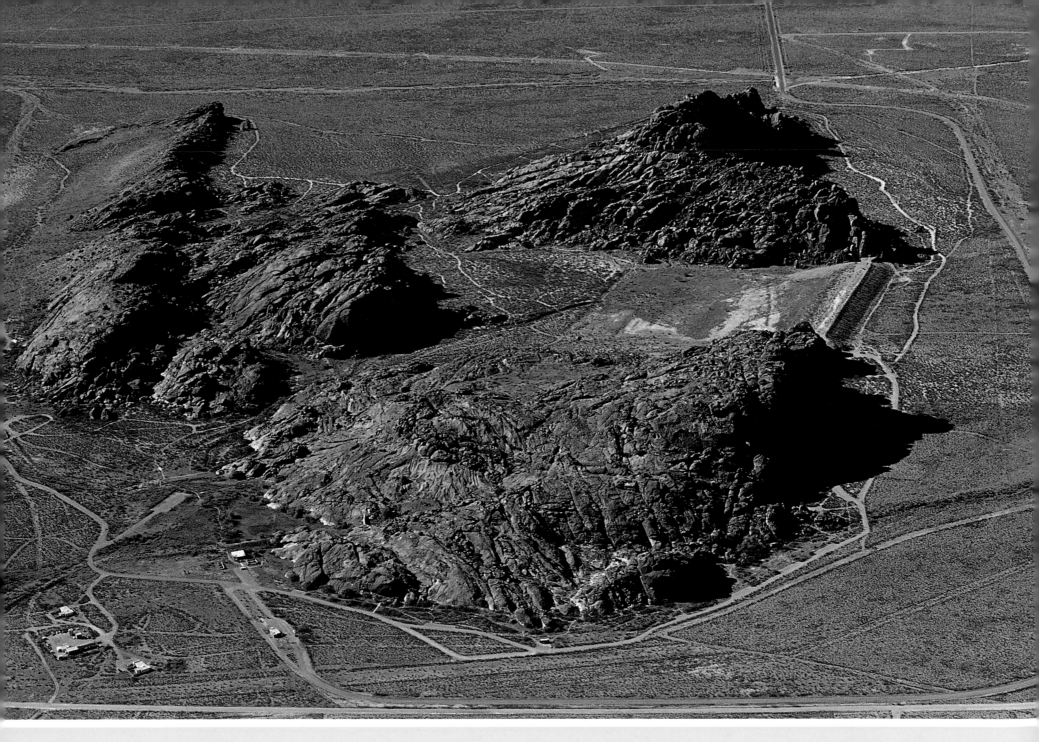

Aerial photograph of Hueco Tanks, 11 April 2005, early morning, looking south.

Hueco Tanks, El Paso

Hueco Tanks is both a remarkable geological feature and an important historical site. Composed of rounded hills of granite-like rock that rise about 450 feet above the surrounding desert floor, Hueco Tanks is named for the site's ability to retain water even when the parched desert offers none. In Spanish, "hueco" means "hollow," referring in this case to the pothole-like depressions, some as big as hot tubs, where fresh water remains after rainy periods. The word "tank" in the English of western ranchers signifies a place where water is ponded either by nature as it collects in low-lying areas, or artificially behind constructed dams. The tanks at Hueco Tanks are natural depressions in the rock.

This site's ability to retain fresh water has made it an oasis for about 10,000 years. Originally, nomadic people hunted and gathered food in the area, but by about AD 1000 some crops were grown here and the people lived in adobe houses. Around AD 1200, a pit-house village existed here, and even into the historic period following the arrival of European Americans, Hueco Tanks was recognized as an important Native American site. By around 1700, Mescalero Apaches lived here. Hueco Tanks was also frequented by Comanches and Kiowas, as well as Indians from the Tigua villages. Thanks to the variety of native dwellers and their long periods of cultural activity, Hueco Tanks boasts a profusion of spectacular Indian rock art. Rendered as both pictographs (painted) and petroglyphs (carved), these images apparently record events of importance to the indigenous peoples, but their meanings are not easily understood today.

Given its strategic position for east-west travelers in this area, it is not surprising that Hueco Tanks became an important site to European Americans after the Mexican-American War (1846–1848) and the California Gold Rush (1849), when the road between San Antonio and El Paso was created to facilitate trade.

By 1858, the Butterfield Overland Mail had a stagecoach stop here, but that company ended its service over this route just before the Civil

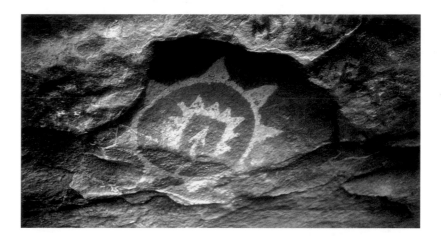

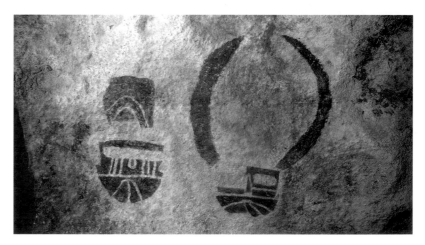

Rock art at Hueco Tanks. Courtesy Texas Parks and Wildlife.

War. By the late 1800s, the Hueco Tanks had become part of a privately owned ranch, and much more recently (1969) became a park to protect the rich natural environment and cultural heritage. It remains an important sacred site to Native Americans and a recreational spot for others.

Michael Freehling. *Hueco Tanks State Historical Park, El Paso County, Texas.* Austin: Texas System of Natural Laboratories, 1976.

Kay Sutherland, with watercolors by Forrest Kirkland. *Rock Paintings at Hueco Tanks State Historical Park.* Austin: Texas Parks and Wildlife Press, 1995.

Palo Duro Canyon, vicinity of Amarillo

Although known chiefly for the beauty of its multicolored cliffs, Palo Duro Canyon is also one of Texas's most interesting historical landscapes. Most visitors to West Texas experience Palo Duro from the ground. They must cross many miles of flat caprock country before the spectacular 800-foot-deep canyon opens before them. Palo Duro Canyon is a striking example of geological subtraction, where the Prairie Dog Fork and Town Fork of the Red River have cut deeply into the high plains of the Texas panhandle. From the air, the labyrinthine Palo Duro Canyon country starkly contrasts with the cultivated rectangular agricultural lands at its western rim. The tamer surrounding landscape is a combination of cotton fields and pastures cut into the big rectangles of the orderly land survey systems that were used to divide up the land in West Texas in the 1880s.

By contrast, the Palo Duro Canyon landscape appears wild, even chaotic from above. Consisting of heavily eroded layers of rock from four different geological periods spanning about 240 million years, this rugged canyon land was a favorite site of Native Americans, who occupied it for about 10,000 years. The canyon is rich in archaeological sites. Archaeologists have recovered artifacts from the canyon, including projectile points, pictographs, and other tools and evidence of former inhabitants. In the 1500s, the Spaniards discovered the canyon and named it "Palo Duro" for the hardwood shrubs and trees found in the otherwise grassy landscape. This area was inhabited dominantly by Indians, including Comanches, through the late nineteenth century. It was also explored by Captain Ran-

VIEW NEAR HEAD OF RED RIVER
Lith H Lawrence 86 John St N Y

"View near head of Red River" from R. B. Marcy, Exploration of the Red River of Louisiana *(Washington, D.C.: Public Printer, 1854), Special Collections, University of Texas at Arlington Library.*

dolph B. Marcy's expedition in 1852 as they searched for the headwaters of the Red River.

The Indian populations finally left the area after Colonel Ranald S. Mackenzie's cavalry troops routed a large number of Kiowa, Comanche, and Cheyenne here in 1874. These plains Indians had gathered from a large area, and their loss here signaled the dominance of Anglo-American culture. By 1876, a topographic and scientific survey had yielded important information about the area. In the same year, ranching began in earnest as Charles Goodnight commenced herding cattle in the area. Since 1933, when Palo Duro Canyon became a 15,000-acre state park, it has been one of the state's most heavily visited scenic spots.

Duane F. Guy, ed. *The Story of Palo Duro Canyon.* Lubbock: Texas Tech University Press, 2001.

William Henry Matthews. *The Geologic Story of Palo Duro Canyon.* Austin: Bureau of Economic Geology, University of Texas at Austin, 1969.

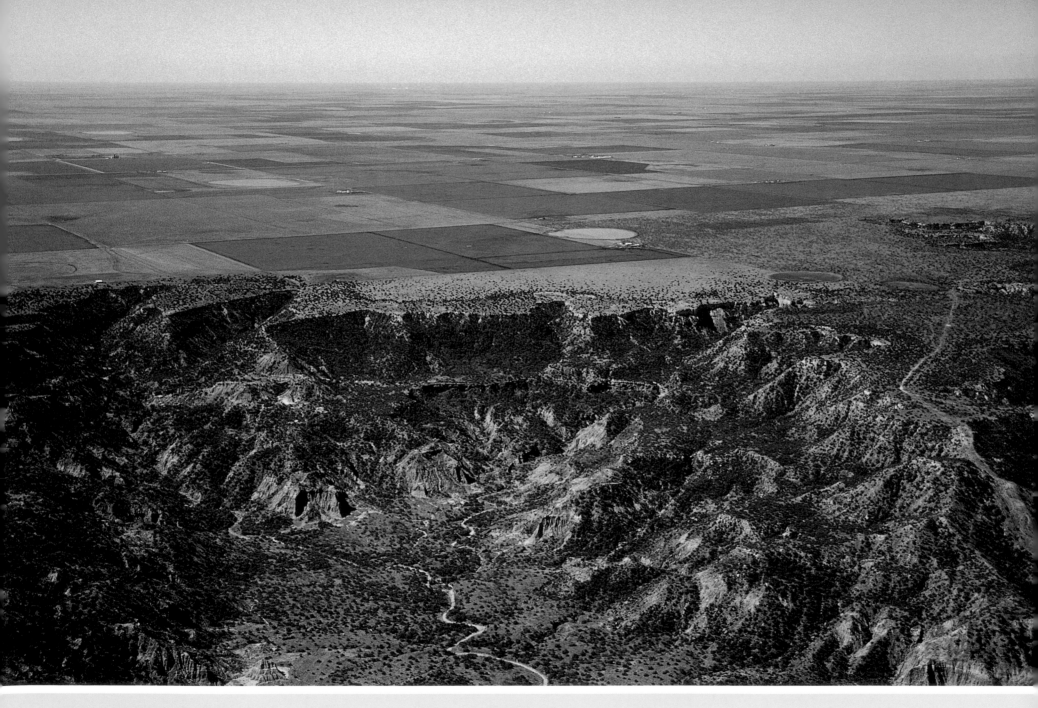

Aerial photograph of Palo Duro Canyon, 10 April 2005, mid-morning, looking west in Randall County.

3

FRENCH AND SPANIARDS

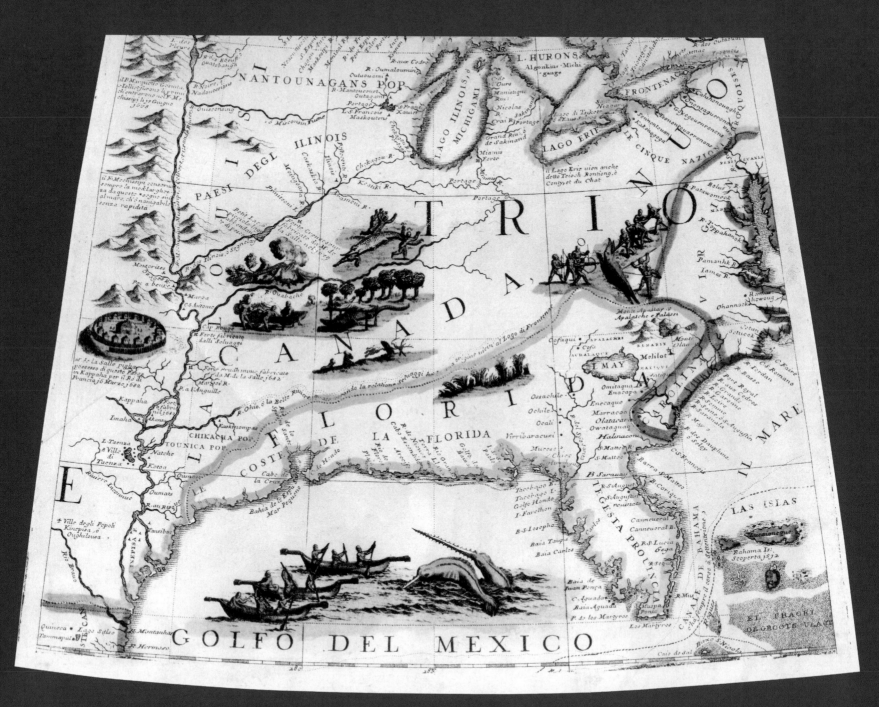

INTRODUCTION

For many years after the first explorations by Spaniards like Álvar Núñez Cabeza de Vaca and Francisco Vásquez de Coronado in the sixteenth century, the area that would become known as Texas remained free from Spanish influence, though Spain claimed it as part of Nueva Vizcaya. The French explorer Robert Cavelier de La Salle changed all this with his voyage in 1682 from the Great Lakes down the Mississippi River to its estuary at the Gulf of Mexico. Returning to France afterward, La Salle persuaded Louis XIV to support an expedition to establish a French colony at the mouth of the Mississippi. This settlement on the Gulf Coast would complete a ring of French settlements from the mouth of the Saint Lawrence River through the Great Lakes area and down to the Gulf of Mexico, which would effectively hem in the English colonies along the eastern seaboard. The Spaniards feared that this plan would bring the French altogether too close to the rich silver mines of Nueva Vizcaya, and perhaps would even threaten Spanish settlements in central Mexico. Authori-

Detail of a gore from a globe compiled by Vincenzo Coronelli (Paris, 1688).

ties in Mexico City reacted quickly and forcefully, sending out six expeditions by land and four by sea between 1686 and 1690 to find and destroy the French colony. In the process, the Spanish gained a good deal of knowledge about the land bordering the Gulf of Mexico.

Ironically, the French settlement that they sought to destroy had already failed on its own account. In 1685, La Salle sailed (by mistake, it would seem) past the mouth of the Mississippi River and tried to establish a settlement about two hundred miles to the west near Matagorda Bay; our map from the 1680s shows how far west he sought the mouth of the Mississippi. One of his ships, *La Belle,* sank in the bay, and he was forced to abandon his land settlement at nearby Fort St. Louis, as the would-be colonists were ill-supplied and poorly led; not long after they left coastal Texas, La Salle's own men murdered him.

Three centuries later, in the mid-1990s, two remarkable archaeological excavations, one by sea and the other by land, revealed both *La Belle* and Fort St. Louis and recovered a huge trove of seventeenth-century artifacts that shed much light on La Salle's intentions. Of the two excavations, that of *La Belle* was the more extraordinary, since it involved sinking a large caisson into Matagorda Bay around

the wreck, and then excavating it as if it had been a land site. Information about these remarkable excavations may be found at the Bob Bullock Texas State History Museum in Austin and at seven museums near the excavation sites, in Corpus Christi, Rockport, Edna, Port Lavaca, Victoria, Port City, and Palacios.

Although disconcerted by the failure of La Salle's venture, the French nevertheless persisted with his plan, and by 1717 had firmly established themselves on the lower Mississippi River at New Orleans. Meanwhile the Spaniards, sobered by how easily La Salle had entered the area, began a long effort to establish their power in Texas. Most Spanish settlements in the New World were located near Native Americans; those in Texas were no exception. Spain recognized the value of engaging the indigenous peoples in the colonization effort, and many of these indigenous peoples soon became laborers and religious converts. Eventually, Spain founded in this area no fewer than thirty-three missions protected by twelve presidios (forts); many of these were temporary, but others lasted into the nineteenth century. A few lay along the Rio Grande, while others were built far into eastern Texas. *Caminos reales,* or "royal roads," linked these settlements; some led to Paso del Norte, today's El Paso, while others ran across Texas

from southwest to the northeastern area near the Red River where Spanish and French jurisdiction came into uneasy contact. Many modern Texan cities lie on old *caminos reales,* whose tracks, often followed by modern highways, provide some of the most powerful memories of the Spanish days.

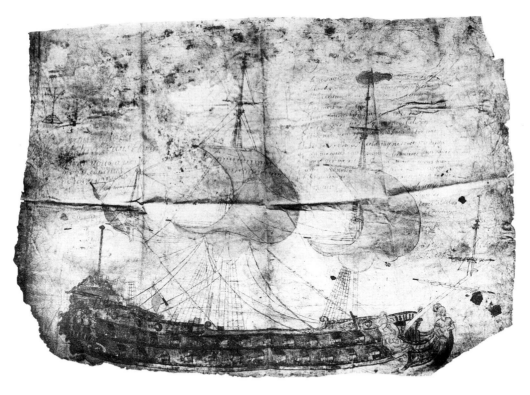

Drawing of Le Joly, University of Texas Archives.

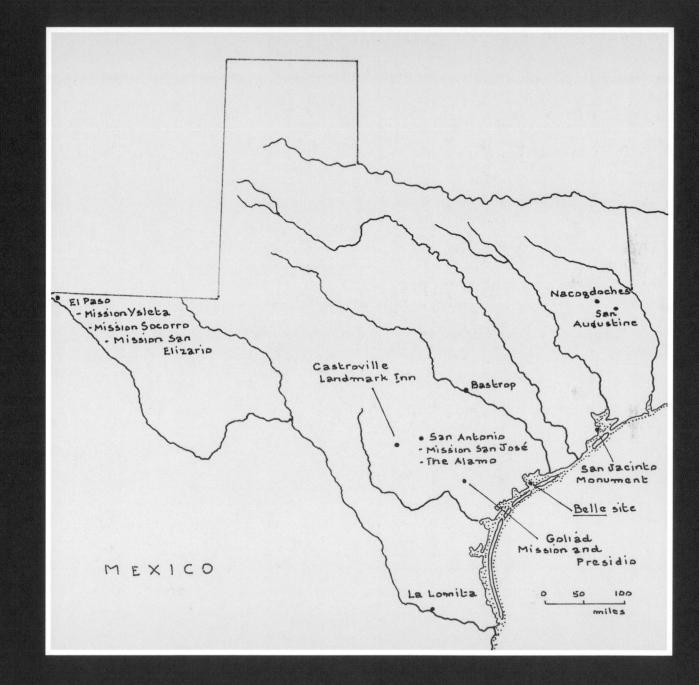

Map to show sites of chapter 3.

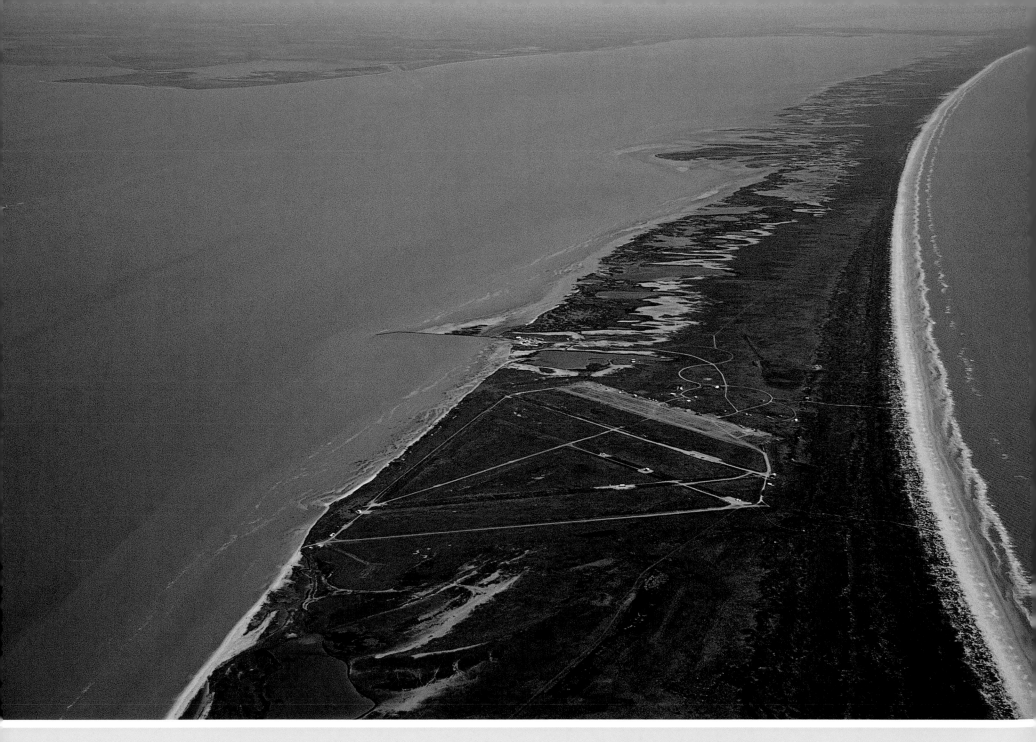

Aerial photograph of Matagorda Bay, 8 March 2008, mid-morning, looking northwest from the Gulf of Mexico across the Matagorda Peninsula.

The Wreck of *La Belle*, Matagorda Bay

From the air the body of water called Matagorda Bay looks placid enough, but it was once the scene of a maritime disaster that changed history. In the early spring of 1685, the French explorer René-Robert Cavelier, Sieur de La Salle, sailed here from La Rochelle, France. La Salle reportedly thought he had reached the mouth of the Mississippi River near today's New Orleans, but he was off by about two hundred miles. La Salle commanded several ships on this voyage, among them *L'Aimable*, *Le Joly*, and his flagship *La Belle*. Attempting to enter Matagorda Bay through treacherous Pass Cavallo, *L'Aimable* stuck in the mud and sank. Following this disaster, many in the group sailed *Le Joly* straight back to the safety of France, but the obsessed La Salle elected to stay here with *La Belle* to begin a French colony. This decision proved fatal. As the colony's supply ship, *La Belle* was loaded with gifts to trade with the Indians and supplies for the settlers. It was anchored in a small embayment at the north side of Matagorda Bay, but unfortunately for La Salle, a strong norther caught *La Belle* by surprise and swept the vessel to the south side of Matagorda Bay. Grounded, *La Belle* was pounded by waves until it sank in shallow water, and only some of the supplies were saved. The sinking of *La Belle* exacerbated an already desperate situation. As conditions deteriorated, La Salle and a few from his colony decided to march northeastward toward the Mississippi in order to make their way to Canada. However, La Salle only made it as far as the Brazos River before he was murdered by two of his own men.

Meanwhile, the Spaniards were incensed by La Salle's arrival so close to their own territory, and they sent out a force that laid waste to the French settlement and fort. Submerged, *La Belle* lay on the shallow sea bottom for more than 300 years. Finally, after years of searching, archaeologist J. Barto Arnold of the Texas Historical Commission discovered the ruins

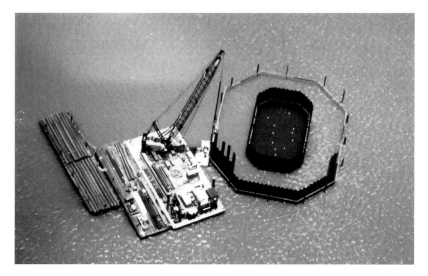

Aerial photograph of the construction of the caisson in Matagorda Bay. Courtesy the Texas Historical Commission.

of *La Belle* in 1995. The ship was completely excavated after a coffer dam was erected around it, providing a dry place to work. Excavating the wreck in such conditions proved wise, not least because an underwater excavation would have had to contend with very low visibility in murky Matagorda Bay. Archaeologists found items including bells and beads meant for the Indians and also the skeleton of a French man huddled in the bow of the ship's hull. When *La Belle* was completely removed, the coffer dam was disassembled, and water reclaimed the site. Today, the location where *La Belle* sank is indistinguishable from the rest of the coastline.

Richard Francaviglia. *From Sail to Steam: Four Centuries of Texas Maritime History, 1500–1900*. Austin: University of Texas Press, 1998.

Henri Joutel. *The La Salle Expedition to Texas: The Journal of Henri Joutel, 1684–1687*. Edited by William C. Foster. Austin: Texas State Historical Association, 1998.

Robert Weddle. *The French Thorn: Rival Explorers in the Spanish Sea, 1682–1762*. College Station: Texas A&M University Press, 1991.

Robert Weddle. *The Wreck of the* Belle, *the Ruin of La Salle*. College Station: Texas A&M University Press, 2001.

Mission Isleta, El Paso

Mission Isleta ("little island" in Spanish), is located in the community of Ysleta, and it has had a long and sometimes troubled history. It was originally founded after the Pueblo Revolt of 1680 in New Mexico. During that bloody uprising, a response to Spain's brutal treatment of the Indian population, Spaniards who were not killed fled southward to the area along the Rio Grande in the vicinity of Paso del Norte (near today's El Paso). Accompanying these Spaniards were Tigua (Tiwa) Indians who had become Spanish subjects and either rejected a return to the pre-Spanish lifestyle, or feared retaliation by the rebels. Like most towns of the Spanish frontier, Ysleta centered around a church where the Indians could be protected and serve the king as "gente de razón" ("people of reason") and Christian converts. These Tigua Indians had lived in this area ever since their forced move from New Mexico. Their life here was not always easy, nor was the Spanish and Mexican development of the area without problems. After several disastrous floods along the Rio Grande swept churches away, Ysleta moved to higher ground in 1844, where the town now stands.

The church seen here was mostly built in 1851, and its bell tower finally completed in the 1880s. Although it had originally been built by the Spanish to convert Indians, the mission was not ultimately completed until after this part of Mexico had joined the United States. Nevertheless, as a testimony to its Spanish/Mexican and Indian heritage, the church still serves a large Spanish-speaking Tigua population. The mission has had several names over the years; it is currently called Our Lady of Mount Carmel, though the Tigua usually call it Mission de San Antonio. Ysleta

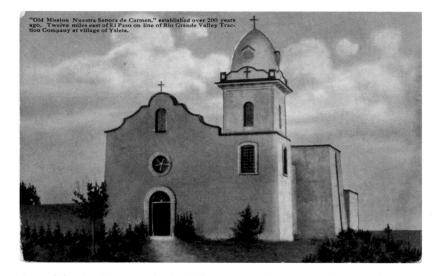

Postcard showing the mission church at Ysleta, ca. 1930. Garrett Postcards, UTA Library.

became an American town at the conclusion of the Mexican-American War (1846–1848), but its Hispanic and Indian heritage remains its predominant characteristic today.

Secular life has always been important here, too. In 1873 Ysleta became the county seat of El Paso County, and in 1955 the town was annexed by the expanding city of El Paso. The *Handbook of Texas* notes that Ysleta "is perhaps the oldest town in Texas," and we include this aerial view for that reason. We should understand, however, that "oldest" does not mean that it appears as it did more than three hundred years ago. This old town is resilient; it has changed over the years, but has fought hard to retain its character. Only in 1967 and 1968—three hundred years after the Pueblo Revolt—were the Tigua finally recognized as an Indian tribe by Texas and the United States, respectively.

Thomas Drain. *A Sense of Mission: Historic Churches of the Southwest.* Photographs by David Wakely. San Francisco: Chronicle Books, 1994.

Leon Metz. *Turning Points in El Paso, Texas.* El Paso: Mangan Books, 1985.

W. H. Timmons, ed. *Four Centuries at the Pass.* El Paso: El Paso Arts Resources Department, 1980.

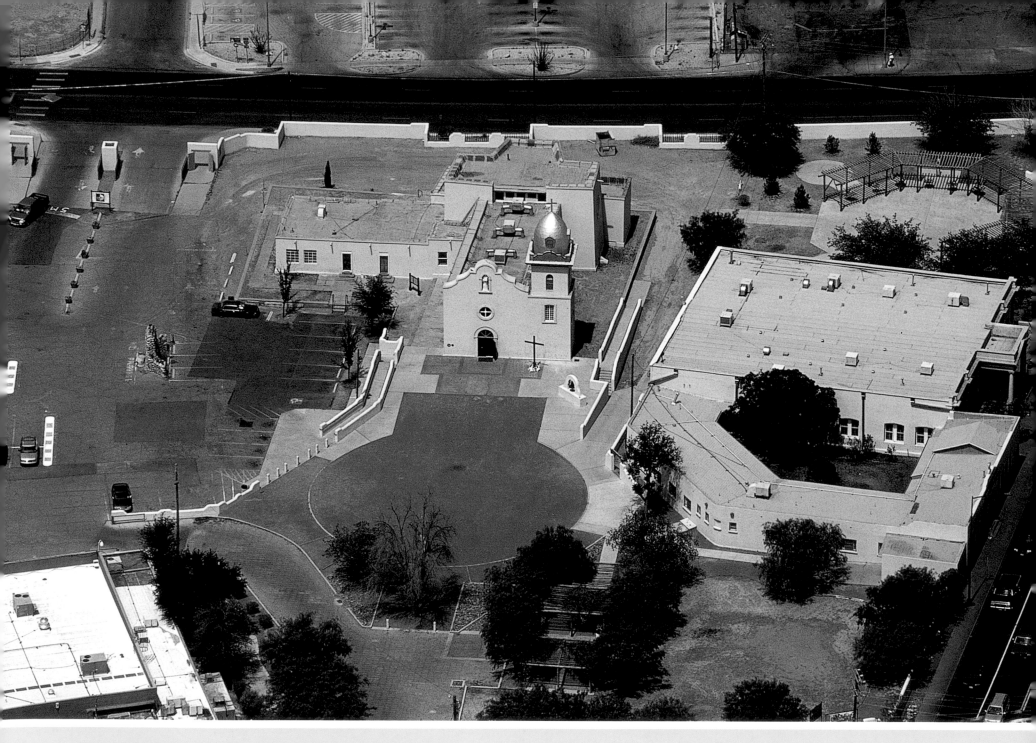

Aerial photograph of the church at Ysleta, 7 May 2006, mid-morning, looking west.

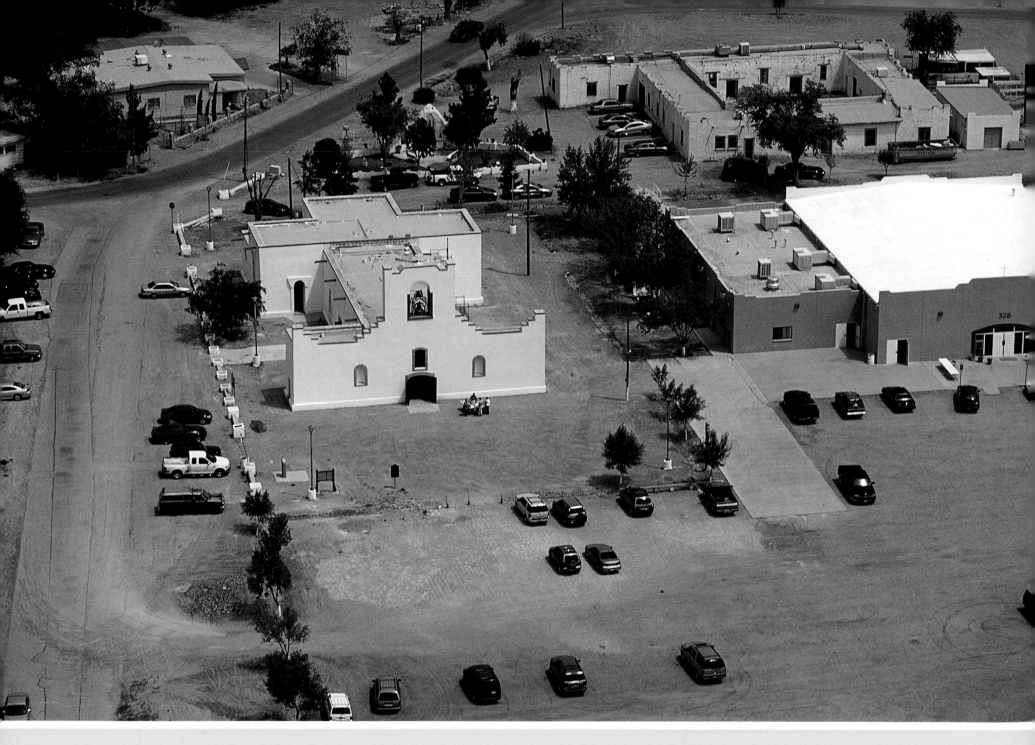

Aerial photograph of the church at Socorro, 7 May 2006, mid-morning, looking north.

Mission Socorro, El Paso

Mission Socorro was one of several missions created just after New Mexico's Pueblo Revolt in 1680. Like Mission Isleta, the mission here at Socorro represented Spain's use of religion as a colonizing force. Missions involved restricting the mobility of native peoples in *reducciones*. Under this system, the Indian population was concentrated at certain locations. For all of the criticism heaped upon it, the mission system offered security for many. Then, too, many of these Indians had now become Christians, and were sustained in part by their Catholic faith.

Mission Socorro was thus begun in less than ideal circumstances, for Spain had to hastily relocate the Indians and create new communities while knowing little about the environment here. Unsurprisingly under these circumstances, Socorro was established quickly but planned poorly. It subsequently flooded or was washed away by the tempestuous Rio Grande in 1744 and again in 1829.

Now located on somewhat higher ground, the present-day Socorro is a more stable community than its predecessors. This aerial photo shows the church at Socorro, which was completed in 1843, and the town of 1,100 clustered near it. Like many churches, Socorro has a *camposanto* (cemetery) nearby. Aerial photos often reveal things not readily apparent from the ground. By looking down on the church, we can see a pattern common in Catholic churches: the floor plan of the building reproduces a religious symbol, the cross. Upon entering the front of the church, which is embellished by a zigzag pattern of steps that rise to a bell tower at its center, the parishioner experiences one long, hall-like space

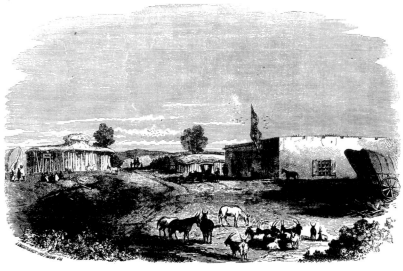

Socorro, Texas.

Socorro, Texas, from William Emory, Report on the United States and Mexican Boundary Survey, *3 vols. (Washington, D.C.: U.S. Department of the Interior, 1857–1859).*

intersected by another shorter space. Straight beyond this intersection is the altar, the most sacred part of the building. Socorro has changed in many ways over the years, but the church remains one of the Rio Grande Valley's historical treasures. Large fields have replaced the small family farms that once surrounded the town, reflecting the increasingly large scale of agriculture. As the El Paso area has boomed in the last thirty years, Socorro has become an island of refuge in an increasingly suburbanized area.

Postcard showing the façade of the mission church at Socorro, ca. 1925. Garrett Postcards, UTA Library.

Ernest J. Burrus, SJ. "An Historical Outline of the Socorro Mission." *Password XXIX*, no. 3 (1984): 145.
Vina Walz. "History of the El Paso Area, 1680–1692." PhD diss., University of New Mexico, 1951.

San Elizario, El Paso

Situated not far from the flood-prone Rio Grande and about 15 miles southeast of El Paso, the small community of San Elizario is a nearly perfect example of the Spanish and Mexican influences in Texas. San Elizario dates from 1790, when a presidio (fort) and chapel were established along the Rio Grande as part of Spain's attempts to build a stronger presence, in order to wield greater influence on the Indians and deter foreign powers from moving into the area. Like most Spanish towns in the arid and semi-arid Southwest, San Elizario had to be carefully planned in order to thrive. The community relies on an elaborate system of irrigation ditches (called *acequias* or *zanjas*) that enabled farming to thrive and the town to grow. Even the actual layout of the town was mandated by the Spanish Law of the Indies—an early sixteenth-century legal document that required towns to be built in a grid pattern and feature a central plaza.

As seen from the air, the central plaza of historic downtown San Elizario has a gazebo or bandstand that can host many civic events, such as musical concerts or political speeches. Like many plazas in the Southwest and Mexico, San Elizario's has been slowly beautified since the nineteenth century. The many trees and prominent bandstand are among these improvements. The San Bernal Plaza today is shaded by beautiful Siberian elm trees, but in the early nineteenth century the nucleus of the young town was only a dusty open square. The word "plaza" derives from the phrase *Plaza de Armas* (a place where the military practiced coming to arms). But the open plaza was also the center of civic life in the town with the church, businesses, and homes clustered around it. The San Elizario Mission Chapel and Rectory faces the plaza, as do several commercial and governmental buildings. In

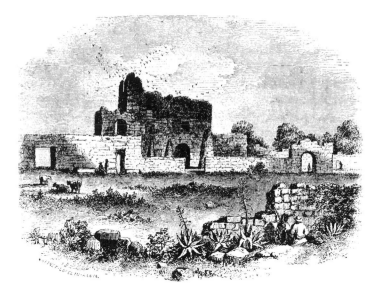

"Presidio of San Eleazario" from John Russell, Personal Narrative of Explorations . . . , *2 vols. (New York: D. Appleton and Co., 1854), Special Collections, University of Texas at Arlington Library.*

keeping with their Spanish heritage, these buildings are one room deep, flat-roofed, and often built of adobe brick covered by plaster or stucco.

San Elizario is one of Texas's most important historic towns. It was the home of the Catholic bishops who oversaw church activities in the El Paso area, and also served as an administrative and legal center for this part of the Rio Grande Valley. San Elizario was also the site of the infamous El Paso Salt War (see the Site of the Salt War pages). In 1876, legend claims, William Bonney (Billy the Kid) broke into the San Elizario jail to free an incarcerated friend. This historic town remains one of the best places in Texas to experience Spanish civic design and architecture firsthand.

Rick Hendricks and W. H. Timmons. *San Elizario: Spanish Presidio to Texas County Seat.* El Paso: Texas Western Press, 1998.

Eugene O. Porter. *San Elizario: A History.* Austin: Jenkins, 1973.

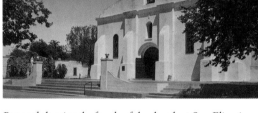

Postcard showing the façade of the church at San Elizario, ca. 1930. Garrett Postcards, UTA Library.

Aerial photograph of the church at San Elizario, 7 May 2006, mid-morning, looking southeast.

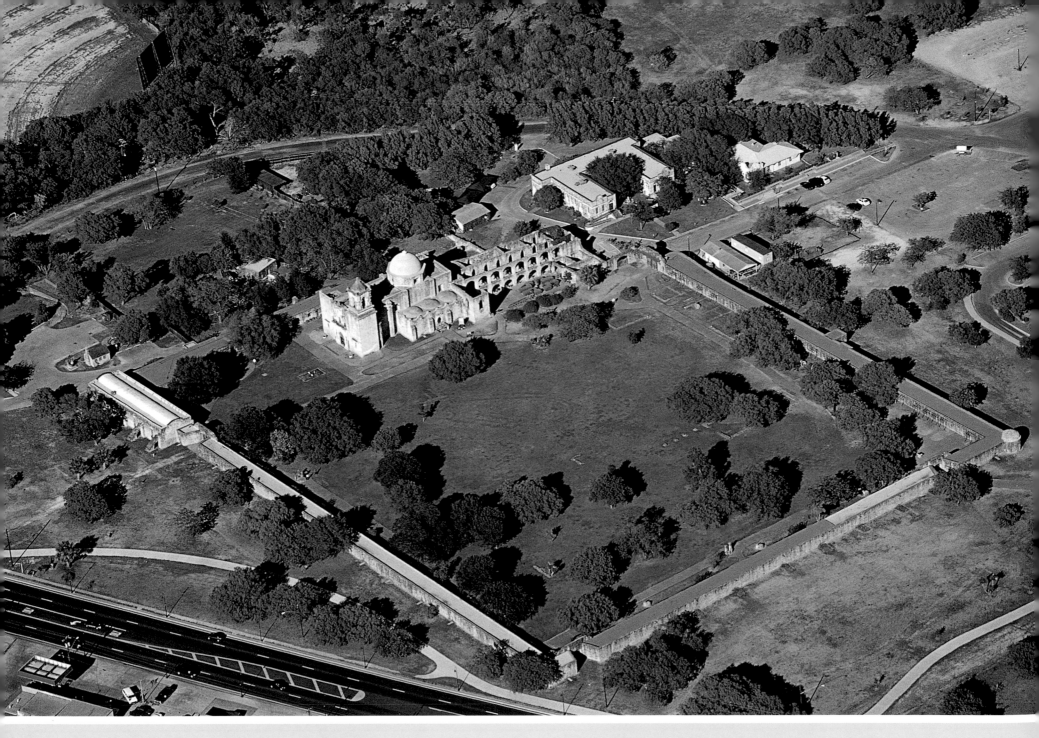

Aerial photograph of Mission San José, 10 April 2006, late afternoon, looking northeast.

Mission San José, San Antonio

If colonial San Antonio was known as the historic heart of Texas, the San Antonio River was the main artery that supplied it. The five missions located along the river are some of the state's most treasured historic sites today. Consider, for example, Mission San José y San Miguel de Aguayo, which lies approximately eight miles downstream from the San Antonio city center. After its conflict with France in 1719, Spain shifted its missionary efforts away from east Texas toward the south. San José was one of the first five southern missions that the Spanish envisioned. Given the fairly large Native American population and the site's agricultural potential, the location was perfect for missionary activity. San José was built in increments between 1768 and 1782 and is widely recognized as a superb example of Spanish colonial architecture. In 1777, the Spanish priest-historian Juan Agustín Morfi called San José "the first mission … in point of beauty, plan, and strength."

More than just a mission, though, San José was something like a small community. Surrounded by a limestone wall that provided protection from marauding Indians and reinforced a sense of separation from the secular world, the mission functioned as a spiritual center and economic engine. The converted Indians lived in special quarters located along the inside of the wall that enclosed the mission grounds.

Like most southwestern missions, San José looks as if it has survived intact from its earliest years. In fact, it has been in a nearly constant state of change since its founding. By 1794, the church was finding the maintenance of five functioning missions difficult. Thus, Mission San José was privatized, and communal life declined among the Indians. After around 1813, Spain was increasingly threatened by revolutionary activity and Indian uprisings in Texas and occasionally stationed troops at the mission until it formally closed in 1824, when Texas became part of Mexico. After years of abandonment, the Benedictines reoccupied San José as a religious building in 1859, but they left about a decade later.

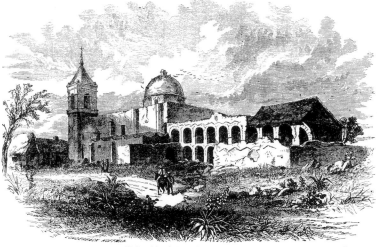

Mission of San José, near San Antonio, Texas.

Mission of San José near San Antonio, Texas, from William Emory, Report on the United States and Mexican Boundary Survey, 3 vols. (*Washington, D.C.: U.S. Department of the Interior, 1857–1859*).

By the early 1900s, the vacant mission was in ruins, but was restored in the 1930s by a group of history-conscious San Antonio citizens. Today it is owned and operated by the National Park Service as part of San Antonio Missions National Historical Park. Our 2006 aerial photo shows the mission still sequestered behind its stone wall. The restored church and sanctuary feature an ornate façade and bell tower, domed sanctuary, and stone cloister. The Indian quarters and granaries appear in the photograph as the linear, roofed section along the outside wall.

Marion A. Habig. *The Alamo Chain of Missions*. Rev. ed. Chicago: Franciscan Herald Press, 1976. First published 1968.

Roger G. Kennedy. *Mission: The History and Architecture of the Missions of North America*. Edited by David Larkin. Boston: Houghton Mifflin, 1993.

Juan Agustín Morfi. *History of Texas, 1673–1779*. 2 vols. Translated by Carlos Eduardo Castañeda. Albuquerque: Quivira Society, 1935. Reprint, New York: Arno Press, 1967.

Alexander C. Wangler, ed. *Archdiocese of San Antonio, 1874–1974*. San Angelo: Texas Newsfoto Publishing, 1974, Archives of San Antonio.

Aerial photograph of the Alamo, 10 April 2006, late afternoon, looking northeast.

The Alamo, San Antonio

The Alamo is, without question, the most easily recognized historic site in Texas. It began life as one of five missions in the San Antonio area. Constructed in 1744, the Mission San Antonio de Valero was later known as the Alamo, perhaps because soldiers from Alamo de Parris in Coahuila, Mexico, occupied the mission after it was abandoned as a church in 1803. Other sources claim that the name Alamo refers to the mission's location near a grove of cottonwood trees ("alamo" in Spanish)—a reminder that the site was fairly rural for much of its history.

History has made the Alamo the quintessential symbol of Texas independence. It was here in late February and early March of 1836 that Texians under the command of Colonel William B. Travis attempted to hold off the Mexican army, led by Antonio López de Santa Anna. It took the Mexicans nearly two weeks to defeat the Texians in one of the most celebrated lost battles in American history. The battle cry, "Remember the Alamo," led the Texians to victory over Santa Anna's forces later that spring at the Battle of San Jacinto, near present-day Houston, resulting in the independently governed Republic of Texas.

Today, a visit to the Alamo in San Antonio is akin to a pilgrimage to a revered shrine, where lives were sacrificed for the cause of freedom. When the battle occurred in 1836, the Alamo was rather isolated, but the city of San Antonio has since grown to surround it. Our aerial view shows the Alamo as a part of modern-day San Antonio's urban fabric—one piece in a tapestry of buildings and open spaces. Although virtually surrounded by taller nineteenth- and twentieth-century buildings, the Alamo grounds

stand out like a serene island. The Alamo's recognizable façade draws our attention first, but we should not overlook the large gray marble cenotaph, which was erected in 1939 to commemorate the defenders of the Alamo.

Frederick Charles Chabot. *The Alamo: Mission, Fortress and Shrine*. San Antonio: The Leake Company, 1935.

George S. Nelson. *The Alamo: An Illustrated History*. Dry Frio Canyon, Tex.: Aldine Press, 1998.

Susan Prendergast Schoelwer, with Tom W Gläser. *Alamo Images: Changing Perceptions of a Texas Experience*. Dallas: DeGolyer Library and Southern Methodist University Press, 1985.

Henry Ryder-Taylor. *History of the Alamo and of the Local Franciscan Missions*. San Antonio: N. Tengg, 1908.

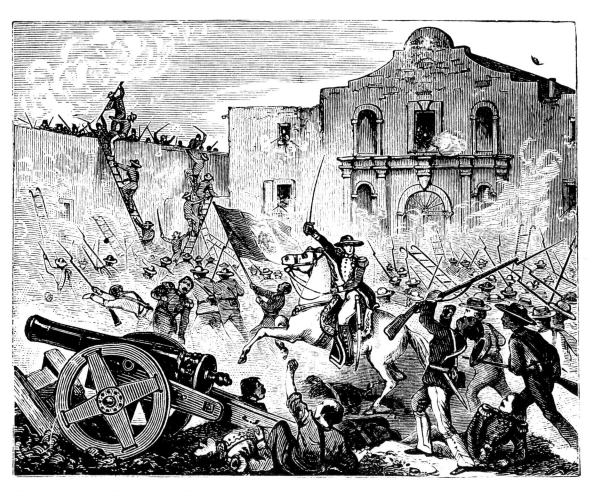

"Storming the Alamo," from Homer S. Thrall, A Pictorial History of Texas from the Earliest Visits of European Adventurers to A.D. 1879 (St. Louis, Mo.: N. D. Thompson, 1879).

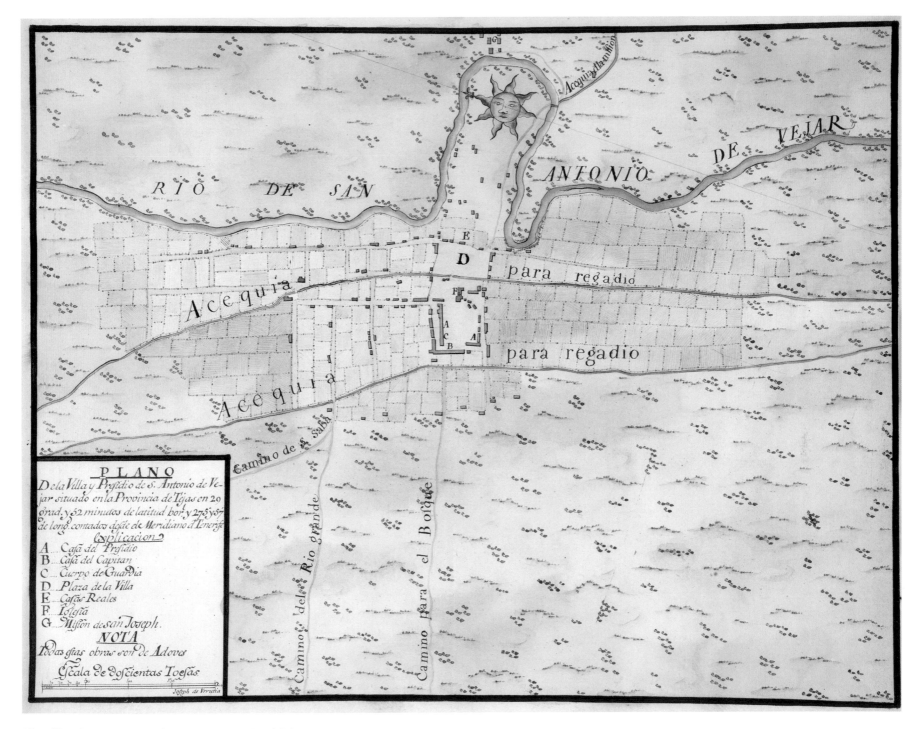

Plan of San Antonio, 1767, José de Urrutia, courtesy British Library.

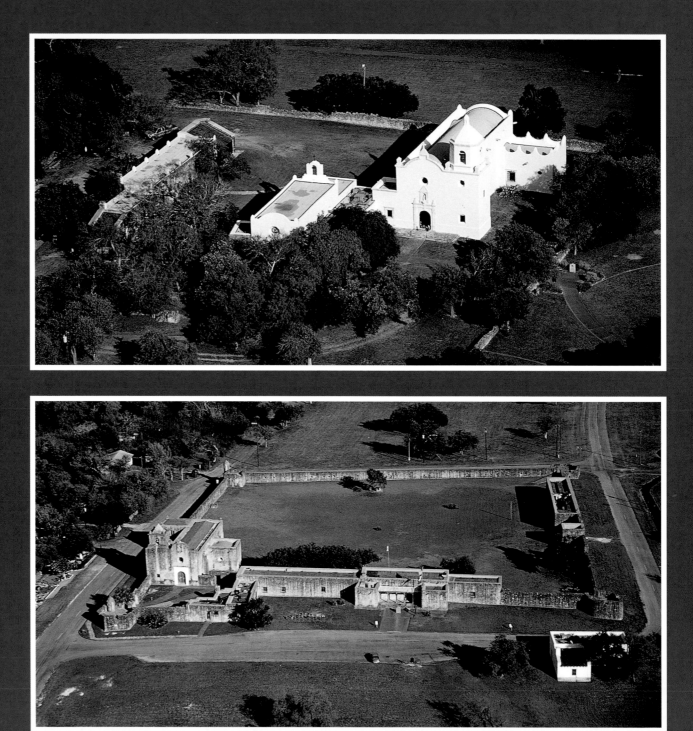

Aerial photograph of mission at Goliad,
24 August 2005, mid-afternoon, looking east.

Aerial photograph of presidio at Goliad,
24 August 2005, mid-afternoon, looking east.

Mission and Presidio, Goliad

From the 1680s to the 1820s, the Spaniards built roughly thirty-three missions in Texas and twelve presidios to protect the missions. Many of these sites have since been lost, but at Goliad the visitor can still see the striking combination of mission and presidio side by side. The mission (Mission Nuestra Señora del Espíritu Santo de Zúñiga) and presidio (Presidio Nuestra Señora de Loreto de la Bahía) were established in 1749, after failed attempts at other sites, with the aim of converting the local Karankawa, Aranama, and Tamique Indians. Goliad stands at an important point of communications, where the lower royal road (*camino real*) crossed the San Antonio River, and so played its part in both the American Revolution and in the Texas War of Independence.

Our first photograph shows the mission (now generally called Mission Espíritu Santo) inside its characteristic enclosure, which resembles the ones at San Antonio. In the eighteenth century, the Franciscans used this mission as the headquarters of a large livestock operation, which has led some historians to claim that the Texas livestock industry began here. Like many other missions in the area, Mission Espíritu Santo was secularized toward the end of the eighteenth century, and soon its buildings fell into disrepair (see our image), much of their stone being reused for local construction projects. Between 1935 and 1941 the mission's buildings were restored by the Civilian Conservation Corps, and honored during this process by a visit from Mrs. Roosevelt. The site then became a Texas state park and historical site, complete with an exhibition that explains the history of the mission.

The second photograph shows the presidio, generally known as Presi-

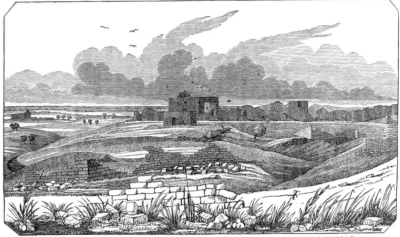

VIEW OF THE RUINS OF THE OLD CHURCH AND FORTIFICATION AT GOLIAD.

View of the ruins of the old church and fortification at Goliad, from George Furber, The Twelve Months Volunteer *(Cincinnati: J. A. and U. P. James, 1848).*

dio la Bahía due to its site by Lavaca Bay. Like the mission, the presidio (except for the chapel) fell into neglect during the nineteenth century, and only in the 1960s were the buildings extensively restored, thanks to the generosity of Mrs. Kathryn O'Connor. The site is now administered by the Catholic diocese of Victoria.

A substantial wall encloses the central area, which contains both quarters for the officers and barracks for the other soldiers. The fort also functioned as a place of refuge for local Indians in times of danger from hostile tribes. At Goliad, the restored buildings of Mission Espíritu Santo and Presidio la Bahía offer the visitor a unique dual vision of the instruments—religious and military—of Spanish colonial rule.

Jack Jackson. *Los Mesteños: Spanish Ranching in Texas, 1721–1821.* College Station: Texas A&M University Press, 1986.

Kathryn Stoner O'Connor. *Presidio La Bahía, 1721–1846.* 3rd edition. Victoria, Tex.: Wexford Pub., 2001.

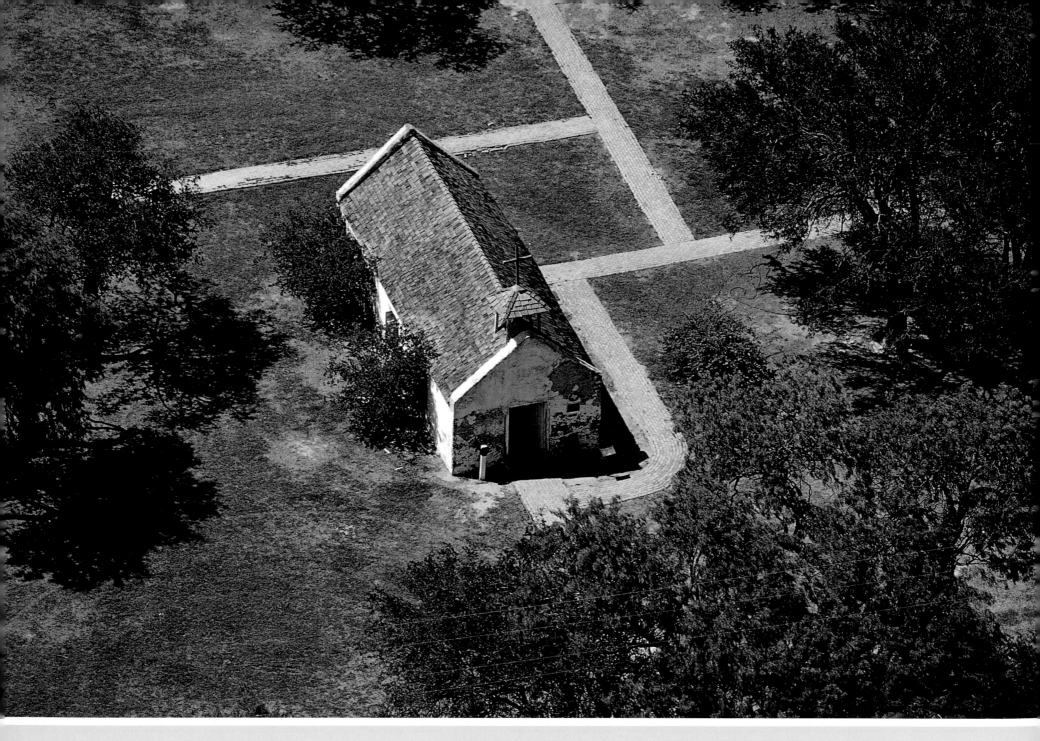

Aerial photograph of La Lomita Chapel at Mission, 27 May 2006, mid-morning, looking south in Hidalgo County.

La Lomita Chapel, Mission

La Lomita, "little hill," was the name of a site of missionizing efforts by the Oblates from France around the middle of the nineteenth century. This land in the valley originated from two *porciones*, Spanish land grants, dated in 1767. Here in their chapel the Oblates not only led educational and missionary activities, but also directed a variety of agricultural enterprises, becoming famous in particular for producing the grapefruit known as "Texas ruby red."

La Lomita was one of several stops on the six-week evangelical circuits ridden by Oblate missionaries between far-flung churches in the Rio Grande Valley. These missionaries—the "Cavalry of Christ," as they came to be called—had to deal with the often violent history of this part of Texas: border lawlessness, civil tumults, yellow fever, and hurricanes. In the twentieth century, the Oblates often led movements to establish a living wage for their parishioners; today theirs is primarily an urban apostolate.

As time went by and the various enterprises of the Oblates waxed and waned, the little chapel was sometimes absolutely neglected and then partially restored. Eventually it was carefully restored, and is now part of Anzalduas Park in the nearby town of Mission, a favorite place for picnickers. It seems impossible now to find any evidence of nearby buildings on the aerial photograph, though the chapel was once surrounded by a variety of structures.

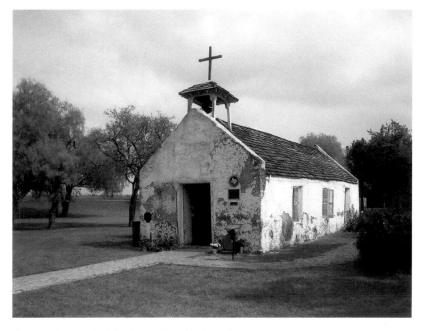

Ground photograph of the chapel (David Buisseret).

Bernard Doyon. *The Cavalry of Christ on the Rio Grande, 1849–1883*. Milwaukee: Bruce Press, 1956.

Pierre F. Parisot. *The Reminiscences of a Texas Missionary*. San Antonio: St. Mary's Church, 1899.

Lost Pines and *Camino Real* Crossing, Bastrop

Bastrop is a place of great interest for both its history and its botany. We had hoped to be able to offer an aerial image of the so-called "Lost Pines," which is the westernmost tract of loblolly pine in the United States, and is thought to be the remnant of an ice age pine forest. Its wood is particularly close-grained, and the forest supported a lively timber industry from the middle of the nineteenth century onward; unfortunately the few remaining stands of pine do not show up well from the air.

Bastrop is also noteworthy, however, for having been an important way station on the Spanish *camino real*, which ran in several strands from the Mexican border eastward out to Nacogdoches. Our aerial photograph shows the Old Iron Bridge across the Colorado River at just about the point of the *camino real*'s ford. This bridge has become the site of a popular annual art fair. At the time of World War I, during a revival of interest in the Spanish period, the surveyor V. N. Zivley was commissioned to establish the main line of the historical *camino*, and his work survives at the Texas State Archives. We show the part of his map that follows the *camino* through Bastrop and across the Colorado. In general, the road followed what is now Route 21 through this area.

Bastrop was part of Stephen F. Austin's original colony in the 1820s, and became a focus point of the resistance to Mexican rule. Its citizens were among those who signed the Texas Declaration of Independence, died at the Alamo, and fought at the decisive battle of San Jacinto.

Joachim McGraw, John W. Clark, Jr., and Elizabeth A. Robbins, eds. *A Texas Legacy: The Old San Antonio Road and the Camino Reales.* Austin: Texas State Department of Highways and Public Transportation, Highway Design Division, 1991.
Bill Moore. *Bastrop County, 1691–1900.* Wichita Falls, Tex.: Nortex Press, 1977.

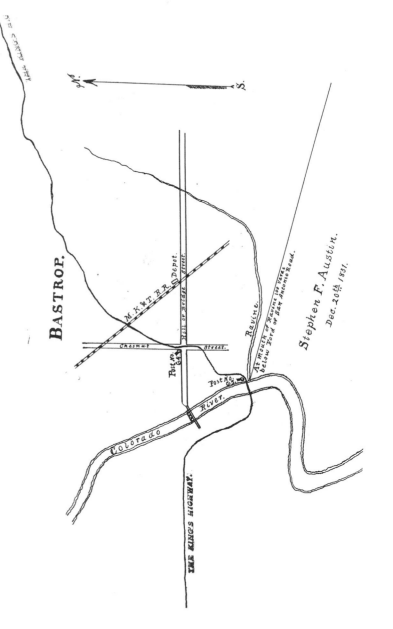

Detail from V. N. Zivley's map of the camino real *in his "Field Notes and Detail Map of the King's Highway," 1915–1916. Courtesy the Archives and Information Services Division, Texas State Library and Archives Commission.*

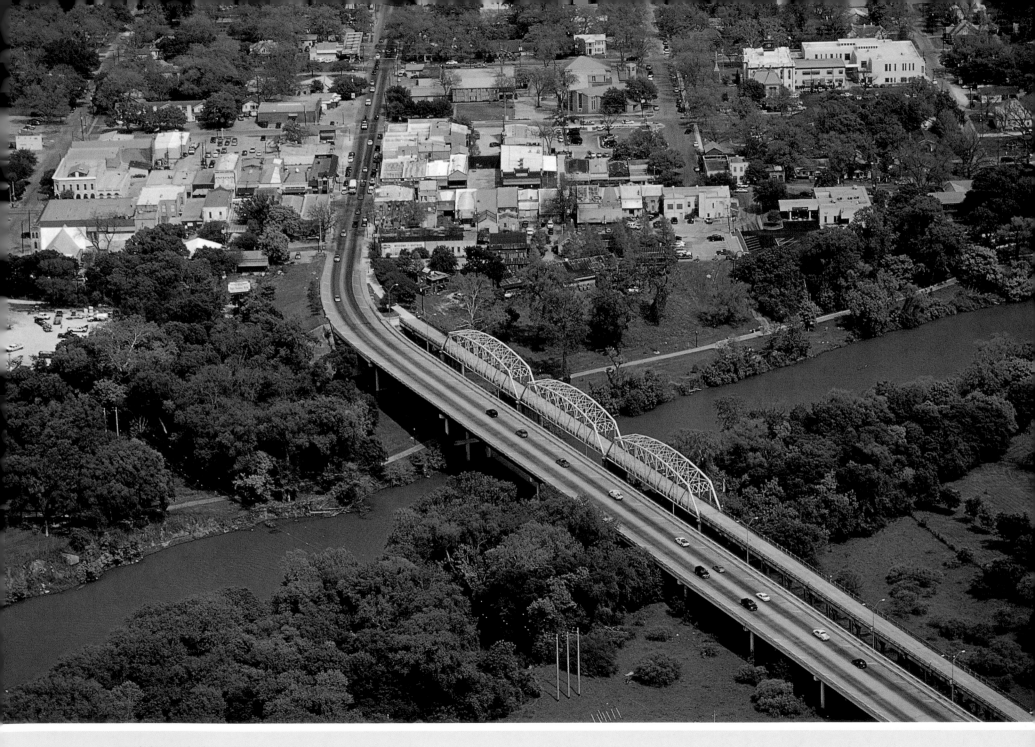

Aerial photograph of Bastrop, 11 April 2006, mid-day, looking east.

Town Center and *Camino Real*, Nacogdoches

Nacogdoches, named after the group of Caddo Indians who lived there, was first occupied by missionaries in about 1716; they remained there intermittently until they left as part of the general Spanish withdrawal in 1772. As our map of the *caminos reales* shows, Nacogdoches lay almost at the end of the long trail from Presidio, on the Rio Grande. In Nacogdoches itself, the trail led in the usual Spanish way into a fine plaza, whose truncated form appears in this 1920s postcard of "Main Street." This evocative trail, as our aerial photograph shows, still winds westward in the modern form of Route 21 through many long-occupied sites in the Piney Woods.

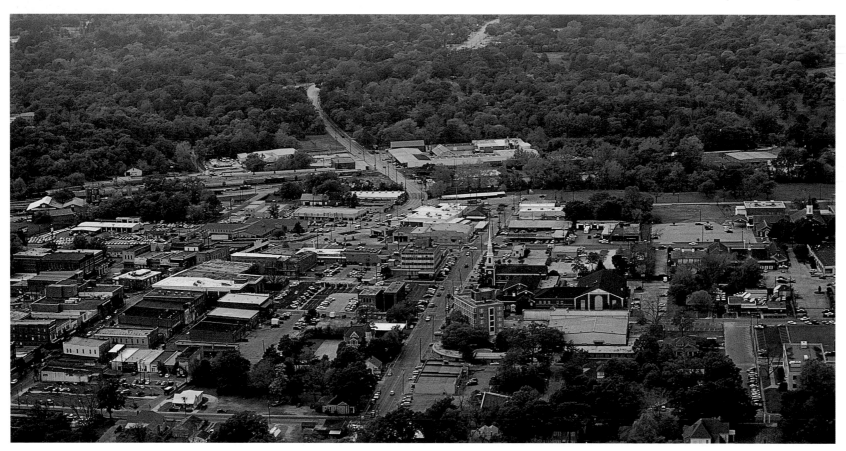

Aerial photograph of Nacogdoches, 12 April 2006, mid-afternoon, looking east.

MAIN STREET, NACOGDOCHES, TEXAS

Postcard showing "Main Street, Nacogdoches, Texas," ca. 1930. Garrett Postcards, UTA Library.

When the United States won its independence, Nacogdoches naturally became a center for Anglo agitators who spearheaded movements to free Texas from Spain and—after 1826—from Mexico. Indeed, they succeeded in driving the Mexican garrison out of Nacogdoches in 1832, which contributed to the outbreak of the Texas Revolution. As Texas won its independence and later joined the United States, Nacogdoches lost its political prominence and became simply a small city out of the way of any intense economic development. Its relatively slow commercial growth has saved many of its elegant Victorian homes, and the presence of Stephen F. Austin State University encourages a lively local preservation movement.

Joe E. Ericson. *The Nacogdoches (Texas) Story: An Informal History*. Bowie, Md.: Heritage Books, 2003.
Archie P. McDonald. *The Old Stone Fort*. Austin: Texas State Historical Association, 1981.

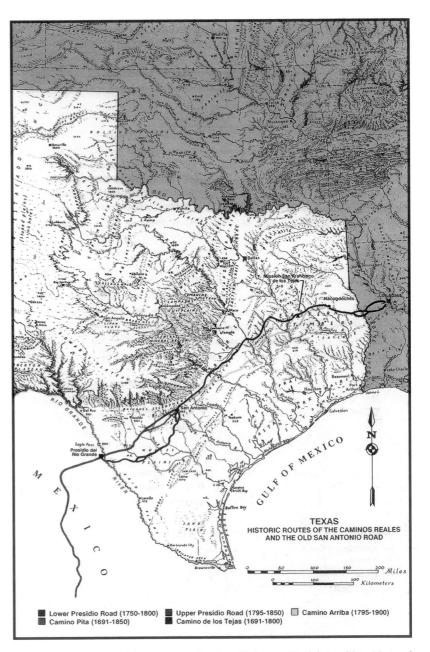

Map showing the routes of the caminos reales, *from* El Camino Real de Los Tejas National Historic Trail Act *(Washington, D.C.: National Park Service, 1958).*

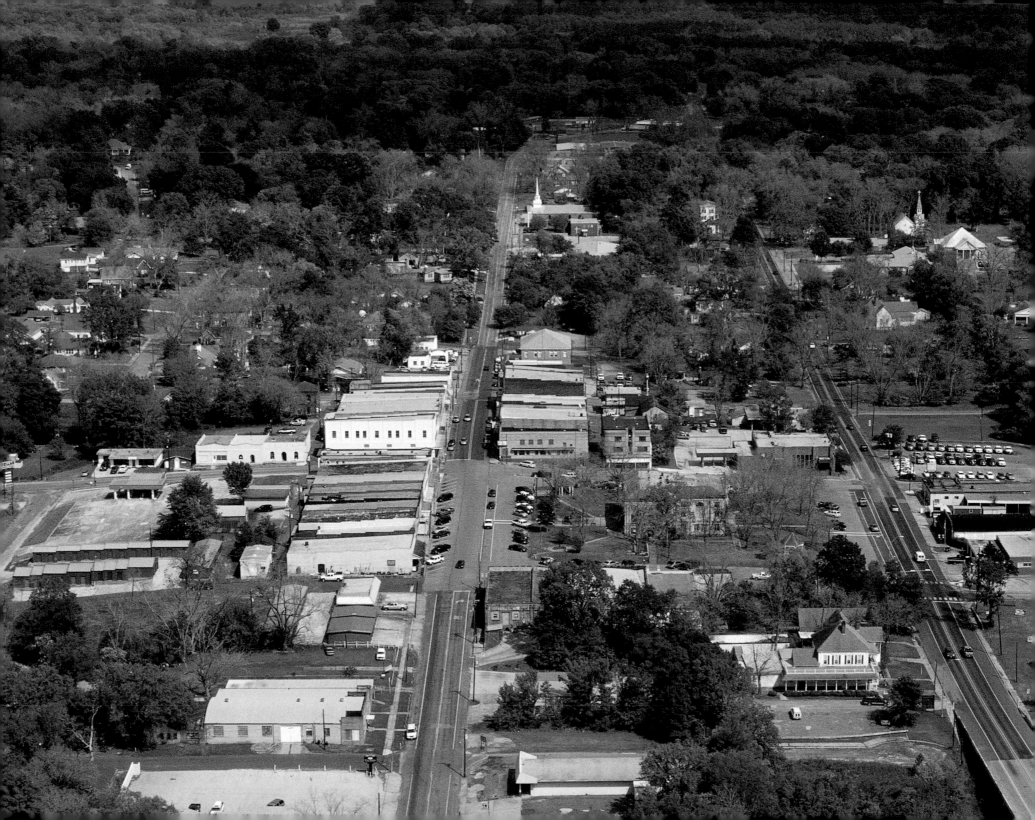

Town Center and *Camino Real,* San Augustine

By some accounts (and according to the map accompanying the previous section on Nacogdoches), one branch of the *camino real* ended at Nacogdoches. But in fact the trail pushed still farther eastward, into the land of the Ais tribe of the Hasinai/Caddo Indians. Here the Franciscans established a mission in 1717, which moved to the site of modern San Augustine in 1721. This region is shown on the map by Guillaume Delisle to the west of the French "Natchitoches," between "Amais" and "Adais," which were French attempts to transliterate the Indians' place-names. The nearby presence of the French discouraged heavy Spanish settlement of the San Augustine area during most of the eighteenth century.

In the late 1770s, the area was overrun by Indians displaced from the east and Anglos eager to establish their own government to escape the tutelage first of Spain and then of Mexico. Like Nacogdoches, San Augustine became caught up in the political ferment that eventually led to the establishment of the Republic of Texas. After the Republic's absorption into the United States, San Augustine thrived as an exporter of cotton until the outbreak of the Civil War severely curtailed this enterprise. Afterward San Augustine never regained its former economic buoyancy. Today the elegant little town remains a reminder of the days when France and Spain disputed their respective boundaries in this region.

Harry P. Noble. *Texas Trailblazers: San Augustine Pioneers.* Lufkin, Tex.: Best of East Texas Publishers, 1999.

William Seale. *San Augustine in the Texas Republic.* Austin: Encino Press, 1969.

David Weber. *The Spanish Frontier in North America.* New Haven: Yale University Press, 1992.

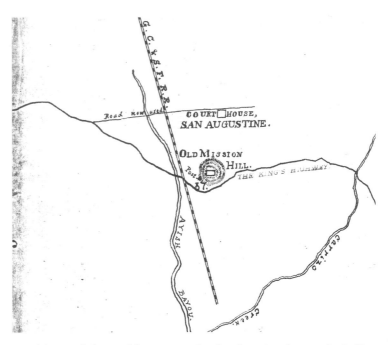

Detail from Zivley's map of the camino real *in San Augustine. Courtesy the Archives and Information Services Division, Texas State Library and Archives Commission.*

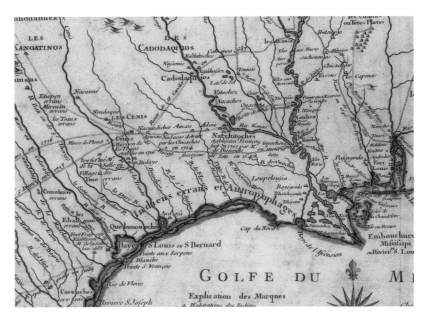

Detail from Guillaume Delisle, Carte de la Louisiane et du cours du Mississippi . . . *(Paris, 1718).*

Landmark Inn, Castroville

Castroville is a remarkable example of the way in which an *empresario* contract could give birth to a thriving town. The Frenchman Henri Castro negotiated such a contract with the Republic of Texas in 1842, and in 1844 brought a group of mainly Catholic Alsatian farmers to settle the land. A little town was laid out; survived raids by Comanches and Mexicans, drought, locusts, and cholera in the late 1840s; and eventually began to thrive. Castroville lay at the edge of the Balcones Escarpment, directly west of the Alamo mission; its location on the road to Mexico made the town an important participant not only in the Mexican-American War and the California gold rush, but also in the Civil War.

From the early 1850s the numerous visitors to Castroville were accommodated at the Vance Hotel, which was renamed the Landmark Inn around 1940. The establishment quickly became the economic hub of the town; it included a grain mill on the river among other things. The defunct complex was donated to the state of Texas in 1974, and in 1981 was reopened as a historic site. It now enjoys many visitors who may also tour other old structures in the town. Foremost among these is Henri Castro's 1844 home, shown on this old postcard; this simple house has a distinctively French feel, with its double-pitched roof and long, open veranda.

Postcard of Henri Castro's house, ca. 1920. Garrett Postcards, UTA Library.

Cornelia E. Crook. *Henry Castro: A Study of Early Colonization in Texas.* San Antonio: St. Mary's University Press, 1988.

Bobby D. Weaver. *Castro's Colony: Empresario Development in Texas, 1842–1865.* College Station: Texas A&M University Press, 1985.

Aerial photograph of Landmark Inn, 10 April 2006, late afternoon, looking east.

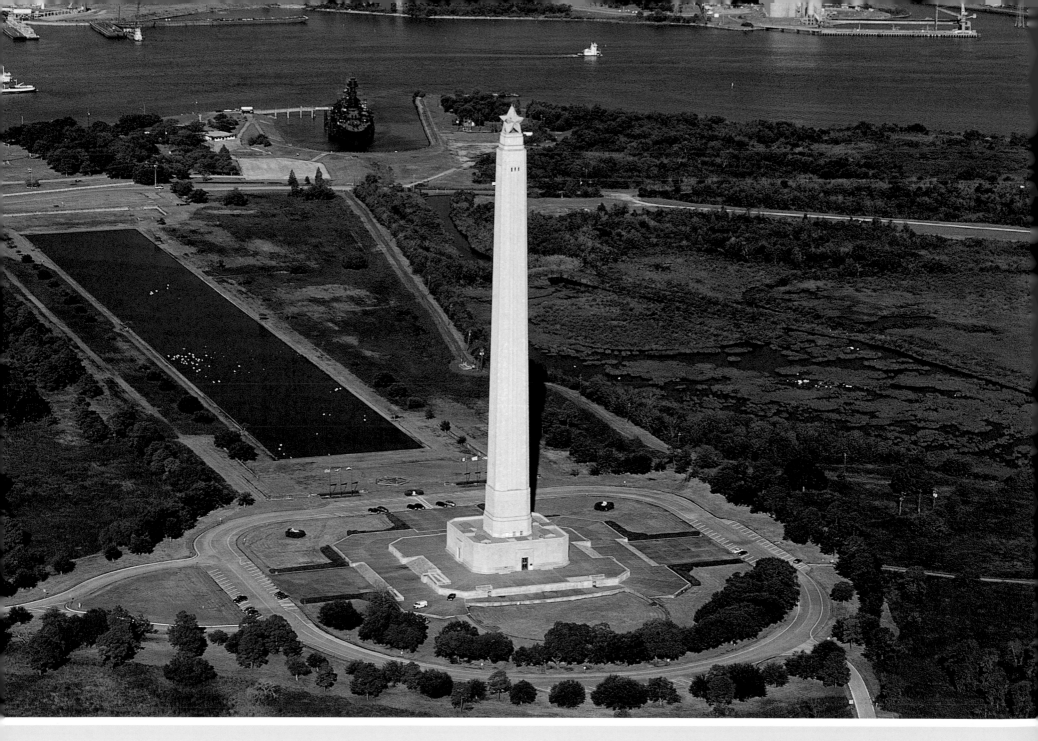

Aerial photograph of the monument at San Jacinto with the Houston Ship Channel and Battleship Texas in the background, 27 November 2007, mid-morning, looking northwest.

San Jacinto Monument, Harris County

The San Jacinto Monument is located 22 miles southeast of Houston on the Houston Ship Channel. At 570 feet tall and more than 70 million pounds, the "Texas-sized" monument is topped by a 34-foot star, symbolizing the lone star of the Republic of Texas. The monument is built of reinforced concrete faced with Texas limestone from a Burnet County quarry north of Austin. The 125-square-foot base of the monument houses the San Jacinto Museum which features eight decorative panels depicting the history of Texas. The monument's shaft tapers from 48 square feet at the base to 30 square feet at the observation deck. A reflecting pool measuring 1,750 feet by 200 feet mirrors the monument. The Public Works Administration authorized construction of the $1.5 million monument on 21 April 1936, one hundred years after the Battle of San Jacinto occurred on the spot, with funds from federal, state, and local sources. The complete project is the tallest stone column memorial in the world (some fifteen feet taller than the Washington monument), and was dedicated on 21 April 1939, to the "Heroes of the Battle of San Jacinto and all others who contributed to the independence of Texas."

The monument was conceived by architect Alfred C. Finn and engineer Robert J. Cummins from a design suggested by prominent Houstonian Jesse H. Jones, then-chairman of the Reconstruction Finance Corporation and the Texas Centennial. The Warren S. Bellows Construction Company of Dallas and Houston built the monument, which is now considered by many to be one of the finest examples of art deco architecture in the United States.

The monument commemorates the 1836 Battle of San Jacinto, which

"Battle of San Jacinto," A. E. Wagstaff, Life of David S. Terry *(San Francisco: Continental Pub. Co., 1892).*

pitted Sam Houston's Texian forces, numbering about 900, against a 1,300-man Mexican army vanguard commanded by Mexican general Antonio López de Santa Anna, the self-styled Napoleon of the West. Fresh off a victory at the Alamo and overconfident, Santa Anna held the Texans in such contempt that he had failed to post sentries to monitor their activities prior to the battle. The Texans attacked late in the afternoon, catching the Mexican forces off-guard and routing them. After only eighteen minutes of fighting, Houston's army gained control of the Mexican camp. More than 600 Mexican soldiers were killed and 700 were captured, including General Santa Anna. The battle ended the Texas Revolution and paved the way for the establishment of the Republic of Texas, an independent nation that existed, albeit rather shakily, for ten years.

Ray Miller. *Texas Parks*. Houston: Cordovan Press, 1984.

James W. Pohl. *The Battle of San Jacinto*. Austin: Texas State Historical Association, 1989.

San Jacinto Museum of History Association. *A Picture Book Introduction to the San Jacinto Museum of History*. Houston: San Jacinto Monument, Tex., 1947.

4

NINETEENTH-CENTURY ANGLOS: FORTS AND COMMUNICATIONS

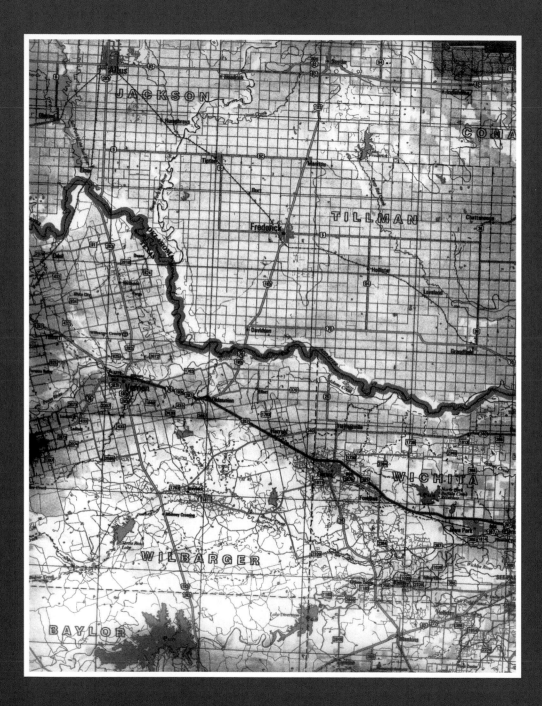

Detail from United States Geological Survey (USGS) map showing different road patterns on the north (Oklahoma) and south (Texas) sides of the Red River.

INTRODUCTION

Invisible on our images, except for the emergence of English and German names on our maps, the constant pressure of immigration by peoples of European descent nevertheless shaped the history of Texas during the nineteenth century. They settled the eastern region first, and here a plantation society similar to those of the southern United States soon established itself. A little later, in the 1840s, a strong wave of German immigrants came from ports like Indianola on the Gulf, to settle in what would become known as the Hill Country, to the northwest of San Antonio.

Although the Germans generally enjoyed more or less peaceful relations with the Indians among whom they found themselves, the Anglos were on the whole determined to eradicate any Indians whom they encountered, especially when they offered violent resistance. To expand their settlements westward, the Europeans built sequential lines of forts from north to south across Texas. The line temporarily fell back to the east during the Civil War, but in general it existed near the westernmost edge of European settlement.

pattern of Oklahoma often contrasts very sharply with the more informal road structure of Texas. In Oklahoma, roads generally follow the method of land division common in the Midwest, dividing the country into blocks 36 miles square, whereas in Texas the road structure is much less rigid, sometimes following land divisions originally set forth by the Spaniards. This difference, etched into the landscape, might also stand for the many other ways in which Texas differs from neighboring states.

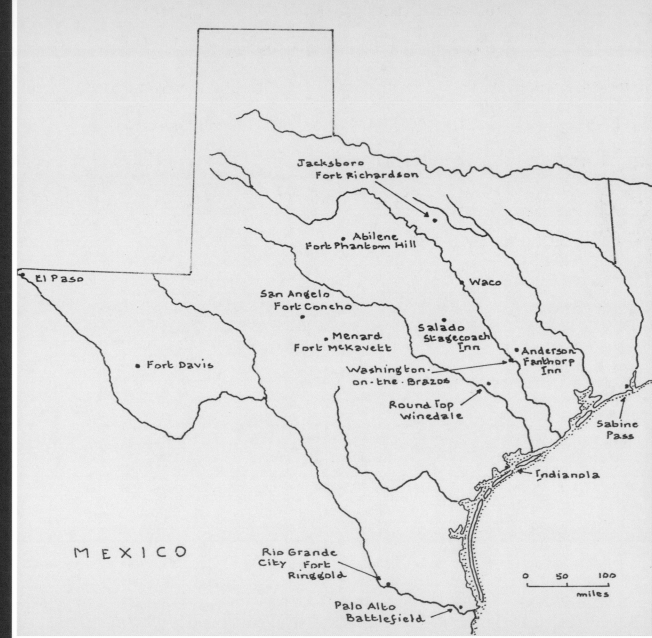

Map to show sites of chapter 4.

HISTORIC TEXAS FROM THE AIR

Aerial photograph of Palo Alto battlefield, 8 March 2008, early morning, looking northeast across the national historic site visitor center.

Palo Alto Battlefield, Brownsville

Today the broad expanse of salt prairie just north of Brownsville appears unremarkable, but on 8 May 1846, U.S. and Mexican troops fought the first major battle of the Mexican-American War here after months of mounting tensions between the two countries. Mexico had never recognized the independence of the Republic of Texas, but instead considered Texas a province in rebellion. The U.S. annexation of Texas in 1845 had prompted a proud Mexico to break off diplomatic relations with its neighbor to the north.

Adding to the tension was the ongoing and increasingly militarized border dispute between Texas and Mexico; Texas claimed the Rio Grande as its southern and western boundary, but Mexico claimed the Nueces River was the boundary, some 150 miles north. To safeguard the Texas, and later U.S., claims north of the river, American General Zachary Taylor ordered the construction of a makeshift fort (later known as Fort Brown) on the northern bank of the Rio Grande opposite the Mexican town of Matamoros. On 24 April 1846, a 2,000-man Mexican cavalry detachment attacked a 63-man U.S. patrol from the fort in the contested territory north of the Rio Grande and killed eleven American soldiers. In early May, Mexican artillery opened fire on the fort, while troops under Mexican General Mariano Arista began to surround it.

On 8 May 1846, General Taylor and 2,400 troops marched to relieve the siege on the fort but were intercepted by 3,400 Mexican soldiers at Palo Alto. A fierce artillery battle lasted from 2:00 p.m. until twilight, resulting in five American casualties and forty-three injuries, while the Mexican military reported 102 soldiers killed and 129 wounded. The next day, the remaining Mexican force moved south and reengaged the same American force at Resaca de la Palma in current-day Brownsville. This second battle was a decisive victory for the United States.

The battle at Palo Alto revealed the effectiveness, accuracy, and mobility of the American artillery. In addition, the military success in South Texas showed the merits of having a standing army and a military acad-

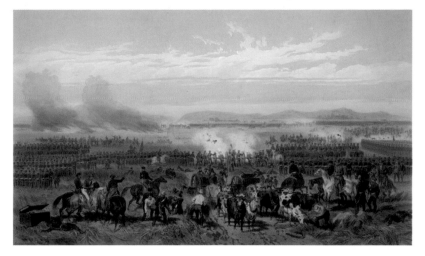

Color lithograph of the Battle of Palo Alto produced by Carl Nebel shortly after the end of the war and sold as part of George Wilkins Kendall's The War Between the United States and Mexico Illustrated *(New York: D. Appleton, 1851). Special Collections, UTA Library.*

emy, at a time when many Americans questioned their value. By defeating the Mexican forces, the United States took control of the disputed territory north of the Rio Grande to use as a staging area for the future invasion of northern Mexico. The victory also galvanized early support for a war that some in the United States deemed unnecessary.

This aerial photograph reveals that nature has reclaimed much of the former battlefield site. Nevertheless, subtle features in the landscape and scattered artifacts are testimonials to the conflict here. In 1991, the National Park Service established the Palo Alto Battlefield National Historic Site. The site presents the Battle of Palo Alto, associated battles, the war, and its causes and consequences objectively for visitors from both sides of the border. The U.S. government is currently acquiring nearby land for what will one day be a national park.

K. Jack Bauer. *The Mexican War, 1846–1848.* New York: Macmillan, 1974.

John Eisenhower. *So Far from God: The U.S. War with Mexico, 1846–1848.* New York: Random House, 1989.

Donald S. Frazier. *The U.S. and Mexico at War.* New York: Macmillan Reference USA, 1998.

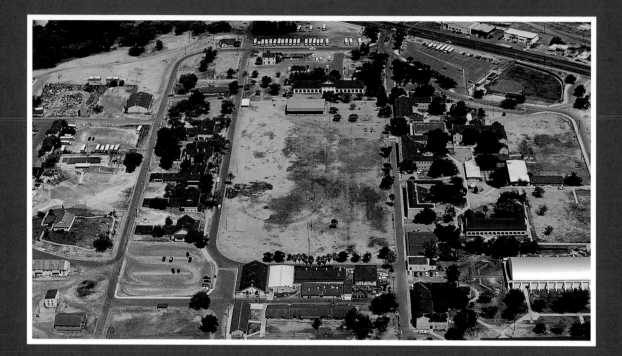

Aerial photograph of Fort Ringgold,
27 April 2006, looking northwest.

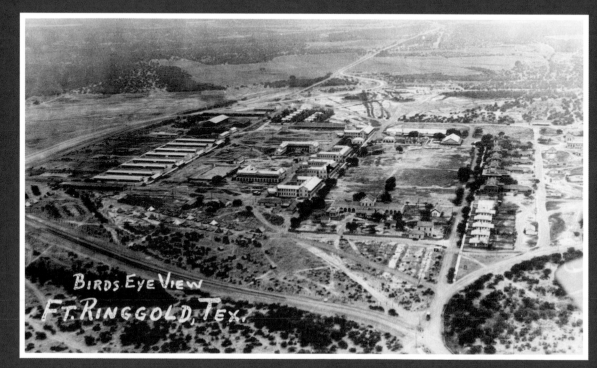

"Birds Eye View of Ft. Ringgold, Tex.," ca. 1920.
Garrett Postcards, UTA Library.

Fort Ringgold, Rio Grande City

This fort, which lies today in the middle of Rio Grande City, was once the southernmost of a line of forts established in the late 1840s at the end of the Mexican-American War. From Fort Ringgold the line of forts ran north-northeast, all the way to Fort Worth. Fort Ringgold provided a focal point for people living nearby; it provided some security from bandits, housed the area's first telegraph office, and generated economic activity.

Fort Ringgold was named after a U.S. Army officer who died at the Battle of Palo Alto in 1846. The fort closed in 1861 at the start of the Civil War, but reopened in 1865, when many of its existing structures were built. When this bird's-eye view was taken in about 1920, the fort was more extensive and not yet surrounded by the town. This image was taken roughly from the north; our aerial photograph was taken from the south about eighty-five years later, and shows essentially the same buildings lining the parade ground.

In both images, the most conspicuous building is the elegant post hospital. Many officers who later became famous served at Fort Ringgold, including Robert E. Lee and Blackjack Pershing. The fort was permanently deactivated in 1944, and sold in 1949 to the Rio Grande City Consolidated Independent School District. Many of the buildings have been preserved for institutional use, offering us an excellent idea of what this outpost looked like as a military station.

Robert W. Frazer. *Forts of the West*. Norman: University of Oklahoma Press, 1965.
Thomas E. Simmons. *Fort Ringgold: A Brief Tour*. Edinburg, Tex.: University of Texas, Pan American Press, 1991.

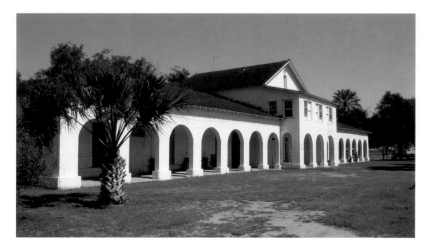

Photograph of the old post hospital, Fort Ringgold, 2005 (David Buisseret).

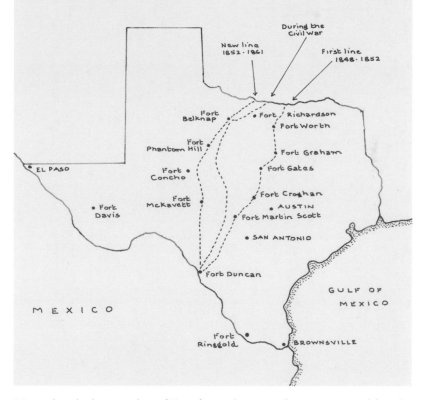

Map to show the three main lines of Texas forts in the nineteenth century, generated from the explanatory panels of Texas Parks and Wildlife.

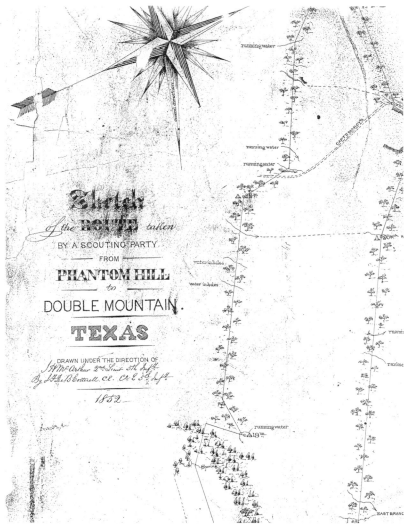

"Sketch of the route taken by a scouting party from Phantom Hill to Double Mountain," 1852. Courtesy Texas General Land Office Archives (K-7-12).

Fort Phantom Hill, Abilene

Anglo settlement in central Texas continued apace in the late 1840s and early 1850s, and the earliest line of forts, which included Fort Worth, soon needed to be supplemented by another line farther to the west. Fort Phantom Hill was accordingly built in 1851–1852 out of local material. It originally comprised an extensive set of structures, including a hospital and quarters for the officers and men, but the continuing westward spread of European settlement meant that the fort soon became outdated, and was abandoned in 1854.

Soon after, most of the buildings were consumed by fire, but in 1858 the remaining structures were repaired for use as way station number 54 on the Butterfield Overland Mail. During the Civil War and its aftermath, the buildings were occasionally used by military forces, and a small town grew up around them. However, when the Texas and Pacific Railway laid its tracks through Abilene fourteen miles to the south, the little settlement was doomed to fail, and today the fort stands alone on private land.

Our aerial photograph shows how the fort was sited above the Clear Fork of the Brazos River, though this did not prove to be a reliable source for water. Three of the buildings remain more or less intact: the magazine, a guardhouse, and the storehouse. Relations with local Indians were generally good, and scouting parties used the fort as a post to explore the adjacent country. The map shows the route taken by a scouting party from the fort in 1852. Note the party's great concern with identifying sources of water; note as well that, contrary to what is sometimes said, the post already was named Phantom Hill.

H. Allen Anderson. *Fort Phantom Hill: Outpost on the Clear Fork of the Brazos.* Lubbock, Tex.: West Texas Museum Association, 1976.

Rupert N. Richardson. *The Frontier of Northwest Texas, 1864 to 1876.* Glendale, Calif.: A. H. Clark Co., 1963.

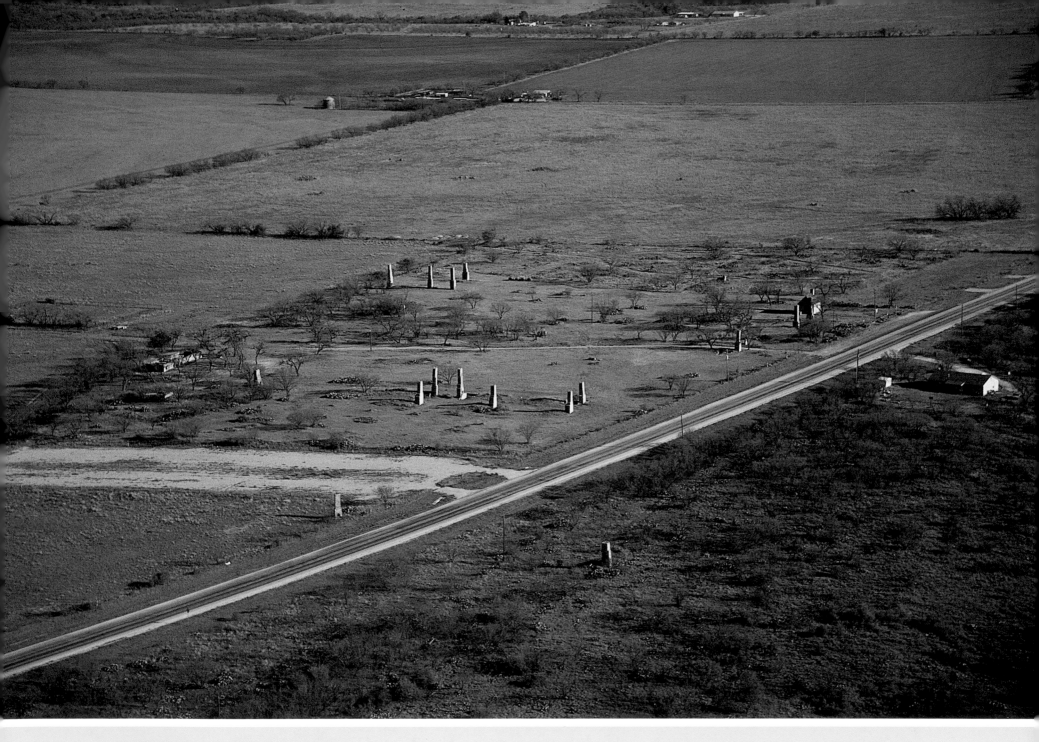

*Aerial photograph of Fort Phantom Hill, 11 April 2005,
late afternoon, looking southeast in Jones County.*

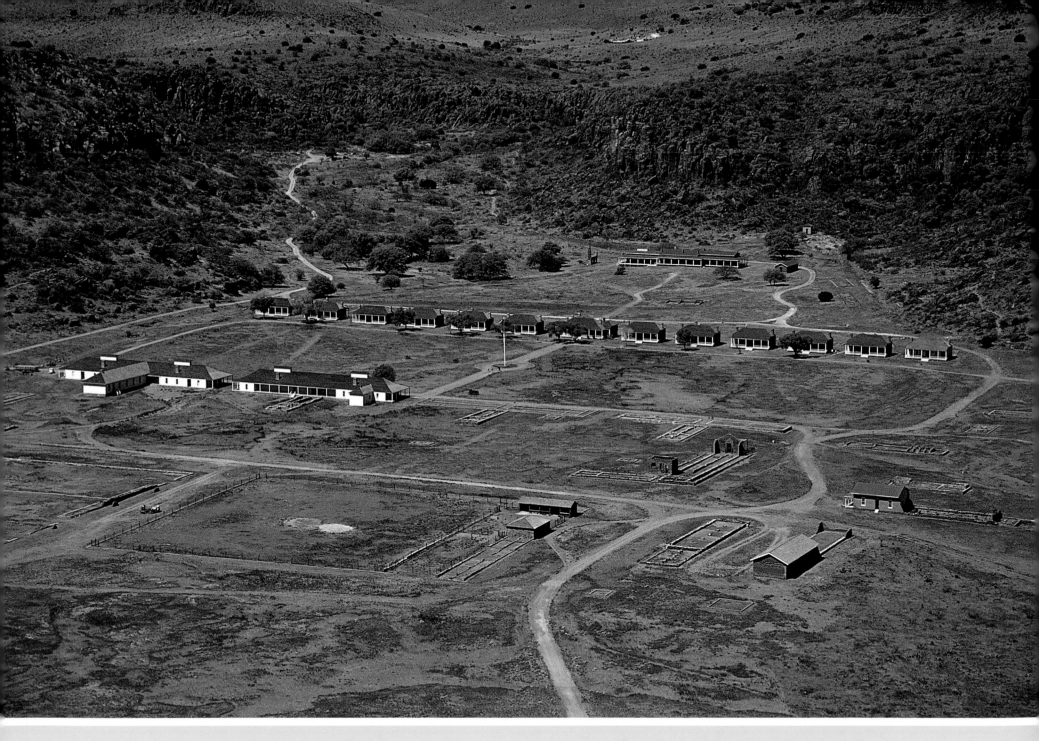

Aerial photograph of Fort Davis, 11 April 2005, midday, looking southwest in Jeff Davis County.

Fort Davis, Fort Davis

The 1850s saw heavy traffic from central Texas to California, composed chiefly of gold seekers, traders, and settlers. The army built Fort Davis in 1854 at a natural halting place on this route, after which a Butterfield Overland Mail way station was established in 1859. The fort was originally built far up into Limpia canyon. The Union forces left Fort Davis in 1861, and apart from a short occupation by Confederates, it remained abandoned until the end of the Civil War. The army then reoccupied the fort in 1867 to provide protection to travelers on the overland trail, and built a new fort just to the east of the original site. The army continued to occupy this newer fort until it closed in 1891; by then, the little town nearby was growing into a center for ranching and tourism.

The aerial photograph shows Fort Davis from the east, near the mouth of the deep valley in the background. The buildings of the 1867–1891 fort are readily recognizable: the long red building at the back is the base hospital, the small individual buildings in front of it are the officers' quarters, and the long building across the parade ground from these quarters is one of the barracks. There were originally six of these barracks for all the enlisted men on this large base.

In 1963 Fort Davis became a national historic site, and today its elegant buildings and grandiose surroundings make it a remarkably evocative place.

Jerome A. Greene. *Historic Resource Study: Fort Davis National Historic Site*. Washington, D.C.: U.S. Department of the Interior, National Park Service, 1986.

Robert Wooster. *Frontier Crossroads: Fort Davis and the West*. College Station: Texas A&M University Press, 2006.

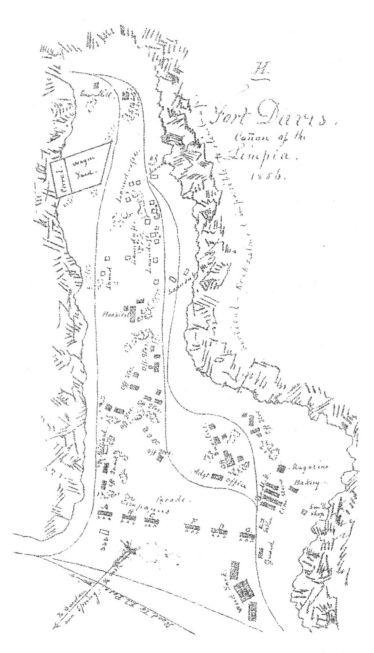

Colonel J. F. K. Mansfield, sketch of Fort Davis, 1856. Courtesy National Park Service.

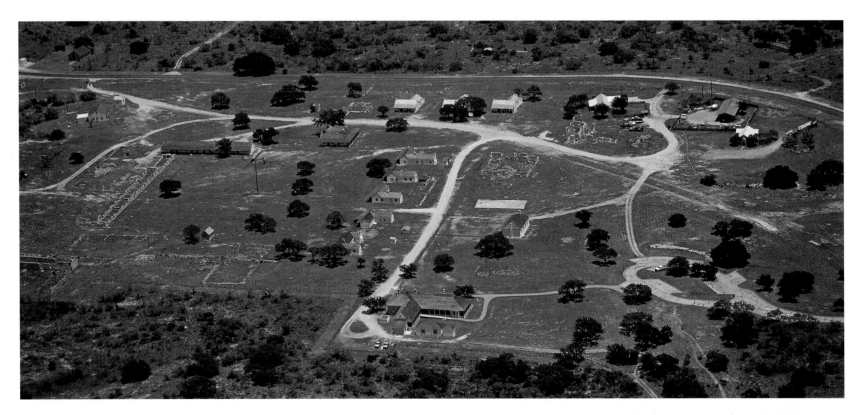

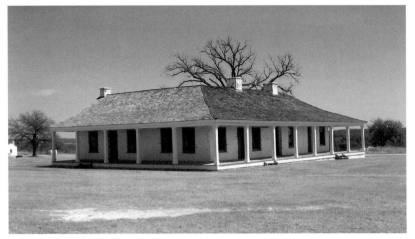

Photograph of the post headquarters, Fort McKavett (David Buisseret).

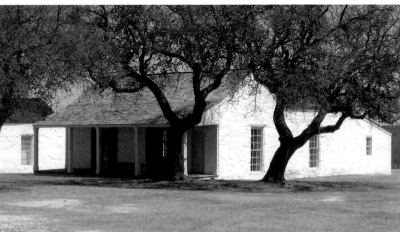

Photograph of one of the officers' quarters (David Buisseret).

Fort McKavett, Menard

A few miles east of the present site of Fort Mc-Kavett, the Spaniards established the mission and presidio of San Saba in 1757. The following year a large force of Comanches and Wichita destroyed these posts, and Spain officially abandoned the area in 1772 (though the remains of some structures still exist). The U.S. Army built Fort Mc-Kavett itself in 1852, but it closed in 1859, forcing many civilians to leave the now unprotected area. The army reoccupied the fort in 1868, to give protection to the settlements that were reviving after the Civil War. As the map shows, the fort was located on the western boundary of European expansion, and its presence discouraged Indian raids in that area. (Note as well on this map the site of Fort Phantom Hill, toward the north.)

The aerial photograph shows what remains on the site today. The large building in the right foreground is the hospital, and the four smaller buildings behind it to the left are officers' quarters. To the left of these, on the edge of the square, is the post headquarters, and to the left of that is a barrack block; adjoining this are the foundations of the long barracks. The foundations of many other structures may be seen in the cleared area; this was a large post.

Fort McKavett, sited in such a remote and beautiful place, unsurprisingly became a state historical park in the late 1960s. Its buildings are still in good condition, as may be seen in the photographs of the post headquarters and one of the officers' quarters.

Margaret Bierschwale. *Fort McKavett, Texas: Post on the San Saba.* Salado, Tex.: A. Jones Press, 1966.

Jerry M. Sullivan. *Fort McKavett: A Texas Frontier Post.* Austin: Texas Parks and Wildlife Department, 1993.

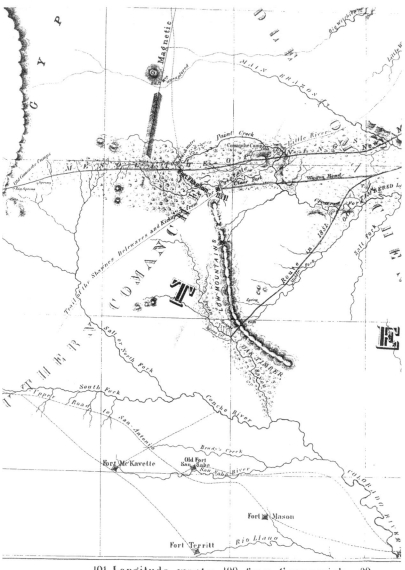

101 Longitude west = 100 from Greenwich. 99

Detail showing "Fort McKavette" [sic] from Randolph Marcy, Map of the Country between the Frontiers of Arkansas and New Mexico *(New York: Ackerman Lith., 1853).*

HISTORIC TEXAS FROM THE AIR

Aerial photograph of Sabine Pass, 27 November 2007, late afternoon, looking north-northwest upstream, with Louisiana on the right and Texas on the left.

Sabine Pass, Jefferson County

Rivers have an important place in Texas history as the routes by which commerce moves from the interior to the Gulf. One of these important waterways, the Sabine River, forms Texas's eastern boundary with Louisiana. Sabine Pass is located where the Sabine River enters the Gulf of Mexico. It is one of many such passes—narrow waterways connecting the Gulf with bays lying behind the barrier islands along the Texas coast.

Connecting the large Sabine Lake with the Gulf, Sabine Pass figures in Civil War history as the site of a major Union defeat. In 1861, Texas became a member of the Confederacy and, despite blockades, defied federal authorities and sent cotton and other goods to the Confederates by sea via the Sabine Pass. On 7 September 1863, more than five thousand Union troops under the command of General William B. Franklin boarded three gunboats—the *Arizona, Clifton,* and *Sachem*—intent on capturing the pass. General Franklin thought his naval forces superior to anything the Texans could offer in defense. Besides, a Union victory here would give the federal government a foothold in defiant Texas. The next day, though, did not go as Franklin had hoped. As seen in the historical map, lithograph, and aerial photograph, Sabine Pass is a narrow waterway, and Franklin's naval vessels were exposed to gunfire and cannon shelling from the adjacent banks. As the Union vessels sailed by the lighthouse and began their way through Sabine Pass, they encountered heavy fire from the Confederate fort. Within minutes, the *Sachem* was out of commission. Next, the *Clifton* became grounded and surrendered. Less than 45 minutes after it began, the Union engagement ended in disaster and disgrace as General Franklin reportedly became the first U.S. general in history to lose a naval fleet to land forces.

Richard Francaviglia. "Blockades and Blockade Runners, 1861–1865." In *From Sail to Steam: Four Centuries of Texas Maritime History, 1500–1900,* 189–220. Austin: University of Texas Press, 1998.

Andrew Forest Muir. "Dick Dowling and the Battle of Sabine Pass." In *Lone Star Blue and Gray: Essays on Texas in the Civil War,* edited by Ralph A. Wooster, 176–208. Austin: Texas State Historical Association, 1995.

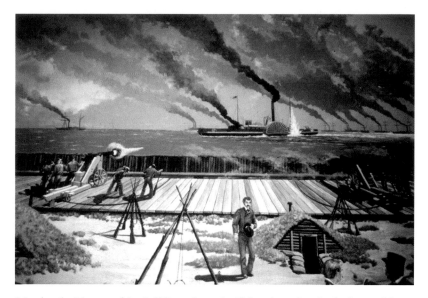

Mural at the Museum of the Gulf Coast shows the Clifton *(center) under fire by Confederate forces. Courtesy Museum of the Gulf Coast, Port Arthur, Texas (photo by Richard Francaviglia, 1995).*

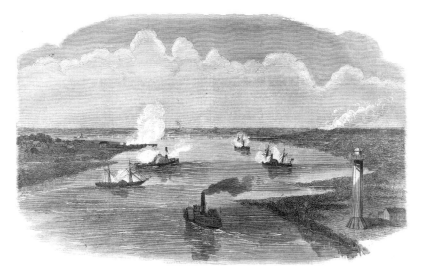

The Battle of Sabine Pass on 8 September 1863 as depicted in the 10 October 1863 issue of Harper's Weekly. *Note the Sabine Pass lighthouse at right, Union vessels at center, and smoke from the Confederate fort at left.*

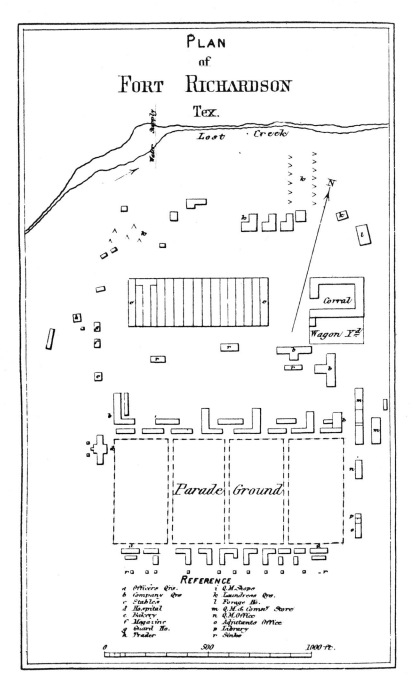

Plan of Fort Richardson in 1876 from Outline Descriptions of the Posts in the Military Division of the Missouri (Chicago: Headquarters, Military Division of the Mississippi, 1876).

Fort Richardson, Jacksboro

Fort Richardson was a relatively late fort, begun in 1866 and finished in 1870. During Civil War hostilities, Anglo settlers lost ground and the line of Indian influence moved about 100 miles eastward. Here, construction of Fort Richardson held the Indians in check and allowed the westward progress of Anglo settlement to resume. In 1872 the fort had the largest garrison (666 officers and men) of any military installation in the United States, and these forces had innumerable fights with the Comanches and Kiowa during the 1870s.

In addition to fighting Indians, the garrison acted as a sort of local police force by helping local law officers, protecting wagon trains, safeguarding cattle herds, and even overseeing elections. Three major anti-Indian campaigns were once launched from Fort Richardson, but today it is hard to imagine how busy this base once was.

The most impressive surviving building on this large field in Jacksboro is the hospital, to the left on the aerial photograph. It stood on the northwestern corner of the parade ground, which was lined in the usual way with quarters and barracks, as our plan from 1876 shows. One of these barracks survives, and appears in our ground photograph; behind it, across another field, stands the curiously shaped magazine, a rare survivor. Abandoned by the army in 1878, Fort Richardson opened as a state park in 1973.

Allen Lee Hamilton. *Sentinel of the Southern Plains: Fort Richardson and the Northwest Texas Frontier, 1866–1878*. Fort Worth: Texas Christian University Press, 1988.

Donald W. Whisenhunt. *Fort Richardson: Outpost on the Texas Frontier*. El Paso: Texas Western Press, 1968.

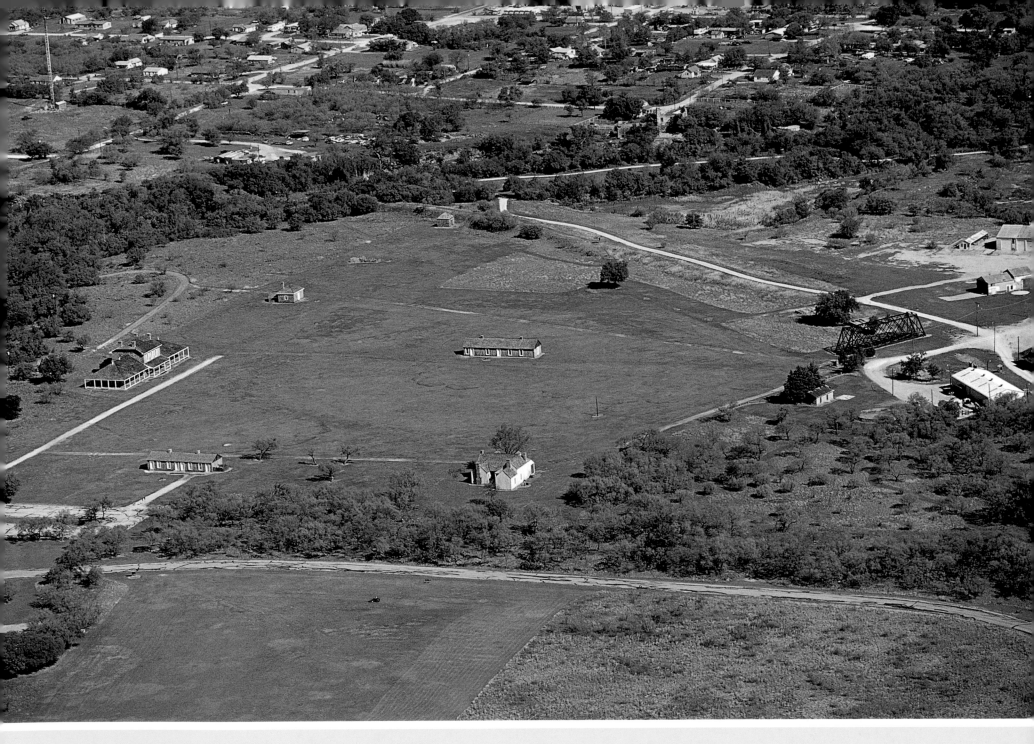

Aerial photograph of Fort Richardson, 14 April 2006, mid-morning, looking north.

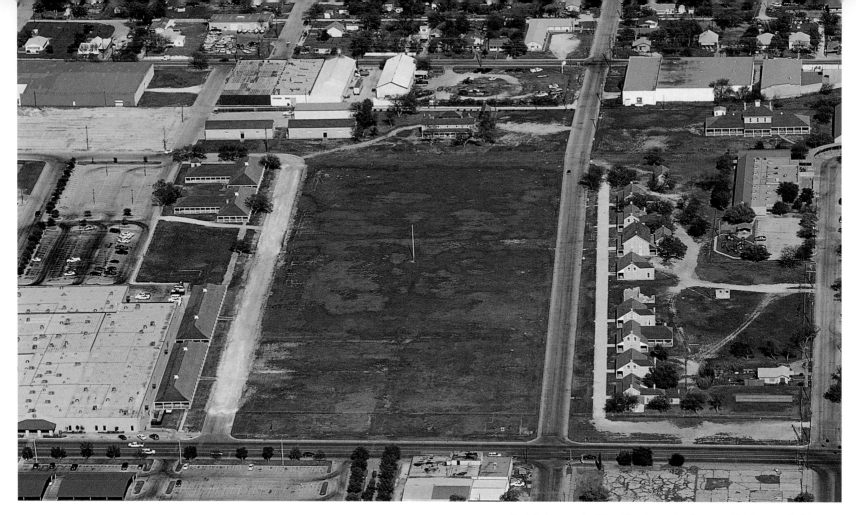

Aerial photograph of Fort Concho, 11 April 2005, mid-afternoon, looking east.

Fort Concho, San Angelo

This is another late fort, but unlike Fort Richardson, it may now be found in the middle of a thriving town. The army map of 1858 shows a Camp Concho, but the fort we see today was not constructed until 1868. Already by 1879 there were some forty permanent structures, in spite of the difficulty of finding suitable local building material. Like Fort Richardson, but unlike Fort McKavett, Concho was a cavalry post with a huge central parade ground; its soldiers undertook many different functions, such as escorting stagecoaches, protecting cattle drives, surveying railroads, building roads, and compiling maps. The fort was in effect the center of administration and law enforcement in otherwise wild country, although it did not play as large a role in the Indian skirmishes as Fort Richardson did.

The army abandoned the fort in 1889, but by then the town of San Angelo was sufficiently developed to ensure the preservation of many of the military buildings. The Fort Concho Museum was founded as early as 1930, and was taken over in 1935 by the city of San Angelo.

Our aerial photograph and the accompanying plan reflect this history of local maintenance. As usual, the enlisted men's barracks (left) face the officers' quarters across the parade ground, on which there is still a flagstaff. The headquarters stands between them (#14 on the plan), and the well-maintained hospital lies to the right (#17). Note that some of the buildings on this plan no longer exist; the site has long been well-managed, so even though it lacks the drama of a remote site like Fort McKavett, it has an architectural history which is remarkably well known, down to the date of construction of individual buildings.

Bill Green. *The Dancing was Lively: Fort Concho, Texas; A Social History, 1867–1882.* San Angelo, Tex.: Fort Concho Sketches Pub. Co., 1974.

J. Evetts Haley. *Fort Concho and the Texas Frontier.* Illustrated by H. D. Bugbee. San Angelo, Tex.: San Angelo Standard-Times, 1952.

James T. Matthews. *Fort Concho: A History and a Guide.* Austin: Texas State Historical Association, 2005.

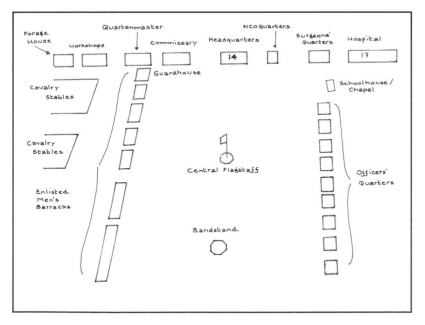

Plan to show the functions of the main buildings at Fort Concho, generated from the information leaflet of Fort Concho National Historic Landmark.

Detail from "Army Map of 1858" published by Lewis Buttery in Old Maps of the Southwest *(Lampasas: L. M. Buttery, 1975).*

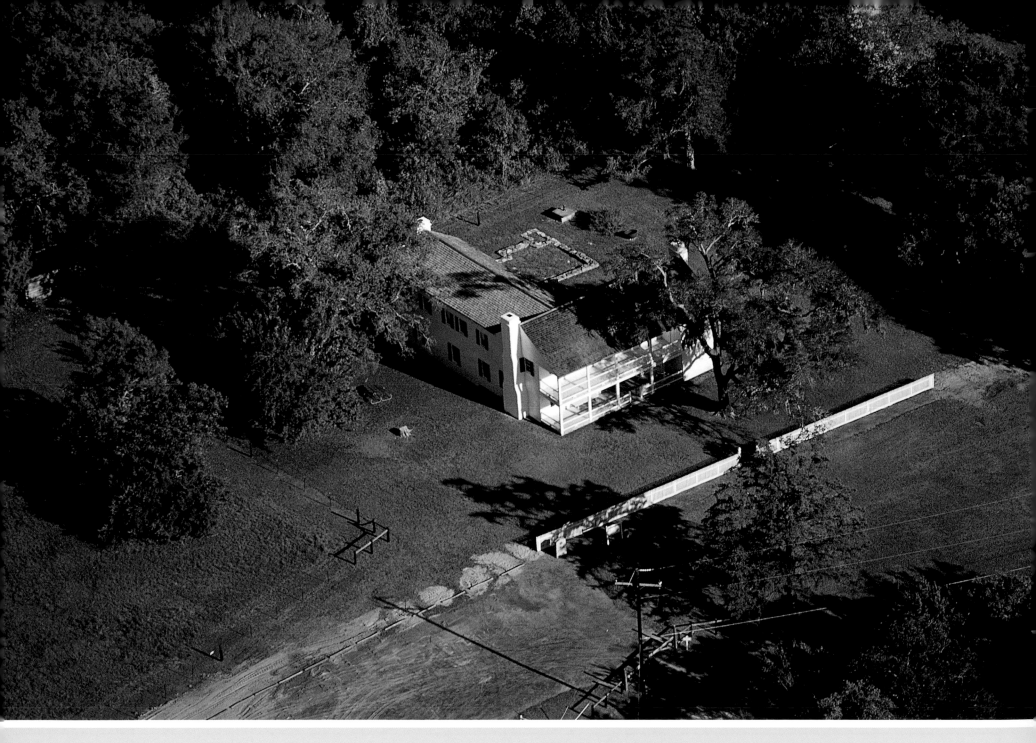

Aerial photograph of the Fanthorp Inn, 13 September 2006, late afternoon, looking east.

Fanthorp Inn, Anderson

There was a brief period of time, perhaps a couple of decades, when Texas was sufficiently prosperous to support a number of stagecoach lines, before they were supplanted by burgeoning railroads in the 1860s. Using contemporary printed lists of stagecoach stops, it is possible to construct maps like the one shown here. The two lines shown on the map were probably the most important of the many such lines that existed. The north-south line roughly followed the route of modern-day Interstate 35, and the east-west line approximately followed the track of one of the Spanish *caminos reales*.

Every thirty miles or so along these lines stood taverns where travelers could rest for the night and change horses. One such tavern was built at Anderson, on the east-west route, in about 1835. As our aerial photograph shows, it was a substantial structure with characteristic galleries on the first and second floors. The Fanthorp Inn thrived in the 1840s and 1850s, when it is said to have been visited by such luminaries as Sam Houston, Ulysses S. Grant, Jefferson Davis, and Robert E. Lee, as well as by many families of settlers making their way to the fertile lands of the West.

The inn closed about 1870, but the building remained in the Fanthorp family until it was conveyed to the state and in 1977 was named a historic site by the Texas Parks and Wildlife Department.

Eva Jolene Boyd. *That Old Overland Stagecoaching*. Plano, Tex.: Republic of Texas Press, 1993.

Kathryn Turner Carter. *Stagecoach Inns of Texas*. Rev. ed. Austin: Eakin Press, 1994. First edition, Waco, Tex.: Texian Press, 1972.

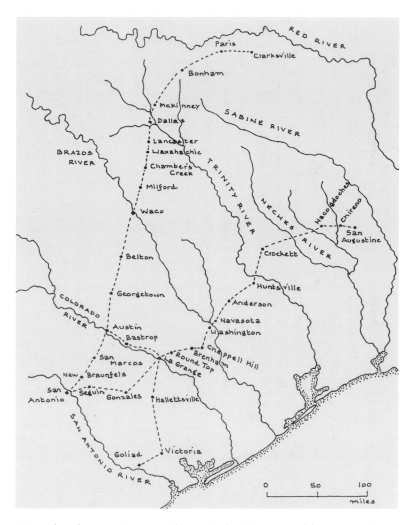

Map to show the two major stagecoach routes in the 1860s, generated from stagecoach timetables of the period.

Stagecoach Inn, Salado

The map accompanying our previous image shows a stagecoach stop at Belton on the main north-south line, between the Brazos and Colorado Rivers. Here the route crossed Salado (Spanish for salty) Creek; the Indians were first to appreciate this place, followed by the Spaniards, and by the 1840s a small European settlement began to grow at the site. The creek was very important to the settlement of Salado, not only as a reliable water supply, but also as a source of power for numerous gristmills.

The outline of the old road through the town may still be seen sinuously winding across the creek and climbing the hill out of town to the south. We have to imagine traffic on this road—not only horsemen, but also stagecoaches, as well as the occasional herd of cattle being driven north. Our aerial photograph, oriented toward the northeast, shows a single car on this old road crossing the creek; many more cars may be seen on Interstate 35, which noisily hems in the former stagecoach site to the west.

The early stagecoach inn is obscured by trees in the middle right of the photograph. Our ground photograph shows it better, from the east; this classic mid-nineteenth-century stagecoach stop has a jointed roof, stone chimneys, and wide upper and lower verandas. A restored coach on the grounds further helps the visitor to imagine how travelers would once have crossed Texas, making their slow way from inn to inn in these unwieldy vehicles.

Mary Harrison Hodge. *Salado and Bell County, Texas*. Salado, Tex.: M. H. Hodge, 1999.

Salado: A Jewel in the Crown of Texas. Salado, Tex.: Salado Village Voice, 1995.

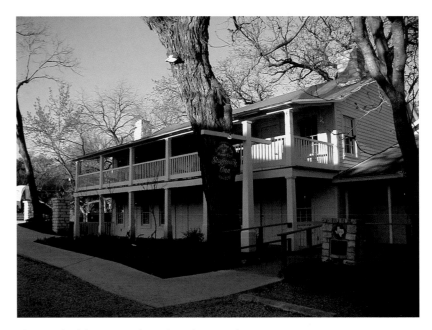

Photograph of the Stagecoach Inn (David Buisseret).

Aerial photograph of the Stagecoach Inn, 10 April 2006, mid-morning, looking northeast.

Aerial photograph of Winedale, 11 April 2006, late afternoon, looking southeast.

104 HISTORIC TEXAS FROM THE AIR

Winedale, Round Top

What makes a historic site? Is it a location where some historic event unfolded or an important family settled that has been kept intact and undisturbed? Or is it a historic structure furnished with original antique furnishings and kept in pristine condition? Or is it something less tangible? Is Winedale, located in the northeastern portion of Fayette County, a legitimate historic site, even though most of its nineteenth-century structures have been moved there from other places? In fact, Winedale represents not only the history of German settlement and culture in Central Texas, but also the story of historic preservation in Texas.

Miss Ima Hogg, Houston philanthropist, preservationist, and daughter of Governor James Stephen Hogg, is responsible for Winedale as we know it today. In the early 1960s, Hogg purchased approximately ninety acres of land near the former community of Winedale in order to preserve a farmstead and home formerly owned by Samuel K. Lewis. Lewis had purchased the original 145-acre site in 1848. Though Lewis died in 1867, his heirs retained the house until 1882. By that time, the home stood on the path of the Sawyer and Risher stage line from Brenham to Austin and so had been turned into an inn known as Sam Lewis's Stopping Place.

The family of Joseph George Wagner, Sr., purchased the home in 1882, and Wagner's children, grandchildren, and great-grandchildren lived there for eighty years. Hogg bought the home, now known as the Wagner House, in 1963, with the intention to develop Winedale into a historical site to support the study of Texas history and culture, with special emphasis on German settlement in the region before the Civil War. With this in mind, Hogg began assembling historic structures from the region and moving them to the Winedale site to create something of a historical laboratory out of a built environment. Much of the furnishings and decorative art in the buildings were produced by German craftsmen.

A couple of years later, Hogg donated the restored Lewis property and the other structures she had acquired to the University of Texas at Austin, which dubbed the site the Winedale Historical Center. Hogg continued to take an active interest in the restoration of Winedale until her death in 1975 at age ninety-three.

Today the Winedale site near Round Top is a 225-acre complex of nineteenth-century structures and modern meeting/conference facilities. The site is used by the UT Center for American History for educational purposes and as a conference site for nonprofit groups. Winedale's existence stands as a testament to Hogg, who wanted it to be, in her words, "a laboratory for the revival and restoration of a way of life."

Virginia Bernhard. *Ima Hogg: The Governor's Daughter*. Austin: Texas Monthly Press, 1984.
Center for American History, The University of Texas at Austin. "Winedale." http://www.cah.utexas.edu/divisions/Winedale.html (accessed 5 May 2006).
Louise Kosches Iscoe. *Ima Hogg, First Lady of Texas*. Austin: Hogg Foundation for Mental Health, 1976.

Miss Ima Hogg, daughter of Texas Governor James Stephen Hogg and the driving force behind Winedale, 1959. Photograph Collection, UTA Library.

Part of the Texas Declaration of Independence, 1836. Special Collections, UTA Library.

Washington-on-the-Brazos, Chappell Hill

Washington, as the settlement was first called, emerged in 1822 on the Brazos River where one of the *caminos reales* crossed it by ferry; by 1833 the settlement had become a thriving town thanks to its location as a transit point for the rich agricultural region. Its finest hour came in March 1836, when a convention of delegates assembled there to sign the Texas Declaration of Independence. As our extract shows, it was redolent with the language of the U.S. Declaration of Independence, and of course similarly led to war.

Washington continued to grow and thrive in the later 1830s, 1840s, and 1850s as a stopping point for stagecoaches and a political meeting place. Although its bid to be named capital of the Republic of Texas was denied, in 1845 the town hosted the session of the Texas Congress that approved annexation to the United States. It seemed for a while as if Washington, situated at the limit of steamboat navigation on the Brazos, might thrive as a center for the export of cotton downriver. However, navigation by river was never easy, and when Washington refused in 1858 to pay a bonus in order to attract a railroad, the town was doomed.

Most residents moved to nearby Brenham or Navasota, and by the end of the century the former town site consisted only of cultivated fields. Since then, as our image shows, some structures have reemerged as the Texas Parks and Wildlife Department tries to suitably commemorate a town that was once of great importance in the early days of the republic.

Wilfred O. Dietrich. *The Blazing Story of Washington County*. Brenham, Tex.: Banner-Press, 1950.

Charles F. Schmidt. *History of Washington County*. San Antonio: Naylor Press, 1949.

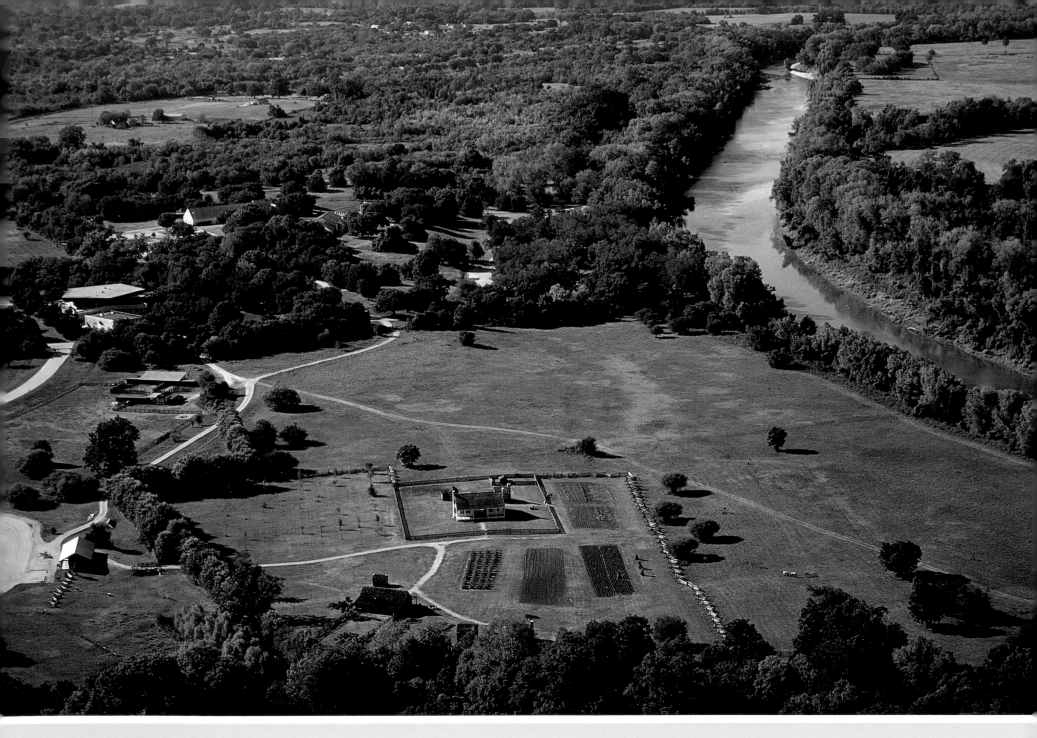

Aerial photograph of Washington-on-the-Brazos, 13 September 2006,
late afternoon, looking north upstream.

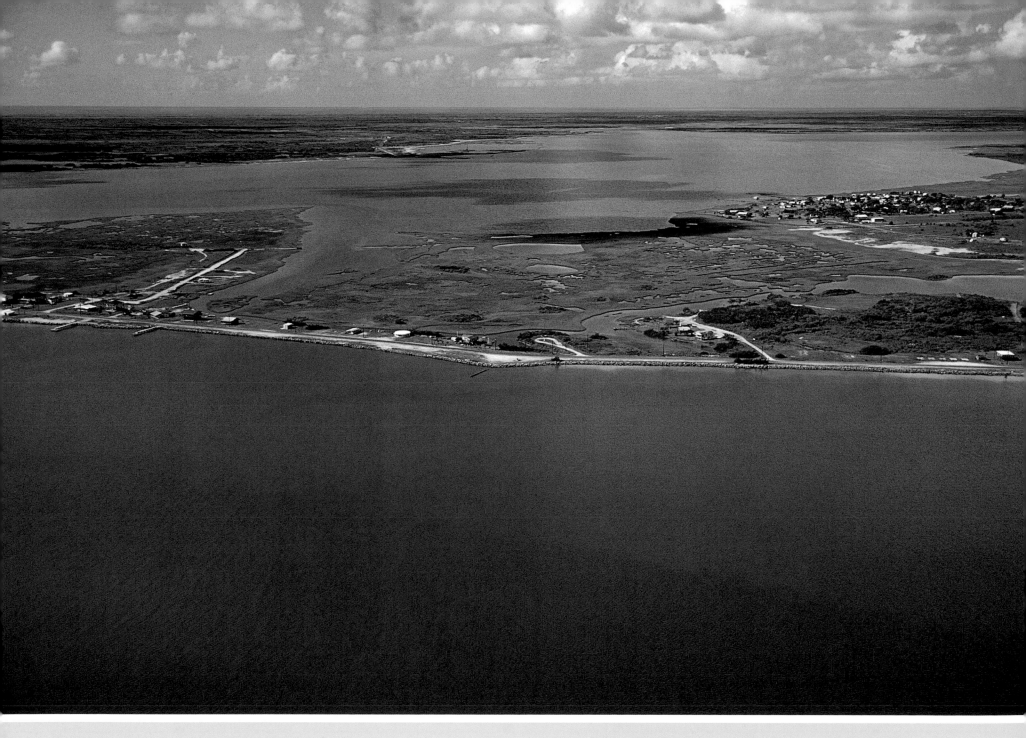

Aerial photograph of Indianola, 25 August 2005, midday, looking southwest
from Matagorda Bay toward Powderhorn Lake in Calhoun County.

Site of Former Port, Indianola

In 1844, Carl, prince of the former German county of Solms-Braunfels, selected a stretch of beach on Matagorda Bay as a landing place for his intended German settlers. Many immigrants arrived the following year, and many of these perished on the laborious road to New Braunfels and Fredericksburg, for want of water and suitable transport. Nevertheless, enough survived to form a little town on the bay, first called *Carlshafen* or (*oder*) Indian Point (first map) and later nicknamed Indian Point or Indianola (second map).

This port flourished as the entry point for migrants headed for German settlements farther north and west; it became the terminal for Charles Morgan's shipping line (*Dampfboet Linie*) from New York, and it even survived a bombardment by Union gunboats, followed by Union occupation, in 1862. It imported ice in huge blocks in the spring, and by 1869 had begun to ship refrigerated beef to eastern U.S. markets. In short, the port seemed destined to flourish as the ocean gateway to western Texas, counterpart to Galveston for the eastern parts.

Alas, all this promise was destroyed by the fearful hurricanes of 1875 and 1886. It became clear that Indianola's location was too exposed to the fury of Matagorda Bay, and its role as a major port of entry was eventually taken by Port Lavaca. Today Indianola stands at the end of a minor road, with very little to remind us of its remarkable past.

T. Lindsay Baker. *Ghost Towns of Texas*. Norman: University of Oklahoma Press, 1986.

Brownson Malsch. *Indianola: The Mother of Western Texas*. Austin: Shoal Creek, 1977.

Helmut Holtz, Hafen von Indian Point oder Indianola (1860). Courtesy the Archives and Information Services Division, Texas State Library and Archives Commission.

Helmut Holtz, Karte von Indian Point oder Indianola (1860). Courtesy the Archives and Information Services Division, Texas State Library and Archives Commission.

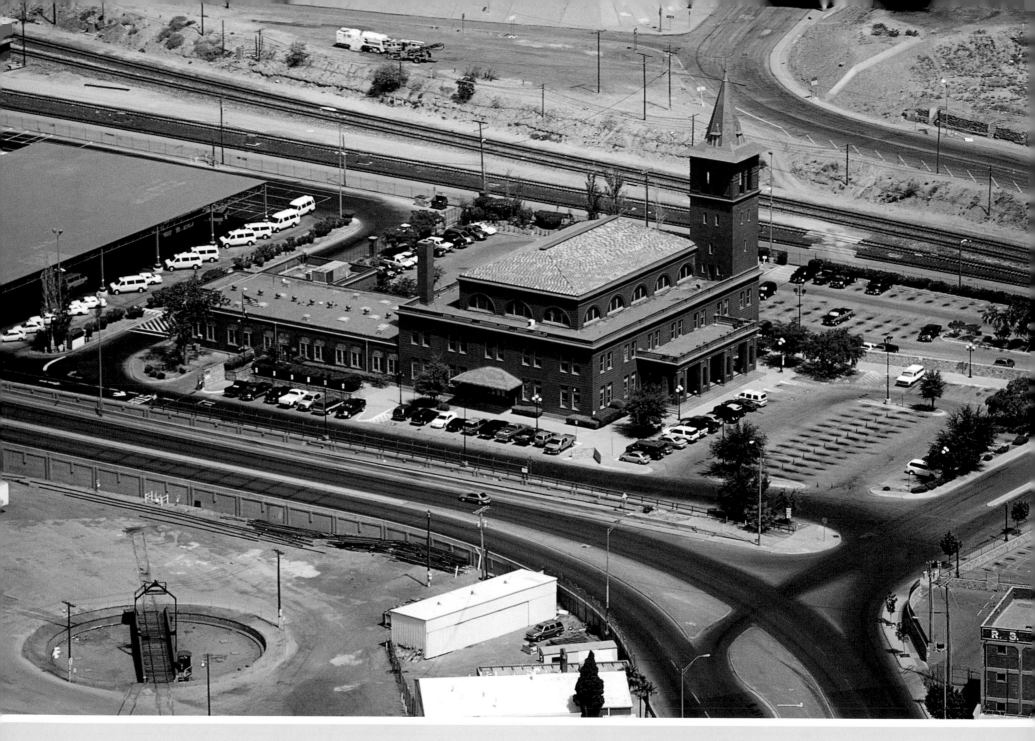

Aerial photograph of Union Depot, El Paso, 7 May 2006, midday, looking northwest.

Union Depot, El Paso

Like many cities that grew rapidly in the nineteenth century, El Paso was served by several railroads and soon it had several railroad stations—one for each of the six companies that served the city. By 1900, the situation had become intolerable for travelers who had to leave one train and travel across town to catch another. Aware of the problem, city leaders supported the creation of a single station that could serve all the railroads more effectively. Thus was born Union Depot, a large building located at the western edge of El Paso's thriving downtown area. Designed by noted architect Daniel H. Burnham of Chicago and erected by Frank Powers of El Paso, Union Depot opened in February 1906. The depot served six railroads—the Southern Pacific, Santa Fe, Texas and Pacific, El Paso and Southwestern, El Paso and Northeastern, and the Nacional de Mexico—making it a uniquely international station. In the 1920s, at least twenty-two trains used or originated at the station daily; today, however, it is only used by one Amtrak train.

This red brick building, with its peak-roofed, six-story tower, became the centerpiece of the city. In the 1950s, in an effort to make the building appear more "southwestern" in style, architects removed the peaked roof, added a tile roof, and painted the entire building white. In the 1980s, however, preservationists called for the building to be restored to its original late Victorian appearance. That process took almost twenty years. Our aerial photo (2006) shows the fully restored building, which is once again a landmark. Note how few tracks serve the depot now that only two trains a day arrive and depart. Note, too, the modern structures located nearby, such as the convention center. Not far from the depot, however, a vestige of El Paso's railroad era remains; note the site of the former roundhouse lying west of the main highway that borders downtown.

City of El Paso Web site. "Union Depot History." www.elpasotexas.gov/SunMetro/sunhis.asp (accessed 16 February 2006).

Edward A. Leonard. *Rails at the Pass of the North*. El Paso: Texas Western Press, 1981.

David F. Myrick. *New Mexico's Railroads: An Historical Survey*. Rev. ed. Albuquerque: University of New Mexico Press, 1990.

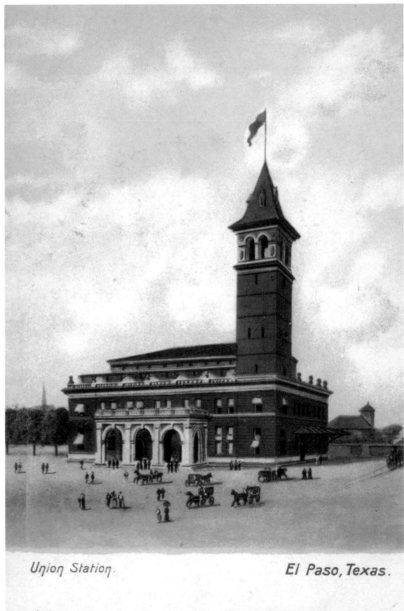

Union Station. El Paso, Texas.

Arthur A. Kline & Co., El Paso, Tex. No 21. Made in Germany.

Postcard from about 1907, showing an architect's version of "Union Station, El Paso, Texas." Garrett Postcards, UTA Library.

Suspension Bridge, Waco

The city of Waco is strategically located on the Brazos River and along the major north-south route of travel that ultimately became Interstate 35. This location helped the city grow, but crossing the Brazos River was a challenge during the mid-nineteenth century, when one bridge soon became outmoded. With traffic increasing and commerce thriving in the 1860s, Waco sought the latest and best technology, a metal suspension bridge. On a suspension bridge, the roadway essentially hangs from cables that are anchored to the ground and supported by towers. The beautiful Waco suspension bridge shown in our aerial photograph represents the height of mid-nineteenth-century technology. A civil engineer and employee of John A. Roebling and Son of Trenton, New Jersey, Thomas M. Griffith of New York designed the bridge and supervised its construction. The cables and steelwork were commissioned from Roebling, the company that would later complete the Brooklyn Bridge in 1883 after more than a decade of construction. Although the bridges at Waco and Brooklyn were conceived at about the same time, Waco's suspension bridge was finished long before the Brooklyn Bridge, and soon became a landmark. The twin double towers that anchor the span were called a marvel of engineering when the bridge was completed late in 1869. The immense towers were constructed of nearly 3 million locally produced bricks. Upon completion, the Waco bridge became the longest single-span suspension bridge west of the Mississippi, with a main span of 475 feet (145 m); it was also, in fact, one of the longest suspension bridges in the world.

The Waco Suspension Bridge was not only beautiful, but also functional. It stood at a crucial point where important roads intersect the river. Its roadway was wide enough for stagecoaches to pass each other, or for cattle to cross on one side of the bridge and humans to cross on the other. As this bridge was the only way

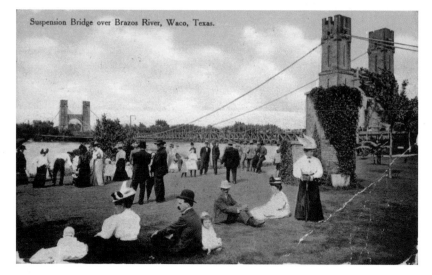

Postcard showing the "Suspension Bridge over Brazos River, Waco, Texas," ca. 1900. Garrett Postcards, UTA Library.

across the Brazos at the time, the city of Waco quickly earned back the $141,000 construction cost by charging tolls for cattle (5 cents per head) and pedestrians. The picturesque bridge was often featured on postcards in the nineteenth century, and remains one of the most significant examples of historical engineering in the state of Texas. It carried vehicle traffic until 1971, but now is reserved for pedestrians and special events. The more recent bridges across the Brazos nearby are a testament to the judicious selection of the historic bridge's location. Compare the bridges side-by-side in the aerial photograph and note the changes in bridge technology over the last 150 years.

James Wright Steely, ed. A Catalog of Texas Properties in the National Register of Historic Places. Austin: Texas Historical Commission, 1984.

Richard J. Veit. A Centennial Salute to the Free Bridge. Waco Heritage and History 19, no. 1 (September 1989): 3–19.

Patricia Ward Wallace. Our Land, Our Lives: A Pictorial History of McLennan County. Norfolk, Va.: Donning Co., 1986.

Postcard showing the "Waco Tex. Suspension Bridge" at night, ca. 1910. Garrett Postcards, UTA Library.

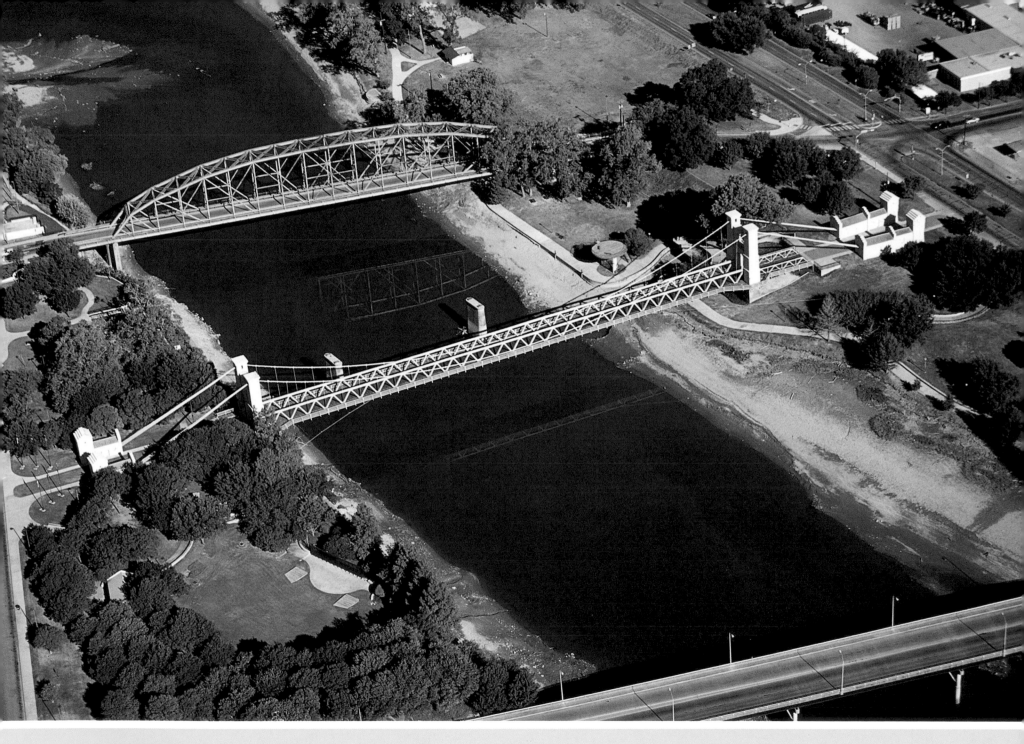

Aerial photograph of Waco Suspension Bridge, 8 October 2006, mid-morning, looking northwest, upstream on the Brazos River.

5

NINETEENTH-CENTURY ANGLOS:
SETTLEMENTS AND INDUSTRIES

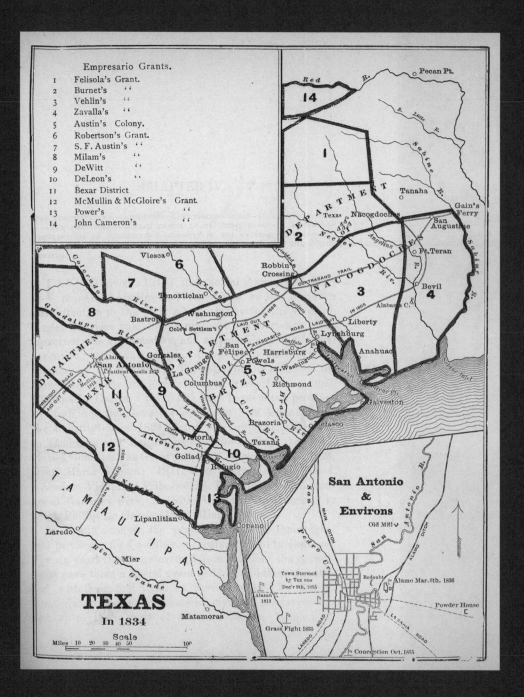

Texas in 1834 *from Homer S. Thrall, A Pictorial History of Texas (St. Louis, Mo.: N. D. Thompson, 1879).*

INTRODUCTION

Immigration to Texas by people of European origin continued throughout the nineteenth century. Sometimes these immigrants brought skills—like brewing, in the case of Heinrich Kreische of La Grange—that remain trademarks of their settlement to the present day. In every case, the immigrants brought an architectural style radically different from the Spanish and Mexican traditions. They also brought forms of town planning which owed nothing to the Laws of the Indies, which from the early sixteenth century onward had governed city planning in the Spanish New World. Often in these new European-style towns, a courthouse occupied the center of town instead of the Spanish *plaza mayor*. Often, too, streets in these newer towns were not oriented by the cardinal directions, but rather aligned with some feature, like a river or a railroad, underscoring the importance of transportation technology to these commerce-oriented northern Europeans.

When the national consensus finally fell apart and the Civil War broke out in the 1860s, Texas, too, became divided. The mainly Anglo eastern part of the

state was fairly solidly Confederate and pro-slavery, so those who opposed slavery, like the Germans of the Hill Country, were apt to meet an unfortunate fate. Curiously, Texas's economy suffered little during the war. General Sherman cut a swathe of economic destruction across a large part of the South, but towns like Jefferson and Marshall often profited considerably from the war as major suppliers of the Confederate army.

At the beginning of this period, as our 1834 map shows, the newest settlements in Texas were concentrated in the southern regions; the great modern metropolitan centers of Houston and Dallas/Fort Worth do not even appear on the map. As time went by, however, the balance of power shifted northward, as industries appeared in places like Thurber to supply burgeoning cities like Dallas and Fort Worth, both founded in the late 1840s. The map reminds us that in Texas, as in some other states like Illinois, the earliest settlement was not in the area that eventually became most populous. Just as the settlements built along the Illinois River in the 1830s were eventually overtaken by metropolitan Chicago, so early cities like San Antonio and Galveston were eventually outstripped by Houston and Dallas/Fort Worth. In chapter six we shall try to offer fresh perspectives on these mainly northerly developments.

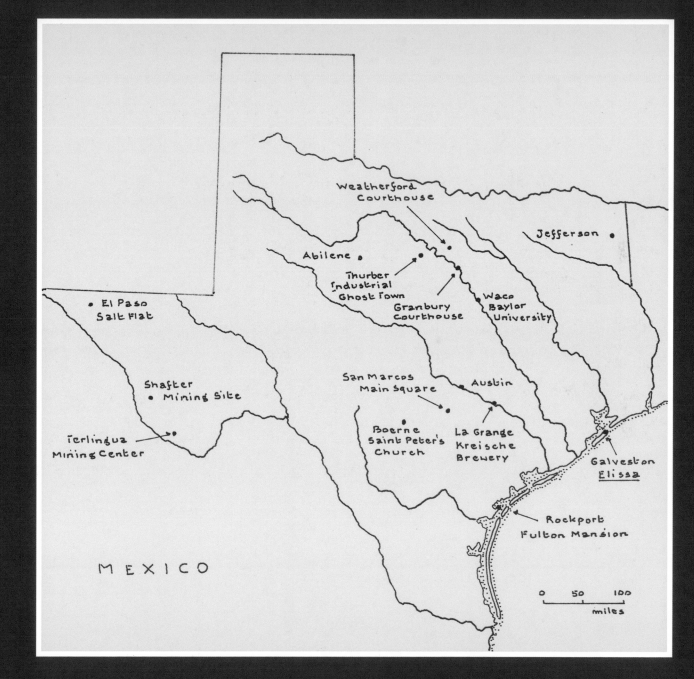

Weatherford
Courthouse

Jefferson

Abilene

Thurber
Industrial
Ghost Town

Granbury
Courthouse

Waco
Baylor
University

El Paso
Salt Flat

Shafter
Mining Site

San Marcos
Main Square

Austin

Terlingua
Mining Center

Boerne
Saint Peter's
Church

La Grange
Kreische
Brewery

Galveston
Elissa

Rockport
Fulton Mansion

MEXICO

0 50 100

miles

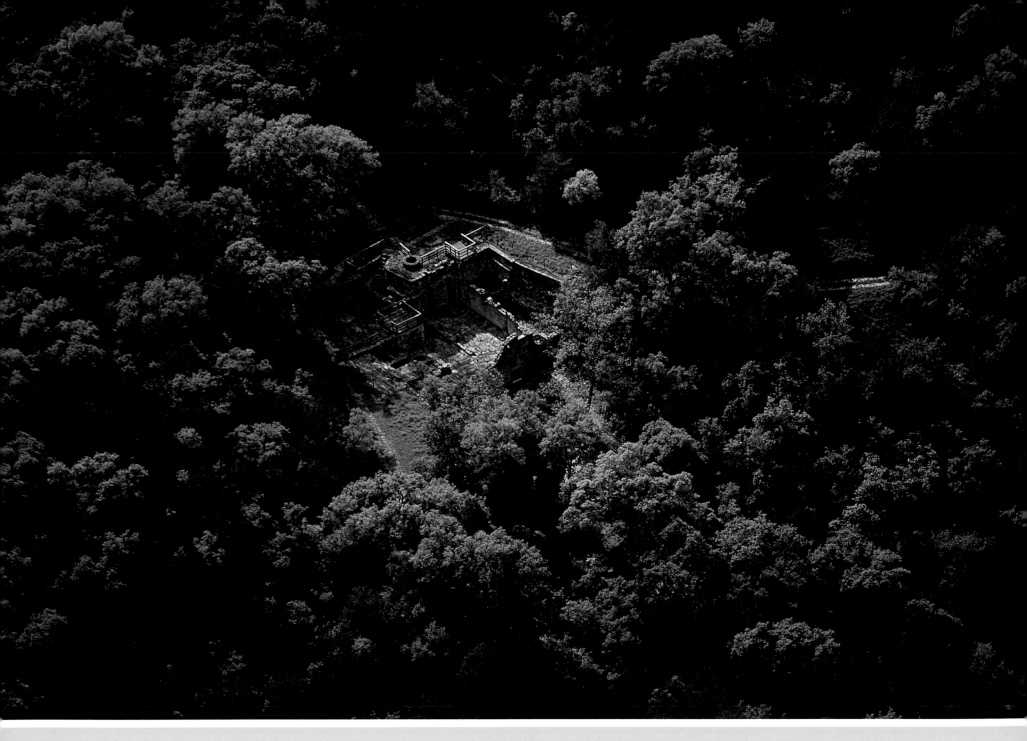

Aerial photograph of the Kreische Brewery Site, La Grange, 11 April 2006, late afternoon, looking northwest.

Kreische Brewery, La Grange

The Tonkawa Indians valued the area around La Grange as hunting ground; in the days of the Spaniards, the lower *camino real* crossed the Colorado River here. Anglos began settling here in the 1820s and established the town of La Grange in 1837.

The surrounding area soon developed a small-scale plantation economy, as settlers grew cotton with the aid of African-American slaves. Meanwhile, during the 1840s and 1850s, Czechs and Germans moved to the area in increasing numbers; among them was Heinrich Kreische, whose primary occupation was stonemason, but who in 1860 founded a brewery on the cliff above the town, which produced a beer that was soon widely sold. Our aerial photograph shows its ruins on a steep hill, whose contours Kreische used in the brewing process, taking advantage of gravity in his operation.

La Grange was seriously affected by the Civil War, which often pitted local Confederate slaveholders against the Germans and Czechs, who were generally opposed to slavery. Kreische apparently weathered this period of unrest, living with his numerous children in the house shown in our photograph. He was killed in an accident at the brewery in 1882, at a time when the coming of the railroad to La Grange in 1880 loaded with imported goods had already begun to provide stiff competition for his homegrown beer. Kreische's brewery soon fell into a ruinous state, as we see it today.

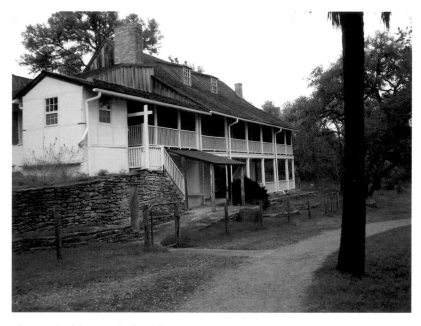

Photograph of the Kreische family house, La Grange (David Buisseret).

Terry G. Jordan. *German Seed in Texas Soil: Immigrant Farmers in Nineteenth-century Texas.* Austin: University of Texas Press, 1966.

Glen E. Lich. *The German Texans.* San Antonio: University of Texas Institute of Texan Cultures, 1981.

Main Square, San Marcos

To the casual observer, Texas towns may appear pretty much alike. However, the attentive traveler can tell them apart. Consider, for example, the town of San Marcos, which, despite its Spanish name, actually has much in common with many towns in the southeastern United States. Many signs of this heritage are seen in this aerial photo. At first glance, the combination of densely built-up areas and refreshingly green, open space feels like a park in the middle of the city. Look even closer, and you can see that the park-like space actually holds a substantial building—the Hays County Courthouse.

The name "San Marcos" was given to the river that flows through the area by explorer Alonso de Leon, who reached the site on St. Mark's Day in 1689. Hays County was named after John Coffee Hays, who commanded a company of Texas Rangers in the 1830s and 1840s. The importance of San Marcos as county seat is underscored by the building's position, dead center in the courthouse square, which sits right in the middle of the entire town. Much like a diamond set in a ring, the courthouse is the centerpiece of the community. This pattern is based on what geographer Edward T. Price calls the "Shelbyville square" plan, which he named after its original appearance in Shelbyville, Tennessee. Faced by commercial buildings on all sides, the courthouse square has represented the heart of town since 1851, when General Edward Burleson (a volunteer in Stephen F. Austin's army) and others laid out San Marcos on a square mile of land from the land grant of Juan Martín de Veramendi, former governor of the state of Coahuila y Tejas. With this enterprising act that combined governmental and business interests, the Texians who, like

Automobiles parked in San Marcos with the courthouse tower in the distance, May 1978 (Richard Francaviglia).

Hays, had hailed from the southeastern United States, superseded the early Spanish heritage of the area by creating new towns like San Marcos without a Spanish influence.

As San Marcos grew from a town of about 350 people in 1850 to about 30,000 in 2000, it still retained that county courthouse square to which all roads led. San Marcos in the early 1850s was an important stagecoach stop as well as the center of government and commerce for the surrounding rural area. As seen in the aerial photograph, it remains an important economic center with many thriving businesses which are patronized by townsfolk and Texas State University students.

Mary Starr Barkley. *A History of Central Texas*. Austin, 1970.

Dudley R. Dobie. *A Brief History of Hays County and San Marcos, Texas*. San Marcos, Tex.: D. R. Dobie, 1948.

Robert E. Veselka. *The Courthouse Square in Texas*. Austin: University of Texas Press, 2000.

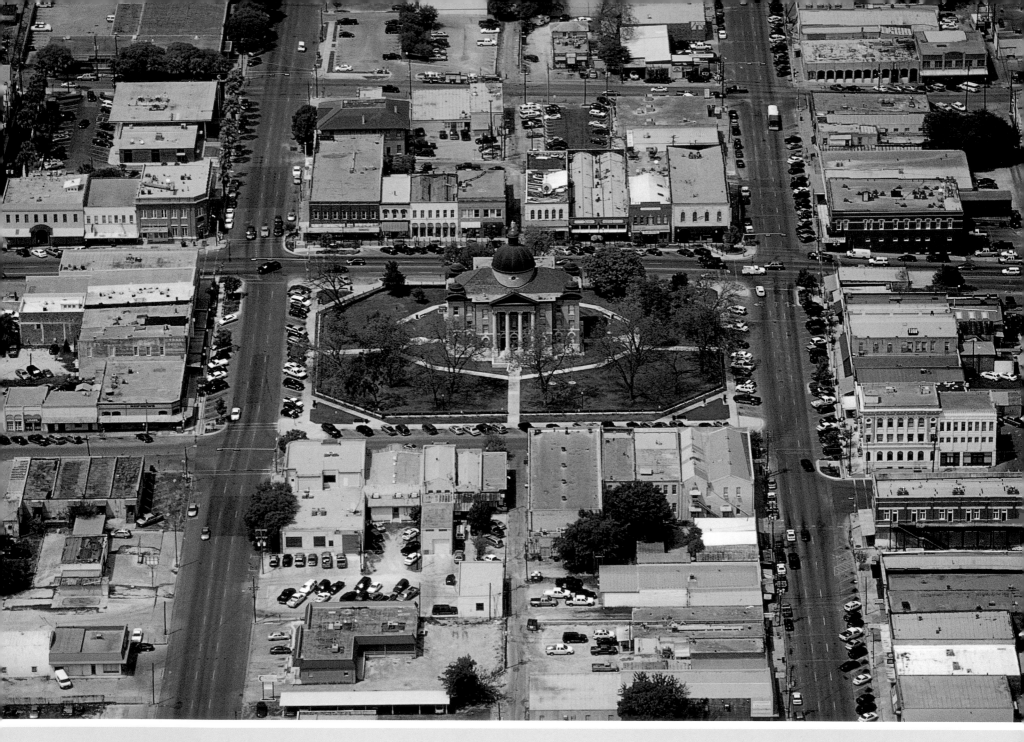

Aerial photograph of the main square, San Marcos,
11 April 2006, mid-morning, looking north.

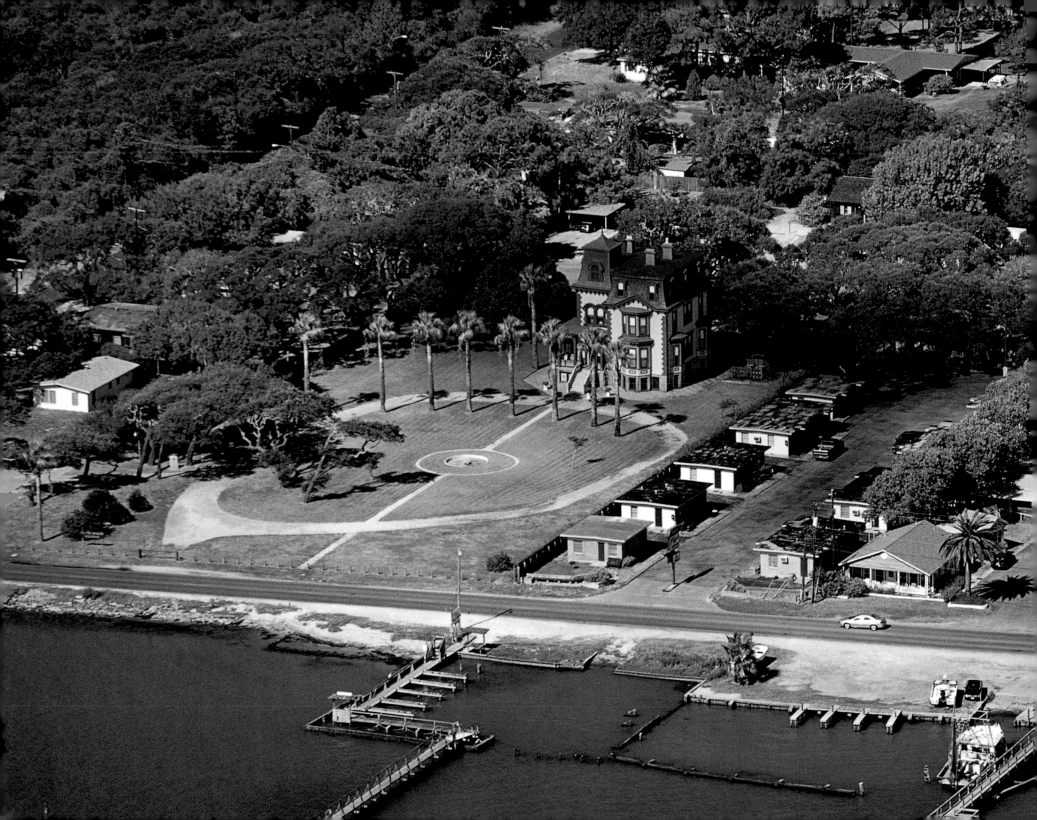

Fulton Mansion, Rockport

Rockport first came to prominence in the 1860s as a very active center for the slaughtering of cattle and the shipping of their meat and hides; it was thus a sort of maritime counterpart to the great cattle drives of the period. This industry thrived during the 1870s, but after the shipping line pulled out in 1886, boatbuilding, fishing, and tourism increasingly replaced the cattle work. Rockport retains to this day a relatively small harbor, home only to a fleet of shrimp boats, despite attempts to develop a deepwater harbor in 1884, 1908, 1910, and 1924.

The entrepreneur George Fulton played a prominent part in the short-lived cattle export industry, and in 1874 began building a mansion in Rockport that he called Oakhurst (known today as the Fulton Mansion). We can see this splendid Second Empire–style house in the aerial photograph, still standing in solitary state next to the water of the harbor; it was specially built to withstand hurricanes, and has now done so several times.

The mansion now stands alone, seeming unique and slightly incongruous, but at one time there were other ambitious buildings in Rockport. One of these was the courthouse of 1889, shown on this postcard from about 1920. Alas, a note on the back of the card observes that "a new and modern building will replace this structure in the near future," as indeed it has.

Postcard showing the old courthouse at Rockport, Texas. Garrett Postcards, UTA Library.

Keith Guthrie. *Texas' Forgotten Ports*. Austin: Eakin Press, 1988.

Hobart Huson. *Refugio: A Comprehensive History of Refugio County from Aboriginal Times to 1953*. 2 vols. Woodsboro, Tex.: Rooke Foundation, 1953–1955.

A Former Confederate City, Jefferson

Jefferson was laid out in the 1840s at the western-most point of navigation on the Red River, and it soon began to prosper as steamboats made their way up to it from the Mississippi River. Its plan resembled that of Dallas in that, as our bird's-eye view shows, the first streets—laid out at right angles to the river—join rather clumsily with the streets from a piece of privately owned land that was absorbed into the city later (Alley's Addition). The bird's-eye view, which is oriented similarly to the aerial photograph, also shows some of the steamboats that increasingly visited Jefferson in the 1850s, bringing a variety of materials for new settlers, and often returning downstream with huge bales of cotton.

For Jefferson, unlike many southern cities, the Civil War was an economic blessing, because the city shipped great quantities of food and other supplies to the Confederate army. Indeed, the gunpowder bunkers constructed at that time still stand just out of the photograph, off the bottom right-hand corner. The town continued to thrive even after the war, reaching the peak of its prosperity in 1872.

However, an event occurred in 1873 that proved disastrous to Jefferson's economic fortunes. The United States Army Corps of Engineers, wishing to make the upper reaches of the Red River navigable, used huge charges of nitroglycerin to remove the so-called Red River "raft," a natural dam on the river above Shreveport that probably formed during the New Madrid earthquake in 1811. The dam was successfully removed, but as an unforeseen side effect, the removal of the dam lowered the water level in some of the Red River's tributaries; navigation to Jefferson in par-ticular became very difficult. The simultaneous emergence of rival towns like Marshall and Dallas overwhelmed the Jefferson economy, but also had the delightful consequence that the undeveloped town now contains many interesting nineteenth-century buildings.

Winnie Mims Dean. *Jefferson, Texas: Queen of the Cypress*. Dallas: Mathis, Van Nort, 1953.

Fred Tarpley. *Jefferson: Riverport to the Southwest*. Austin: Eakin Press, 1983.

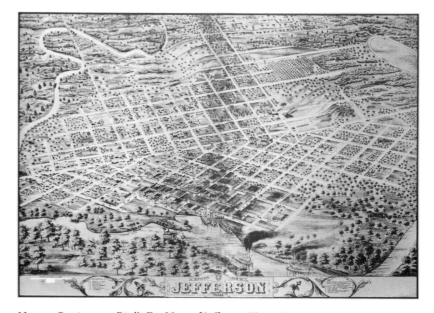

Herman Brosius, 1872 Bird's-Eye View of Jefferson, Texas. *Garrett Maps, UTA Library.*

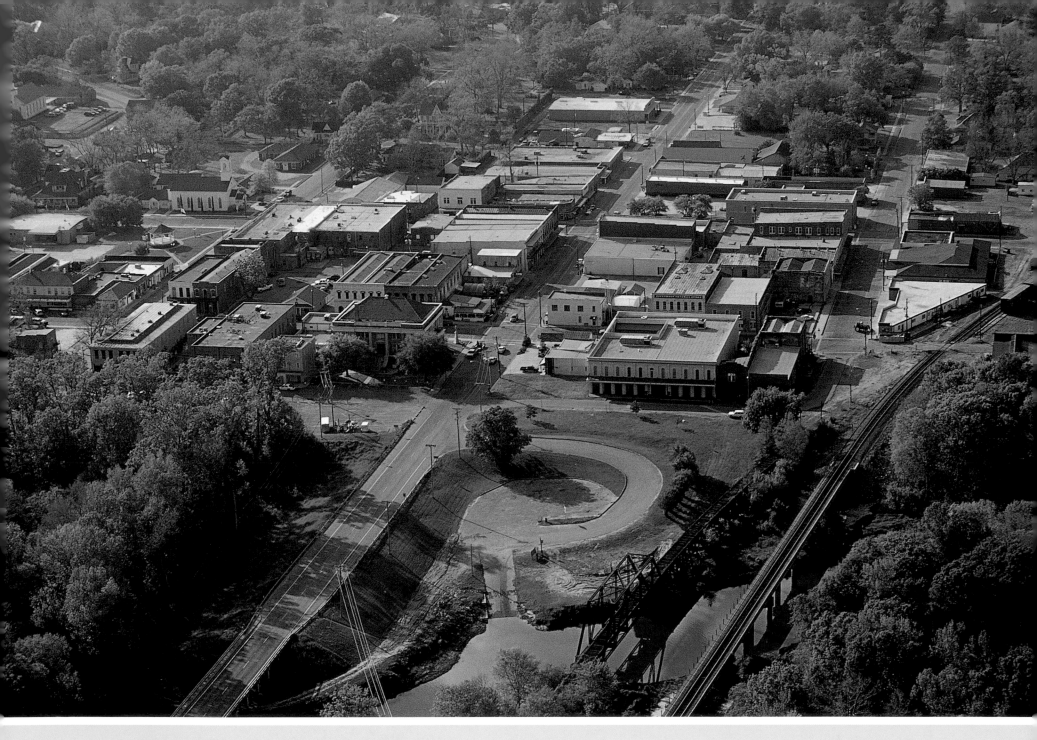

Aerial photograph of Jefferson, 12 April 2006, late afternoon, looking north.

Town Center, Abilene

Abilene began in 1881 when local ranchers and businessmen met with officials of the Texas and Pacific Railway to determine the location of a town site along the rail line from Fort Worth to El Paso. As in many towns laid out along the Texas and Pacific Railway, Abilene's streets are arranged in reference to the railroad's right-of-way, which in this case ran due east-west. As was typical in towns along the T&P, Abilene's commercial buildings lined N. 1st Street, which faced the railroad, but as the town grew, retail stores also appeared on Pine Street. As the 1883 bird's-eye view of Abilene reveals, along the railroad tracks that bisected the town stood a large, two-story T&P passenger station (#3 in the illustration), a freight station (#4), and a lumberyard (#5). Lumber from East Texas pine forests served as early building material, and large quantities of it were used, as the town's population had recently grown to about 2,000 people when the bird's-eye view was published.

Our aerial photo reveals considerable change in Abilene over 125 years, but a number of similarities remain. For example, the newer railroad station is also situated on the north side of the tracks, although it is now located closer to Pine Street. This new station, built in 1909 with a red tile roof, serves as a visitor information center now that passenger trains no longer run through Abilene. The railroad still bisects the town, but it is now part of the sprawling Union Pacific system, which runs only freight trains. Note, too, that the railroad line through town is now elevated, and that the major streets pass under the railroad; this expensive improvement eased traffic delays and eliminated grade crossing accidents. The commercial district remains clustered along Pine Street, but now most of the buildings are constructed of masonry (mostly buff-colored brick) and many are much taller than the wooden buildings shown in the 1883 image. The early hotels are gone, replaced by others closer to the interstate highway more than a mile to the north of downtown and out of the photograph.

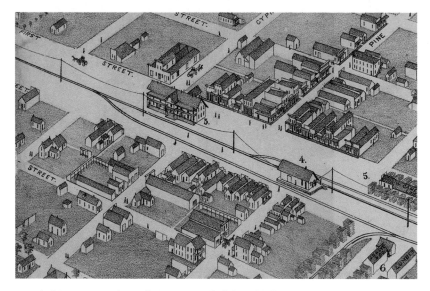

Detail of Augustus Koch, Bird's-Eye View of Abilene, Taylor County, Texas, *1883. Garrett Maps, UTA Library.*

In addition to portraying many historical aspects of Abilene's downtown area, such as its architecture and the types of businesses that existed, this aerial photograph reveals how modernization affects the look of a community. Like many other communities, Abilene has experienced remarkable growth since World War II, as proven by its current population of 115,930, fifty times what it was in 1883. From its early years in the 1880s to the present, then, Abilene has grown to fifty times its original population. And yet, looking down at the city today with a keen eye, we can still detect many vestiges from the past.

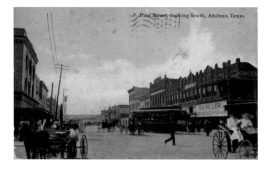

Postcard of Pine Street, Abilene, ca. 1920. Garrett Postcards, UTA Library.

Fane Downs, ed. *The Future Great City of West Texas: Abilene, 1881–1891.* Abilene: Richardson, 1981.

Katharyn Duff, with Betty Kay Seibt. *Catclaw Country: An Informal History of Abilene in West Texas.* Burnet, Tex.: Eakin Press, 1980.

Paul D. Lack, et al. *The History of Abilene.* Abilene, Tex.: McMurry College, 1981.

Juanita Daniel Zachry. *Abilene, the Key City.* Northridge, Calif.: Windsor Publications, 1986.

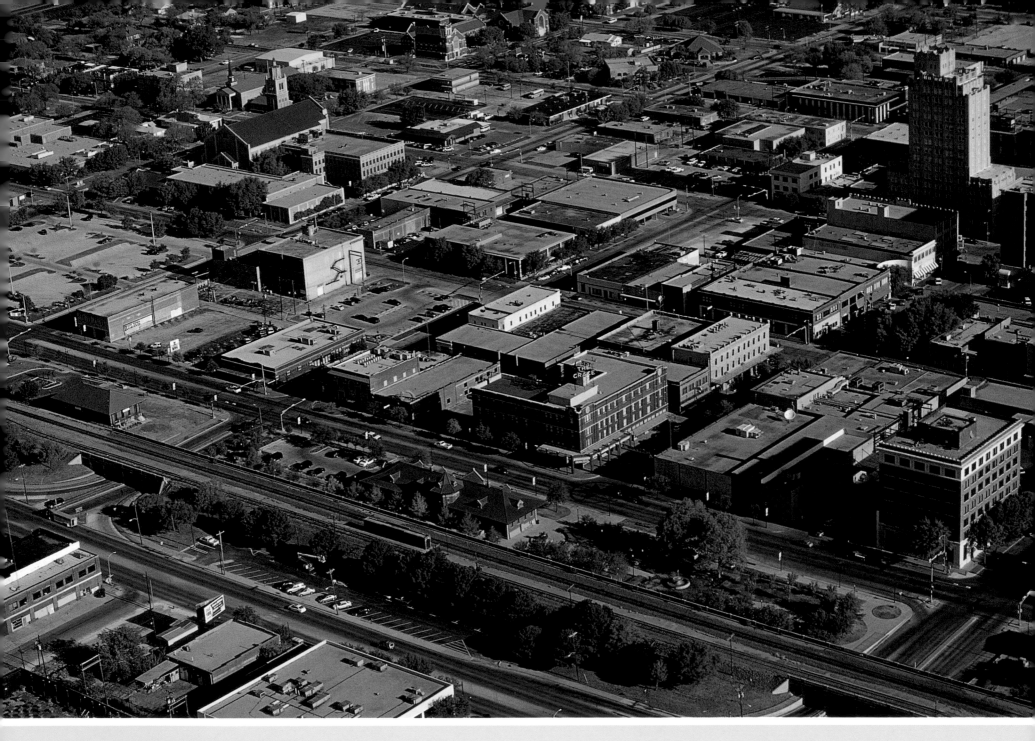

Aerial photograph of the Abilene town center,
13 April 2006, early morning, looking northwest.

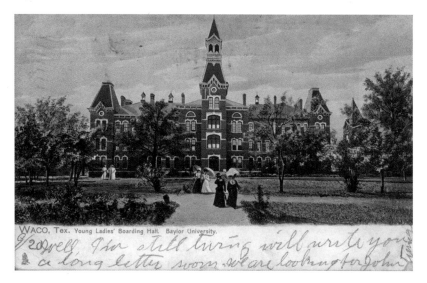

Postcard showing "Waco, Texas, Young Ladies' Boarding Hall, Baylor University," ca. 1910. Garrett Postcards, UTA Library.

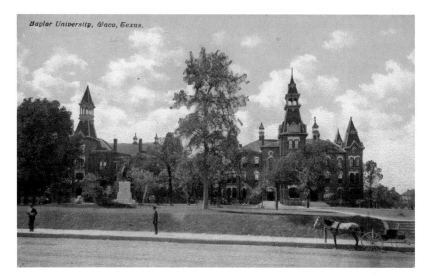

Postcard showing "Georgia Burleson Hall and 'Old Main,' Baylor University, Waco, Texas," ca. 1920. Garrett Postcards, UTA Library.

Baylor University, Waco

Like a number of towns and cities in Texas and across the United States, Waco sits on the site of an earlier Indian village. The modern city of Waco dates from the mid to late 1840s, when surveyors began laying out town sites along the Brazos River. By the late nineteenth century, Waco had become an important commercial center, known as the "Athens of Texas" because of its numerous educational institutions. Among the more than half a dozen of these was the Waco Classical School, which was founded in 1860 and became Waco University in 1861. About twenty-five years later, Waco University merged with Baylor University, which was founded in 1845 and moved from Dallas to Waco about forty years later. Baylor University has been called the oldest institution of higher education in Texas, although the Waco campus dates from the mid-1880s. Baylor is organized around a beautiful rectangular "quad" in the nineteenth-century tradition of college and university design. With its picture-postcard red brick buildings, the idyllic Baylor campus reminded people of the older Ivy League universities in the East. Its lush trees and beautiful landscaping made it seem like an oasis.

Baylor has always been a Baptist university and today is the largest Baptist institution of higher education in the world. Our aerial photograph reveals the original design of the campus and the impact of fairly recent growth. In the twentieth century, the university not only expanded outward, but also was forced to add on to buildings that increasingly impinged on the quad. The architects who designed the expansions

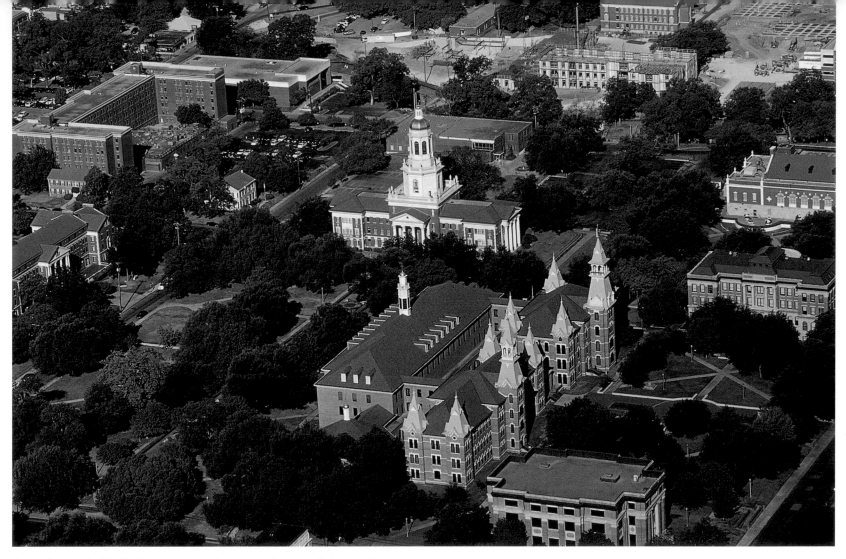

Aerial photograph of Baylor University, 8 October 2006, mid-morning, looking southeast.

attempted to preserve the historic style of the campus, but new construction occupies one of the streets that originally formed the border of the nineteenth-century quad. Our aerial view graphically reveals the impact of the growth of Baylor's student population—from several hundred occupying a few buildings in the 1880s, to more than 14,000 students who require about fifty buildings in 2009.

Eugene W. Baker. *To Light the Ways of Time: An Illustrated History of Baylor University, 1845–1986.* Waco, Tex.: Baylor University, 1987.

Kent Keeth. *Looking Back at Baylor: A Collection of Historical Vignettes.* Waco, Tex.: Baylor University, 1985.

The Story of Baylor University at Independence, 1845–1886. Waco, Tex.: Baylor University, 1986.

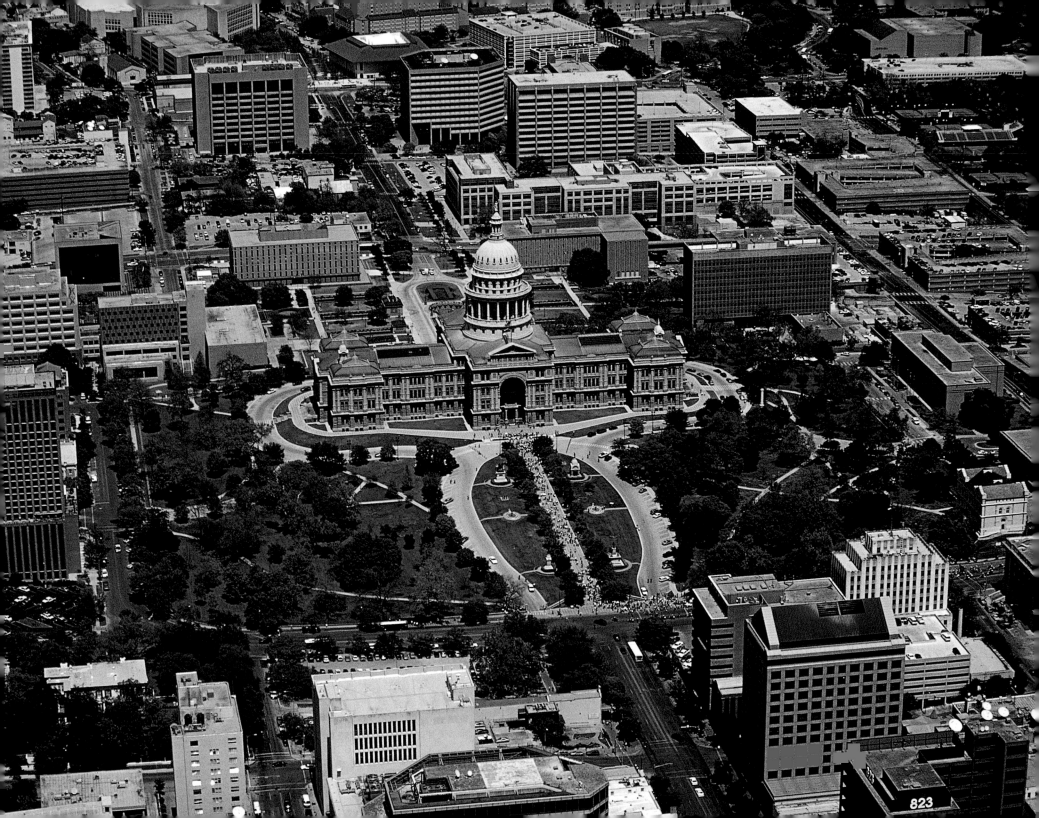

Capitol Building and University of Texas, Austin

This map of Austin was drawn in 1839 by W. H. Sandusky, a draftsman with the General Land Office, and shows "the whole site selected for the seat of government" of the Republic of Texas. Sandusky marks a large "capitol square," where the Texas State Capitol shown in our aerial photograph was eventually built between 1882 and 1888 out of pink granite (from Marble Falls) and limestone. The contractor was paid for the job with a huge grant of land in the Panhandle, which eventually became the XIT Ranch.

Just to the north of the area that he divided into building lots, Sandusky marks an area of land as a "cottage grove," which would one day be the site of the University of Texas at Austin. The "perspective of future development" shows that in 1933 planners imagined the campus would be rather like the University of California campus at Berkeley. But, like the Berkeley campus, the campus at Austin became enmeshed in a rapidly developing city with high-volume roads and huge, impersonal buildings. Austin today has come a long way from the rather charming, bucolic image from the 1930s.

Margaret Catherine Berry. *UT History 101: Highlights in the History of the University of Texas at Austin*. Austin: Eakin Press, 1997.

Curran Fletcher Douglass. *Austin Overview: A Guide to, and Souvenir History of, the City of Austin, Texas*. Austin: Eakin Press, 1995.

Richard A. Holland, ed. *The Texas Book: Profiles, History, and Reminiscences of the University*. Austin: The University of Texas Press, 2006.

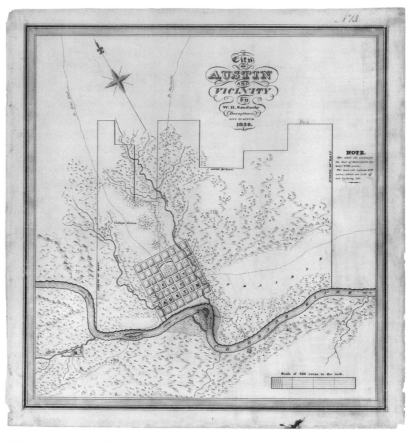

"The City of Austin and Vicinity" by W. H. Sandusky, 1839.

"Perspective of Future Development" of the Austin campus of the University of Texas, by Paul Philippe Cret, 1933, in Campus Master Plan (Austin: University of Texas, 1999).

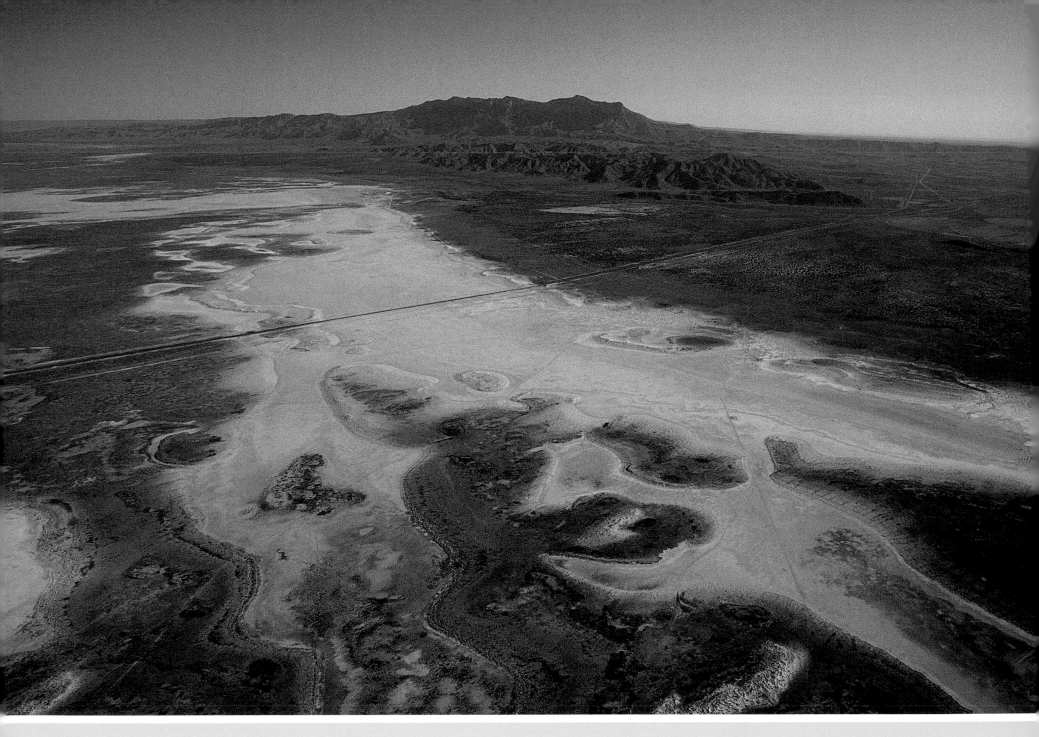

Aerial photograph of the salt flats, 11 May 2005, mid-morning, looking north in Hudspeth County.

Site of the Salt War, El Paso

The desolate area in this aerial photograph is part of the basin and range province of Texas. The mountains here (like the Guadalupe and Sierra Diablo) consist of fault blocks and receive more rain and snow than the low-lying areas. The run-off from these mountains drains into valleys that have no outlet to the sea. Thus, the bottoms of these valleys turn into lake beds called *playas* (Spanish for "beaches") that are usually dry due to the arid climate. Evaporation pulls mineral-rich groundwater from aquifers in this area, leaving a residue of salts such as gypsum and halite (common table salt). This salt was an important commodity in frontier times, when it was mined (actually just collected from the surface), shipped by wagon to San Elizario, southeast of El Paso, and sold as a preservative and seasoning.

This sounds straightforward enough, but the process reached a flash point when the catalyst—free salt for the taking—was denied to those who harvested it there. The result became known as the El Paso Salt War of 1877, also known as the San Elizario Salt War. This conflict began in the late 1860s as a partisan struggle over control of the salt resources from *playas* about 100 miles east of El Paso and continued in several phases for more than a decade. Those who advocated privatization of the salt deposits tended to be Republican, while their opponents, often Democrats, favored public ownership and use of the salt.

Emotions and passions about the issue ran high, and various acts of violence culminated in 1877 with several murders. After these incidents, no one continued to oppose paying for the salt collected near El Paso; the "free" resources of the early frontier days were things of the past as the salt

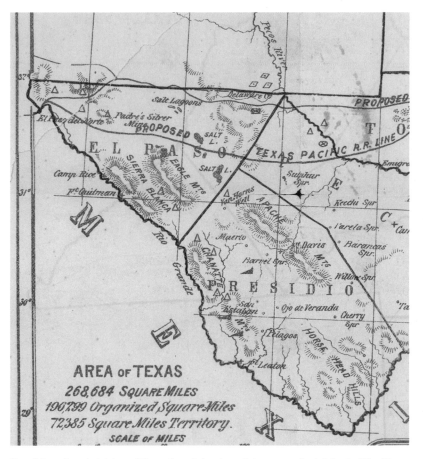

Detail from Roessler's Map of Texas *(1874) showing salt lagoons and salt lakes in West Texas. Garrett Maps, UTA Library.*

beds became private land whose owners charged fees for their use. The entire issue became moot when commercial salt became readily available in the twentieth century.

C. L. Sonnichsen. *The El Paso Salt War, 1877.* El Paso, Tex.: C. Hertzog, 1961.

Owen P. White. *Out of the Desert: The Historical Romance of El Paso.* El Paso, Tex.: McMath, 1924.

Industrial Ghost Town, Thurber

To motorists driving along Interstate 20 about halfway between Fort Worth and Abilene, the townsite of Thurber appears as little more than a tall smokestack and a few buildings near the central plaza. A century ago, however, Thurber was home to about 6,000 people, most of them coal miners and brick plant workers. Thurber was a classic company town, owned lock, stock, and barrel by the Texas and Pacific Coal Company. Thurber's diverse population of Poles, Italians, Czechs, African-Americans, Mexican-Americans, and others lived in separate neighborhoods. The Thurber mines were located some distance from the plaza, so miners rode the company's railroad to work. This railroad also shipped coal out of town via the Texas and Pacific Railway (no relation to the coal company of the same name) main line at Mingus Junction, 1½ miles north of Thurber. The bituminous coal mined here fueled trains, power plants, and breweries. The huge Thurber brickyard stood just east of the plaza, and Thurber brick was used for buildings and highways.

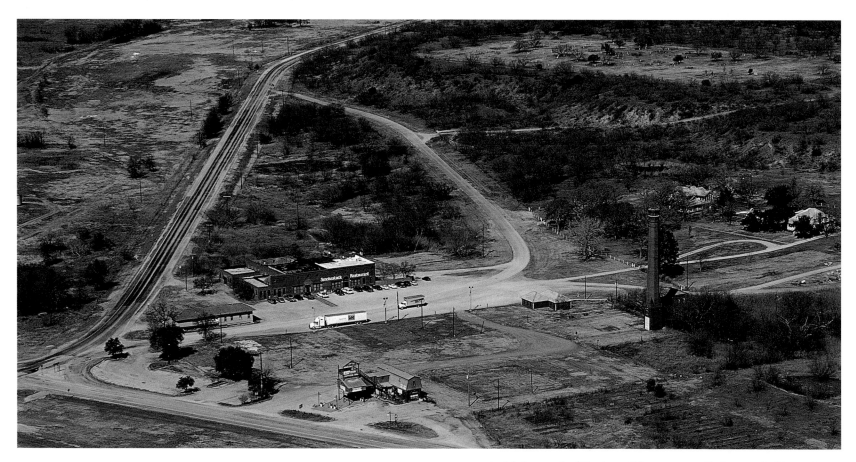

Aerial photograph of Thurber, 4 February 2003, mid-afternoon, looking northwest.

As we can see in this historical photograph, the Thurber plaza was a hub of activity. The company's dry goods store, general offices, and power plant stood here. The company railroad line ran alongside the plaza, and the rest of the town consisted of hundreds of small, wood-framed company houses. When coal mining ended in the 1920s as petroleum became more plentiful, and cheaper, and the brick plant closed in the 1930s, these homes were sold and Thurber became a ghost town. Its population now only numbers about a dozen rather than thousands.

As seen in this 2003 aerial photo, the area around Thurber plaza is all that remains of the town. The prominent smokestack looms above the east side of the plaza, which is flanked on the north by the red brick dry goods store (now the Smokestack Restaurant). The long rectangular building on the west edge of the plaza is a railroad depot. It was not originally located here, but was moved from the nearby town of Strawn about ten years ago to create a sense of history. Similarly, the industrial-looking metal building just south of the smokestack is actually an abandoned service station designed to look like a coal mine. The town of Thurber once had about a dozen separate mines, but their buildings were removed long ago. East of the plaza stand a few of the finer company-owned houses (managers' homes). The Thurber cemetery lies on a hilltop to the north; like the town once did, it has separate sections for various ethnic populations. To the south of the interstate highway (bottom, just out of the picture) is a part of Thurber called New York Hill and the W. K. Gordon Center, a museum of Texas industrial history.

Richard Francaviglia. "Black Diamonds & Vanishing Ruins: Reconstructing the Historic Landscape of Thurber, Texas." *Mining History Journal* (1995): 51–62.

Mary Jane Gentry. *The Birth of a Texas Ghost Town: Thurber, 1886–1933.* College Station: Texas A&M University Press, 2008.

Weldon B. Hardman. *Fire in a Hole!* Lim. ed. Gordon, Tex.: Thurber Historical Association, 1991. First published 1975.

Marilyn D. Rhinehart. *A Way of Work and a Way of Life: Coal Mining in Thurber, Texas, 1888–1926.* College Station: Texas A&M University Press, 1992.

John S. Spratt, Sr. *Thurber, Texas: The Life and Death of a Company Coal Town.* Edited by Harwood P. Hinton. Austin: University of Texas Press, 1986.

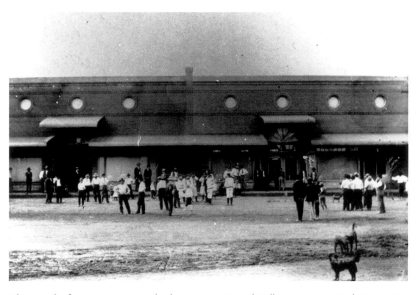

Photograph of company store in Thurber, ca. 1915. Special Collections, Texas Tech University.

Map of Thurber, 1920, by the Texas and Pacific Coal Company. Special Collections, UTA Library.

Mercury Mining Town, Terlingua

Located in Big Bend country in far West Texas, Terlingua is a ghost town whose life once depended on mercury mining. The Terlingua seen in this photo is actually the last of three towns to bear that name. The ghost town is normally home to only about fifty people, but every November thousands of people descend on the area for its annual chili cook-off.

Just after the turn of the twentieth century, Terlingua became a major producer of quicksilver, a common name for mercury (which was used in gold mining to separate gold from powdered ore, medicines, and chemicals). The mercury ore mined here is called cinnabar (mercury sulfide), a bright red mineral found in this area's limestone. Miners would carry the ore to the surface, where it was crushed and the mercury was driven from it in furnaces. The piles of grayish material scattered about in the photograph are forty years worth of crushed waste rock from which the mercury has already been extracted. Such dumps and tailings are typical of mining districts, but are made all the more obvious here by the sparse vegetation in this extremely arid area.

Howard E. Perry established the Chisos Mining Company in 1902 as one of the most secretive companies to ever operate in Texas. This isolation worked in Perry's favor, as it has been reported that his employees worked in exceedingly difficult conditions. The ruins of Perry's pre-1910 "mansion," as locals call it, still stand at Terlingua, at the center of our photo. The foundations of the Perry School and the ruins of its furnaces are the only other remnants of a town that produced mercury until the bankruptcy of the mining company in 1942. Terlingua featured two segregated

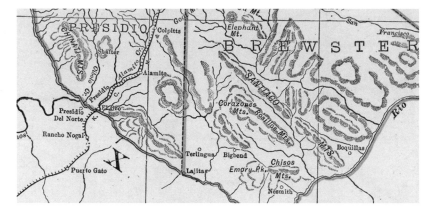

Detail of Texas map from the Doubleday, Page, & Co. Geographical Manual and New Atlas *(1918) showing the location of Terlingua, Brewster County. Garrett Maps, UTA Library.*

sections: the west side where the Anglos lived near Perry's mansion, and the Mexicans' side, east of the company store. A cemetery, not pictured, still holds the graves of Mexican miners.

Now that its old mine shafts are cemented over and their head frames are gone, Terlingua is a forlorn site indeed. Who would guess from these ruins that Terlingua produced forty percent of the nation's mercury in 1922? Interestingly, the only buildings still used in Terlingua are the old company store (now a gift shop and art gallery) and the old movie theater (now a dinner theater).

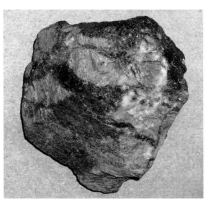

A two-square-inch specimen of cinnabar, a mercury sulfide which is commonly called "red mercury ore" and occurs in limestone at Terlingua, Texas (Richard Francaviglia).

T. Lindsay Baker. *Ghost Towns of Texas.* Norman: University of Oklahoma Press, 1986.

Richard Francaviglia. *Hard Places: Reading the Landscape of America's Historic Mining Districts.* Iowa City: University of Iowa Press, 1991.

Kenneth B. Ragsdale. *Quicksilver: Terlingua and the Chisos Mining Company.* College Station: Texas A&M University Press, 1976.

Trent Jones and Carlton Stowers. *Where the Rainbows Wait: The Remarkable Lessons Taught and Learned in a One-room Texas Schoolhouse.* Chicago: Playboy Press, 1978.

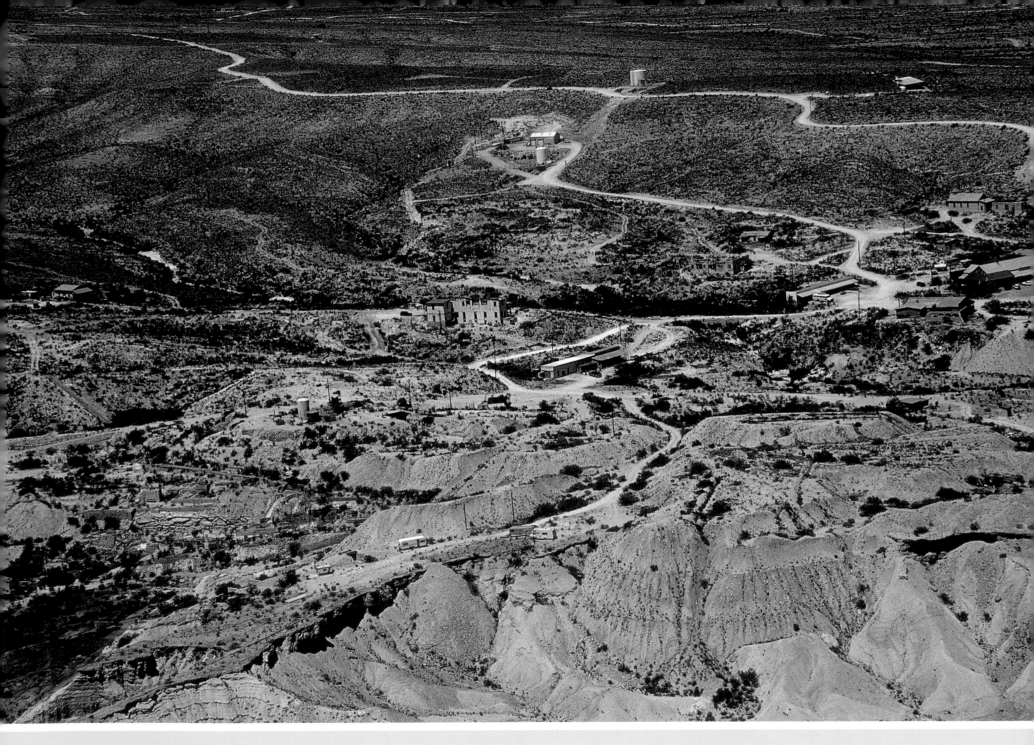

Aerial photograph of Terlingua mining area, 11 April 2005, midday, looking northeast in Brewster County.

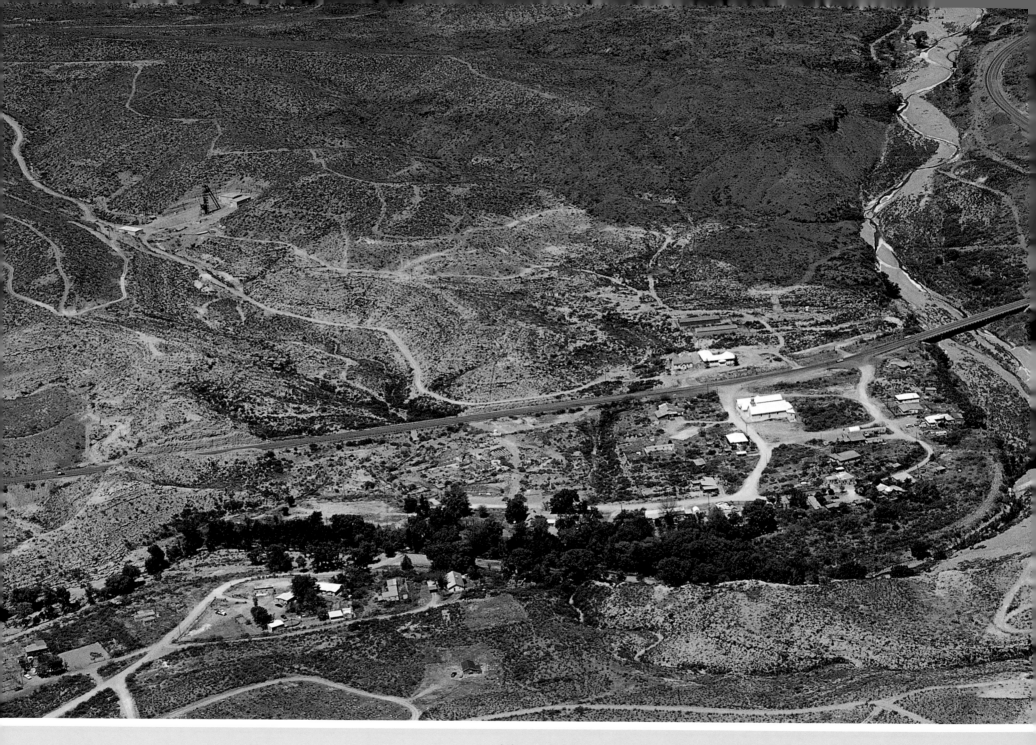

Aerial photograph of Shafter mining area, 11 April 2005, midday, looking northwest in Presidio County.

Silver Mining Town, Shafter

Rumors of a silver mine in central Texas permeated the nineteenth century. Although such a mine was never found, and perhaps never even existed, Texas did produce a bona fide silver mining town. Shafter, located along Cibolo Creek near the Chinati Mountains in south central Presidio County, is the only Texas silver mining town similar to those in New Mexico or Arizona, and the first significant mining town in West Texas. The rancher John W. Spencer first discovered silver ore in 1880 and showed it to Colonel William Shafter for confirmation. After having the ore assayed, Shafter convinced other Fort Davis military officers in the area to purchase the land and then lease it to the Presidio Mining Company in 1882. Eventually these holdings became the town of Shafter. Because virtually all the land in the area belonged to a few of the officers and their wives, Shafter did not attract the usual assortment of prospectors. Rather, Mexican-American, African-American, and Californian miners worked for the Presidio Mining Company. The mines were scattered about the area, and an aerial tramway hauled some of the ore to a substantial mill where ore was crushed and processed. The Shafter post office opened in 1885 and the company store by 1900, when the town's total population was 110.

By 1942, a shortage of miners forced the mines to close. Detailed records are scarce, but it was reported in the popular and mining presses that the Shafter mine produced $20,000,000 worth of silver (30,972,286 ounces) and over 2,000,000 tons of lead. As you can see in our aerial photograph, today Shafter is a collection of about 45 adobe and stone buildings, many of which date from the boom period. Still prominent today are the church, the former post office, and the adobe two-story Shafter mercantile store.

A geological cross-section of the Shafter Silver Mine District by J. A. Udden (1904) shows the Cibolo limestone and Shafter beds in the upper portion of a column of varied sedimentary rocks. From J. A. Udden, The Geology of the Shafter Silver Mine District, Presidio County, Texas (*Austin: Von Boeckmann-Jones, State Printers, 1904*).

Paul H. Carlson. "The Discovery of Silver in West Texas." *West Texas Historical Association Yearbook* 54 (1978):55–64.

Richard Francaviglia. *Hard Places: Reading the Landscape of America's Historic Mining Districts.* Iowa City: University of Iowa Press, 1991.

Cecilia Thompson. *History of Marfa and Presidio County, Texas, 1535–1946.* 2 vols. Austin: Nortex Press, 1985.

J. A. Udden. *The Geology of the Shafter Silver Mine District, Presidio County, Texas.* Austin: Von Boeckmann-Jones Company, State Printers, 1904.

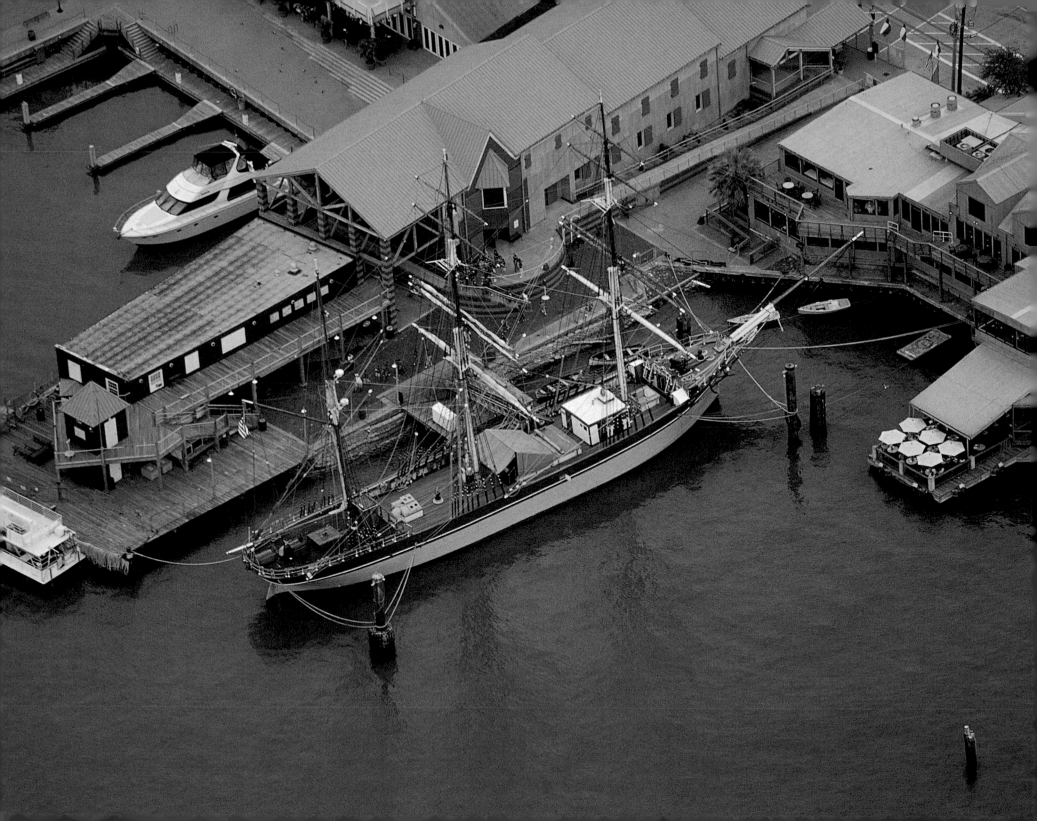

The *Elissa*, Galveston

These days, the *Elissa* resides at the Texas Seaport Museum, Pier 21 in Galveston most of the year as a testament to her 130 years of maritime history. More than a historical relic of the past, the fully functioning ship sails annually and is carefully maintained by a dedicated crew of volunteers and sailing enthusiasts.

She is a three-masted, iron-hulled sailing ship built in 1877 in Aberdeen, Scotland, by Alexander Hall & Company. She has nineteen sails and technically is considered a *barque* because she carries square and fore-and-aft sails on her foremast and mainmast but only fore-and-aft sails on her mizzenmast. She measures 205 feet from stem to stern, and almost 100 feet in height at the mainmast. Her name comes from the Roman epic poem *The Aeneid*, which tells of a Phoenician princess named Elissa who fled from Tyre to Africa and founded Carthage.

The *Elissa* began service as a British trading ship near the end of the "Age of Sail." She carried small cargoes around the world, even to and from Galveston. During her long history she sailed under many flags, had many names and owners, and underwent numerous renovations and changes. In 1975 the Galveston Historical Foundation purchased the *Elissa* from Canadian interests headed by David Groos for $40,000, and by 1982 had restored her to her past glory, winning the ship and the foundation awards and accolades.

In 2000 the ship was designated one of "America's Treasures" by the National Trust for Historic Preservation. Every year the ship comes to life on the open seas when her volunteer crew sails her around the Gulf of Mexico to ensure her seaworthiness. The sight of her tall, billowing sails is something to behold.

Patricia Bellis Bixel. *Sailing Ship* Elissa. Photography edited by Jim Cruz. College Station: Texas A&M University Press, 1998.

Richard V. Francaviglia. *From Sail to Steam: Four Centuries of Texas Maritime History, 1500–1900.* Austin: University of Texas Press, 1998.

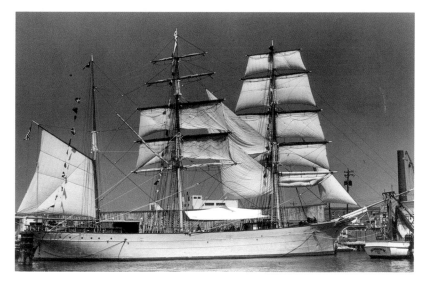

The Elissa *fully restored, 1982. Photograph Collection, UTA Library.*

Saint Peter's Church, Boerne

In 1849 a group of German colonists moved to Texas and in 1852 laid out a town-site and named it after Ludwig Boerne, a German author. For the many Catholics among these settlers, the bishop of Galveston sent a new young deacon, Emil Fleury, to establish a congregation there in 1866. Fleury built the little church immediately to the right of the parking lot in our photograph. Boerne quietly flourished for many years as both a health resort and an agricultural center for commodities such as cotton, wool, and grain.

By the 1920s, the little church had become too small, so in 1923 the parishioners of Saint Peter's built a splendid new church, modeled after a church from a San Antonio mission. Its façade may be seen in our aerial photograph and in our closer view from the ground. Boerne continued to grow after World War II, spurred by medical and educational institutions, and in about 2000 the parishioners decided to add the very large extension seen on our aerial photograph. This extension was not well received by conservation groups, and it is indeed very large and prominent. But the aerial sight of the three structures together, each one considerably larger than the last, could serve as an architectural summary of the history not only of Saint Peter's, but also of churches of a variety of denominations in Texas towns.

In spite of two world wars against Germany, Boerne has tenaciously clung to some of its German traditions. The town's *Gesangverein*, or singing club, disbanded in 1977, but it would seem at the time of writing that the shooting club and the village band still survive.

Kendall County Historical Commission, ed. *A History of Kendall County, Texas: Rivers, Ranches, Railroads, Recreation.* Dallas, Tex.: Taylor Pub. Co., 1984.

Garland A. Perry. *Historic Images of Boerne, Texas.* Boerne, Tex.: Perry Enterprises, 1982.

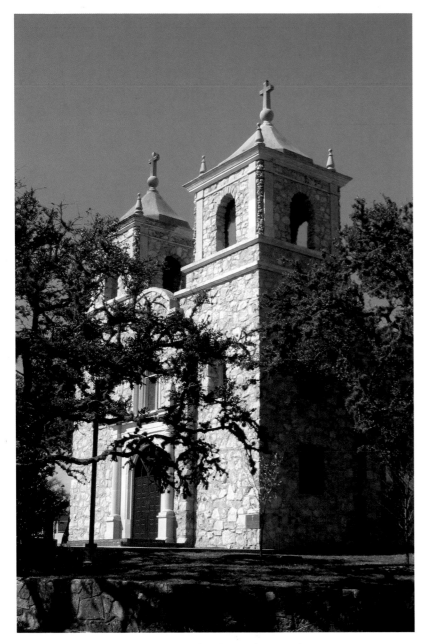

Photograph of the façade of Saint Peter's Church (David Buisseret).

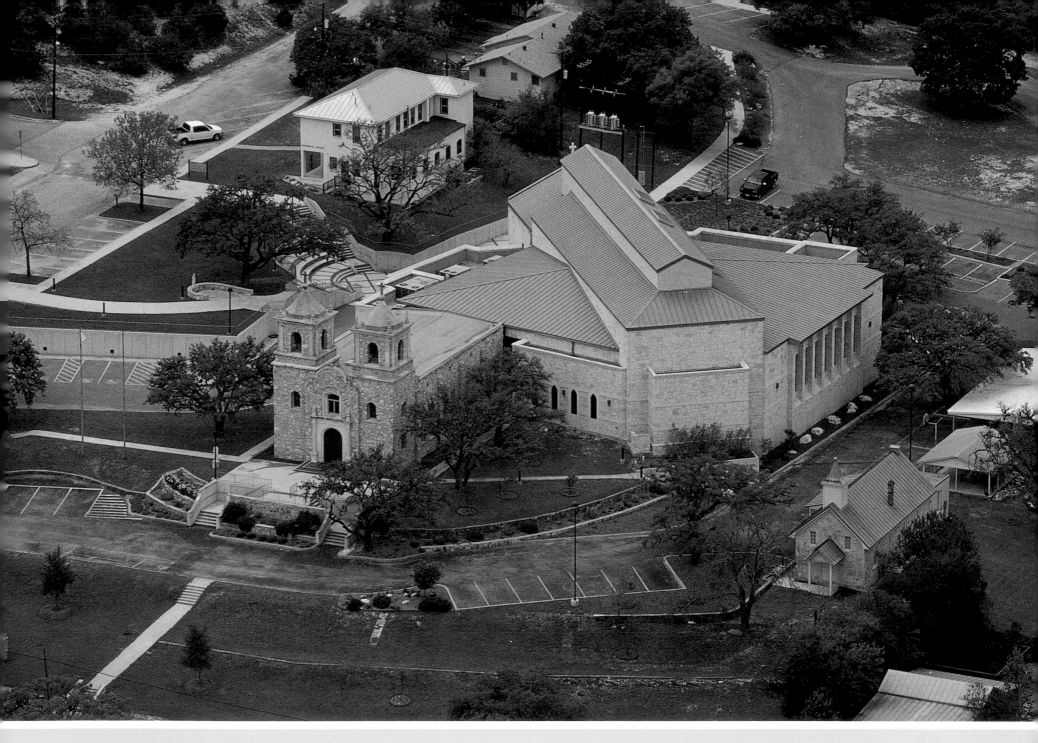

Aerial photograph of Saint Peter's Church, Boerne,
11 April 2006, midday, looking west.

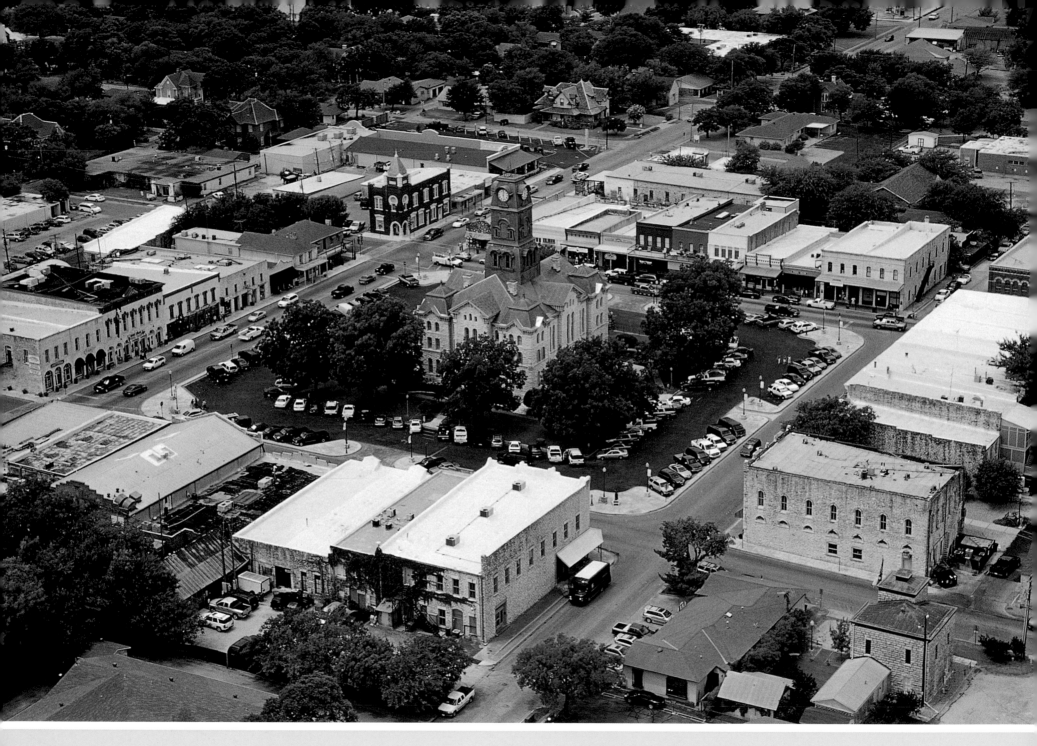

Aerial photograph of Granbury Square, 28 July 2005, midday, looking northwest.

Courthouse Square, Granbury

The significance of becoming a county seat is beautifully revealed in the aerial photo of Granbury. The historic Hood County Courthouse, which was completed in 1875, crowns this community's downtown. The courthouse, which is built of Brazos limestone, occupies one complete block of the town, which was platted to feature a courthouse square. Consider this town's layout as a microcosm of the larger world: The courthouse square is central to the town, just as Granbury is more or less centered within the boundaries of Hood County. Commercial buildings face inward on all four sides of the square, reminders of the importance of the courthouse in the affairs of the town and the county.

When it was laid out in 1866, Granbury was one of many towns on the western frontier to feature the "Shelbyville square" plan, as previously discussed in the "Main Square, San Marcos" section. However, modernization from the 1930s to the 1950s often replaced the lawn of the courthouse square with automobile parking in Texas towns, and that is the case here. Note that about 150 cars and pickup trucks are parked near the Hood County Courthouse where lawn and trees once existed—a reminder that the automobile consumes considerable space even in small towns like Granbury. Note, however, that Granbury's courthouse remains a gem of Victorian architecture; many towns unfortunately replaced or remodeled their historic courthouses in the 1950s and 1960s, before historic preservation became such an important factor following the passage of the Historic Preservation Act of 1966. In Granbury, large trees flanking the courthouse help downtown retain its historic character. So do the historic homes and lush shade trees located just a block from the square.

Thanks to a growing sense of history and appreciation of historic buildings, Granbury's charming courthouse square has become a destination for twenty-first-century tourists. Antique shops and cafes now flourish next to more traditional county seat services like attorneys' offices and pharmacies. In our aerial photo of Granbury, the state highway along the

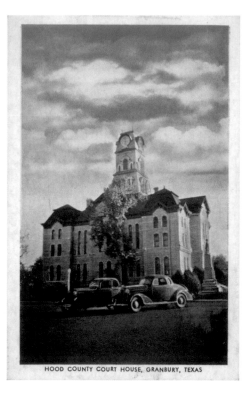

Postcard of Hood County Courthouse, Granbury, ca. 1935. Garrett Postcards, UTA Library.

HOOD COUNTY COURT HOUSE, GRANBURY, TEXAS

left side of the square and the United Parcel Service truck in the lower center remind us that a town can still retain considerable historical character while serving the needs and expectations of people in the early twenty-first century.

Michael A. Andrews. *Historic Texas Courthouses*. Albany, Tex.: Bright Sky Press, 2006.

Richard V. Francaviglia. *Main Street Revisited: Time, Space, and Image Building in Small-Town America*. Iowa City: University of Iowa Press, 1996.

C. L. Hightower, Sr., ed. *Hood County History in Picture and Story, 1978*. Fort Worth, Tex.: Historical Publishers, 1978.

Terry G. Jordan-Bychkov. *The Upland South: The Making of an American Folk Region and Landscape*. Santa Fe, N.M.: Center for American Places, 2003.

Edward T. Price. "The Central Courthouse Square in the American County Seat." *Geographical Review* 58, no. 1 (January 1968): 29–60.

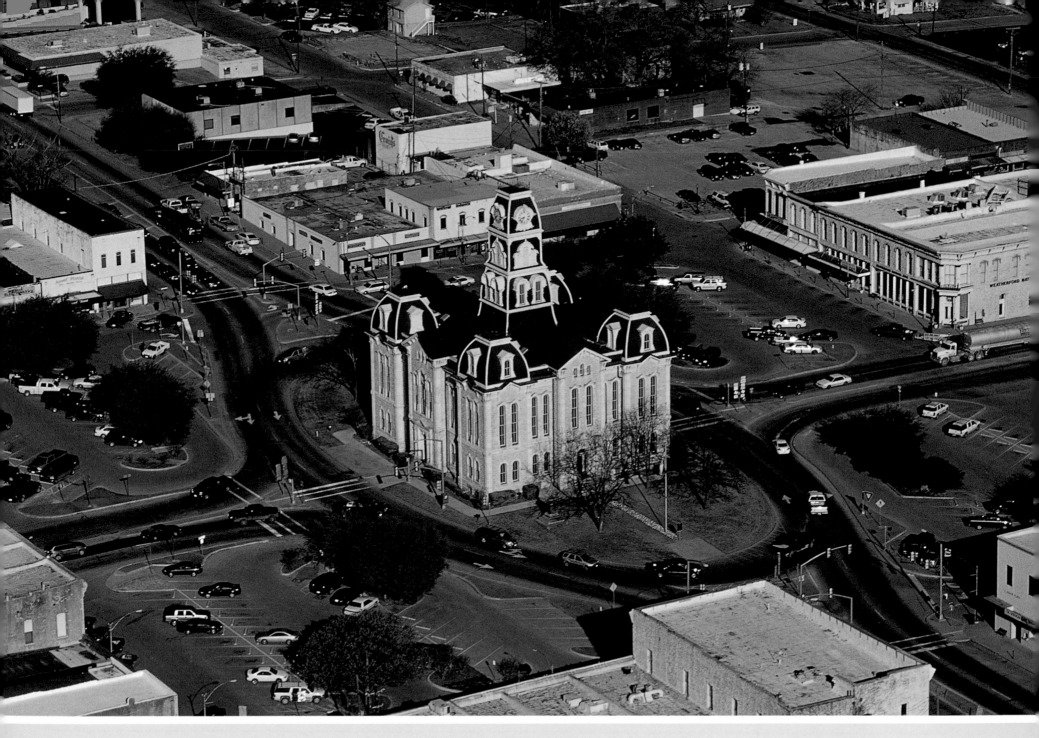

Aerial photograph of the Weatherford courthouse, 11 March 2005, early morning, looking northwest.

Courthouse Square, Weatherford

Located at the crest of a low divide between the Trinity and Brazos Rivers, the historic town of Weatherford was incorporated in 1858 midway between Fort Worth and Fort Belknap. Weatherford, the Parker County seat, boasts one of Texas's classic Victorian-era courthouses. The Parker County Courthouse is the tallest building in town and stands on relatively high ground, which helps show off its Second Empire–style architecture. As we can see from the air, the courthouse is positioned on a piece of land around which all traffic must travel. No matter how one enters downtown, the courthouse appears to sit in the middle of the street and arrests the view of residents and travelers alike.

Like many features of the Texas landscape, Weatherford's town plan originated elsewhere, probably in the southern United States or perhaps central Pennsylvania. Its unusual town plan is called a "four-block" arrangement in which an open square is created by cutting a corner off each of the four blocks of the center of the town.

To quote an urban geographer, "the Weatherford courthouse retains its position in the center of a four-block space, but most of the space is now devoted to parking lots and traffic central islands for the two major highways that converge on the square" (Veselka, p. 53). Our bird's-eye view indeed reveals a sea of asphalt surrounding the courthouse. The curved roads have considerably rounded off the corners of the original land blocks, so the courthouse now appears to stand on an island.

The courthouse represents the importance of the county government in town and highway growth, and continues to dominate downtown in the twenty-first century.

John S. Grace and R. B. Jones. *A New History of Parker County*. Weatherford, Tex.: Parker County Historical Association, 1987. First published 1906 by Democrat Pub. Co.

Robert E. Veselka. *The Courthouse Square in Texas*. Edited by Kenneth E. Foote. Austin: University of Texas Press, 2000.

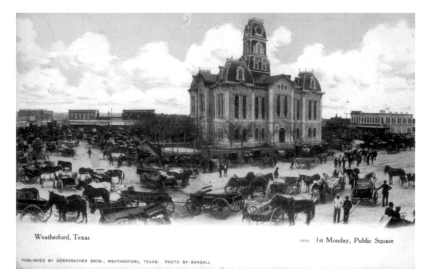

Postcard showing the Parker County Courthouse, Weatherford, ca. 1910. Garrett Postcards, UTA Library.

6

TEXAS IN THE
TWENTIETH CENTURY

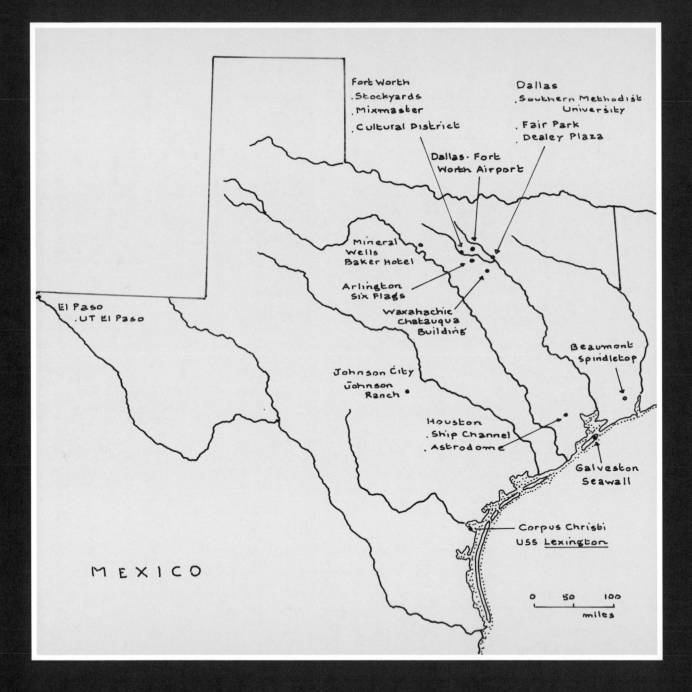

Fort Worth
. Stockyards
. Mixmaster
. Cultural District

Dallas
. Southern Methodist
 University
. Fair Park
 Dealey Plaza

Dallas · Fort
Worth Airport

Mineral
Wells
Baker Hotel

Arlington
Six Flags

Waxahachie
Chatauqua
Building

El Paso
. UT El Paso

Beaumont
Spindletop

Johnson City
Johnson
Ranch

Houston
. Ship Channel
. Astrodome

Galveston
Seawall

Corpus Christi
USS Lexington

MEXICO

0 50 100
miles

INTRODUCTION

Ever since the American War of Independence it was clear that states like New York, Pennsylvania, and Virginia would become populated and rich, rivaling and often surpassing the great provinces of Europe. The subsequent development of the Old Northwest—which grew into the powerful states of Indiana, Illinois, and Minnesota—meant that this new union would be of a size and power an order of magnitude larger than its European progenitors.

The addition of the territories acquired from Mexico after the Mexican-American War of 1846–1848 simply confirmed the great scale of the United States. As time went by, two of these formerly Mexican states, California and Texas, outstripped many of the union's earlier states in wealth and population. This last chapter comments on this development. In some ways, Texas has not kept pace with California, but most people would agree that its global persona is more distinctive.

Curiously, the idea of Texas largely focuses on the images of the cowboy and the ranch, even though these do not represent the twentieth century's most

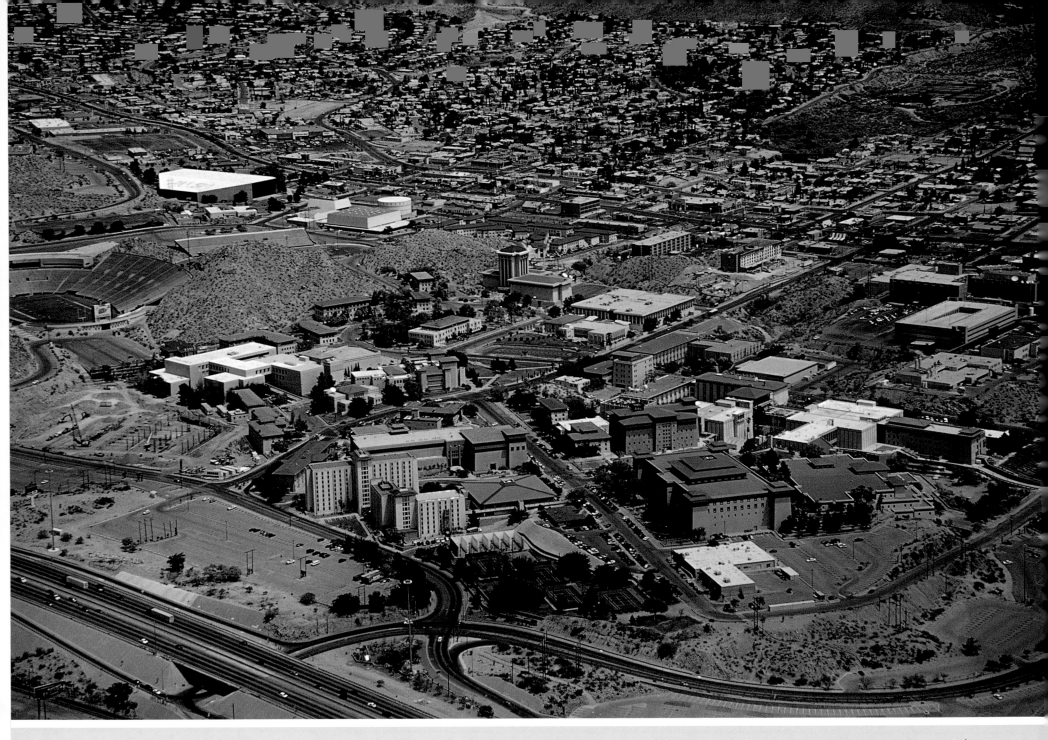

Aerial photograph of the campus of the University of Texas at El Paso, 7 May 2006, midday, looking northwest.

The University of Texas at El Paso

The International Mining Convention of 1903 was held at El Paso, which was the site of a huge copper smelter responsible for the Southwest's booming copper mining economy. At the convention, a geologist from the University of Texas at Austin suggested a school of mines be formed in El Paso. The Texas School of Mines and Metallurgy opened near Fort Bliss in 1914, but a fire destroyed most of the buildings in 1917. That year, El Paso's civic leaders donated land and the school reopened on a mesa just north of downtown El Paso, where it grew into the University of Texas at El Paso (UTEP).

In a state with many beautiful college and university campuses, UTEP has no peer. Its stunning buildings are rendered in the Bhutanese style of architecture from the Himalayas, which features bold horizontal lines and spreading rooflines; many of the buildings feature clerestories or cupolas, all of which are capped by red-tiled roofs that provide a campus-wide architectural uniformity rare on college campuses. Mrs. S. H. Worrell, the first dean's wife, suggested the Bhutanese style. Noted El Paso and Tucson architect Henry C. Trost executed Worrell's vision on the earliest buildings, and subsequent architects have continued the Bhutanese tradition. This gives UTEP an unusual quality—architecture that is integrated over time rather than fragmented by current fads.

Lloyd C. Engelbrecht and June-Marie F. Engelbrecht. *Henry C. Trost, Architect of the Southwest*. El Paso, Tex.: El Paso Public Library Association, 1981.

Francis Fugate. *Frontier College: Texas Western at El Paso: The First Fifty Years*. El Paso, Tex.: Texas Western Press, 1964.

Charles H. Martin and Rebecca M. Craver, eds. *Diamond Days: An Oral History of the University of Texas at El Paso*. El Paso, Tex.: Texas Western Press, University of Texas at El Paso, 1991.

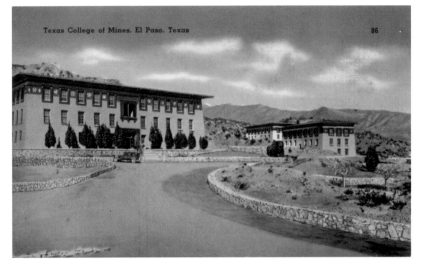

Postcard showing the Texas College of Mines, El Paso, ca. 1920. Garrett Postcards, UTA Library.

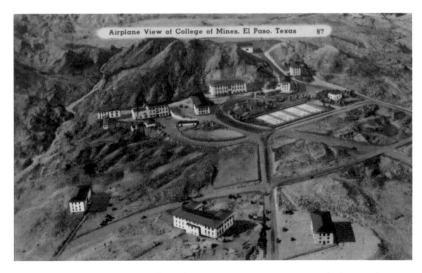

Aerial postcard view of Texas College of Mines, ca. 1920. Garrett Postcards, UTA Library.

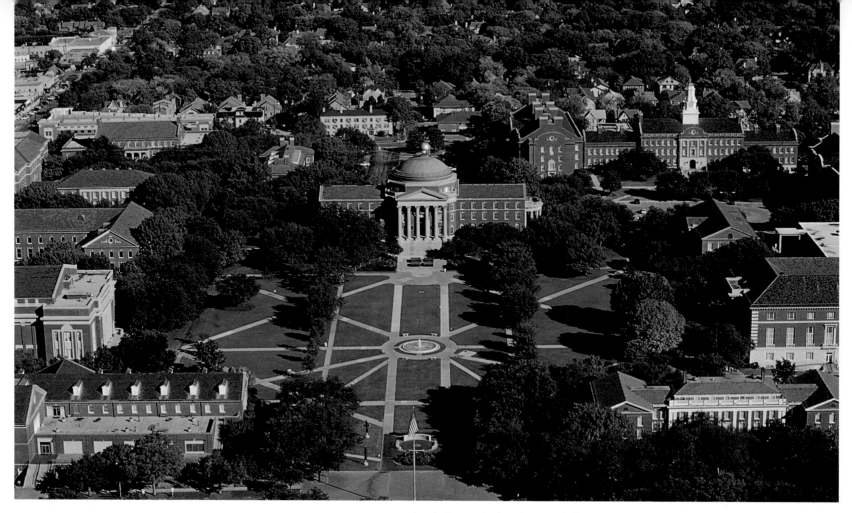

Aerial photograph of Southern Methodist University, 28 October 2006, mid-morning, looking north.

Southern Methodist University, Dallas

Those familiar with colonial architecture often comment that the Southern Methodist University campus in Dallas reminds them of Thomas Jefferson's Monticello, or even the University of Virginia campus, which Jefferson also designed. They are correct in that Jefferson's designs inspired generations of architects who followed, including the original designers of SMU's beautiful campus. This type of design creates an impression of grand openness while accentuating individual buildings that fade to open space.

SMU represented the latest in formal architecture when it was built in 1915. The private university is a jewel in the crown of the United Methodist Church's system of higher education. But the citizens of Dallas also supported SMU, donating $300,000 to secure the university in their city.

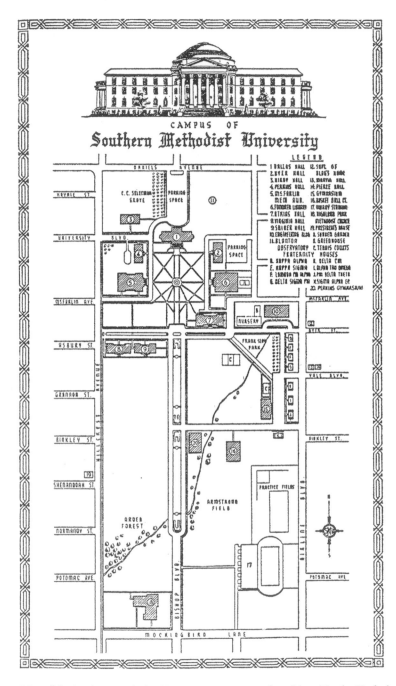

Map of the Southern Methodist University campus, 1940 from Mary Martha Hosford Thomas, Southern Methodist University: Founding and Early Years (Dallas: SMU Press, 1974), reproduced with permission, Southern Methodist University.

As our aerial photo reveals, SMU's campus is symmetrical, with the long quad faced by classically styled buildings, with the Monticello-inspired Dallas Hall as the dot under the exclamation point.

Clockwise from lower left in the picture are McFarlin Memorial Auditorium (1926), Perkins Administration Building (1925), Dallas Hall (1915), Hyer Hall (1927), and Fondren Library (1940). These make up the nucleus of the SMU campus, which now has grown to serve 11,000 students. Due to its growth and involvement with the national and international community, SMU was recently named as the site of the George W. Bush Presidential Library and Archives.

Marshall Terry. *"From High on the Hilltop . . .": A Brief History of SMU.* Dallas, Tex.: Southern Methodist University, 1993.

Mary Martha Hosford Thomas. *Southern Methodist University: Founding and Early Years.* Dallas, Tex.: Southern Methodist University Press, 1974.

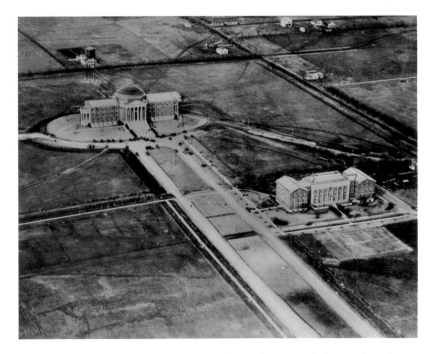

Southern Methodist University, Dallas, aerial photograph, ca. 1920, looking north-northeast, reproduced with permission, Southern Methodist University.

Chautauqua Auditorium, Waxahachie

The unusual eight-sided building at the center of our aerial photograph is the Chautauqua Auditorium in Waxahachie. The auditorium's architecture is not only functional, but its octagonal form can also be traced to nineteenth-century architect Orson S. Fowler, who believed that eight-sided buildings fostered a cultured and spiritual atmosphere. Situated by Waxahachie Creek on the western edge of town, the auditorium was built in 1902 as part of the Chautauqua movement. Waxahachie at that time was a town of about 4,000 people in the middle of a thriving cotton-producing area. Also in 1902, Trinity University moved to Waxahachie, where it operated until 1942.

The Chautauqua movement originated in the state of New York with the goal of enlightening participants through education. It was originally associated with the Methodist church, although a Presbyterian minister organized the Chautauqua Association in Waxahachie. The auditorium was a perfect setting for Chautauquas. It could hold 2,500 people under its high roof, and for two weeks each July hosted programs including religious education, secular instruction, and evening entertainment. Families would come in from the countryside and camp by the river in the nearby park so that they could attend the events. The building's large, wooden windows could slide up into the ceiling to let in additional light and fresh air. Sometimes so many people attended the sessions that they stood or sat outside in front of the window areas to listen.

The Chautauqua movement lasted until the 1930s when radio, movies, and automobiles became generally available, although these new types

Postcard of the Chautauqua Auditorium, Waxahachie, ca. 1905. Garrett Postcards, UTA Library.

of entertainment often lacked the moral purpose that had marked the Chautauqua programs. The elegant, tent-like Chautauqua Auditorium at Waxahachie survived the years well. It was restored in 1976 in honor of the national bicentennial. A rare survivor, it is still used for a variety of functions, including concerts by the Fort Worth Symphony Orchestra.

Kathleen Crocker and Jane Currie. *Chautauqua Institution, 1874–1974*. Charleston, S.C.: Arcadia Publishing, 2001.

Orson S. Fowler. *A Home For All, or, The Gravel Wall and Octagon Mode of Building*. New York: Fowlers and Wells, 1854.

Jeffrey Simpson. *Chautauqua: An American Utopia*. New York: Harry N. Abrams in association with the Chautauqua Institution, 1999.

John E. Tapia. *Circuit Chautauqua: From Rural Education to Popular Entertainment in Early Twentieth Century America*. Jefferson, N.C.: McFarland & Co., 1997.

Aerial photograph of the Chautauqua Auditorium at Waxahachie, 4 February 2003, mid-morning, looking southwest.

Aerial photograph of Spindletop, 27 November 2007, late afternoon, looking east.

Spindletop, Beaumont

Every schoolchild in the Lone Star State learns the story of Spindletop in seventh-grade Texas history. On 10 January 1901, Captain Anthony F. Lucas's discovery of oil under a small hill south of Beaumont essentially jump-started the modern petroleum industry. For close to a decade before the discovery, geologists and others had drilled and probed the ground under Spindletop. All of these early efforts to find oil fell victim to lack of funds, old drilling equipment, and tricky sand that made drilling difficult. In late October 1900, however, using heavier and more efficient rotary drilling equipment and an experienced team from Corsicana, Lucas struck oil ten days after the turn of the New Year. That day, a geyser blew oil 100 feet into the air, capturing the attention of the world and marking the beginning of a boom in Beaumont.

Beaumont changed from a peaceful southern town of 9,000 people to a boomtown of 50,000 almost overnight. Lucas's well produced an estimated 100,000 barrels of oil a day, more than the rest of the world's wells combined. Speculation continued in earnest on the land around Spindletop, and veritable forests of oil wells sprang up in no time. Such heavy drilling quickly depleted the petroleum deposits, and by 1904, all the wells in the area produced a total of only 10,000 barrels a day.

The oil boom in Beaumont attracted businesses and businessmen, legitimate and otherwise. By 1902 more than 500 Texas corporations did business in Beaumont, and many of them would later develop into the largest oil companies of the twentieth century. Among those getting their start at Spindletop were the Texas Company (later Texaco), Gulf Oil, Sun Oil, Magnolia Petroleum, and Humble (later Exxon). By the end of the century, more than 153,000,000 barrels of oil had been drawn from the fields in and around Spindletop, and Beaumont had become the center of the petrochemical industry in the state.

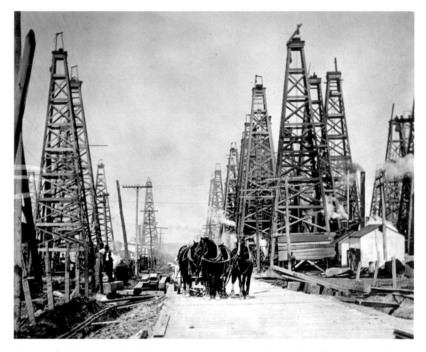

Photograph of numerous oil wells near Beaumont, ca. 1901. Photograph Collection, UTA Library.

In 1941 a granite monument was erected close to the original site of the Lucas well, but it was moved in the 1980s to the Spindletop/Gladys City Boomtown Museum re-creation on the campus of Lamar University. In the 1950s businessmen mined the former oil fields for sulphur, leaving behind sunken spots where sulphur had been extracted. Today these oil fields look like a wasteland—an ignominious end to a site that transformed local and U.S. history.

James Anthony Clark and Michel T. Halbouty. *Spindletop*. New York: Random House, 1952.

Judith Walker Linsley, Ellen Walker Rienstra, and Jo Ann Stiles. *Giant Under the Hill: History of the Spindletop Oil Discovery at Beaumont, Texas, in 1901*. Austin: Texas State Historical Association, 2002.

Paul N. Spellman. *Spindletop Boom Days*. College Station: Texas A&M University Press, 2001.

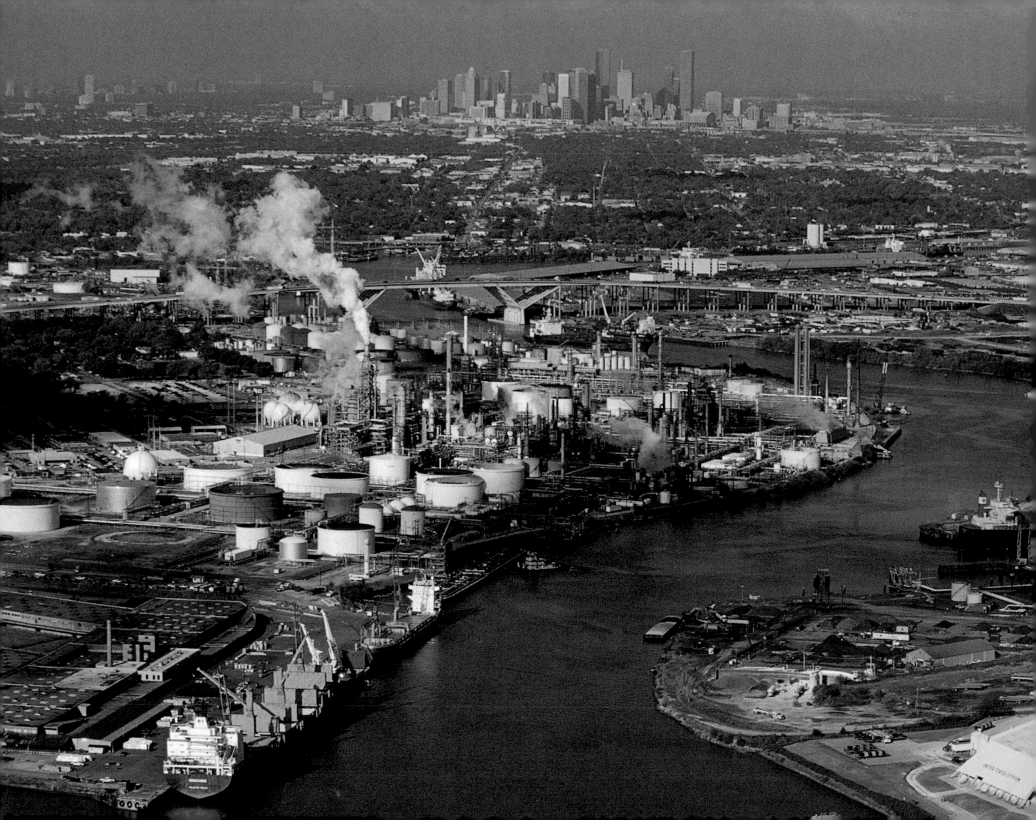

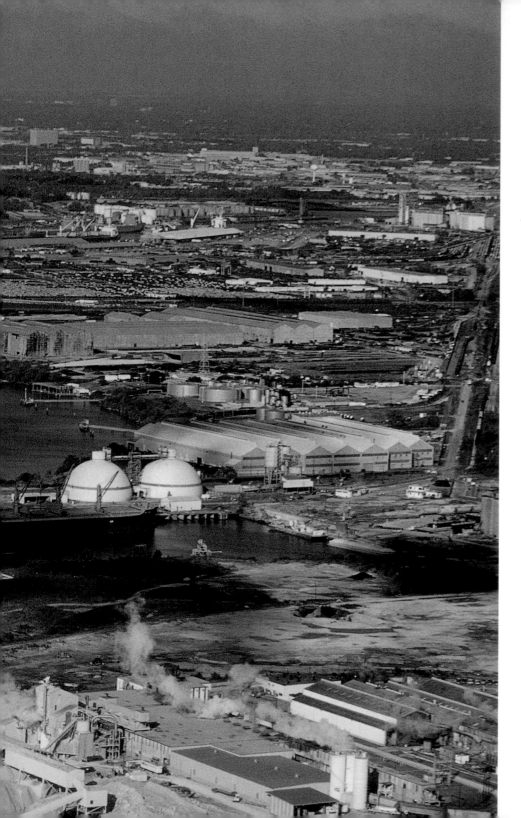

Aerial photograph of the Houston Ship Channel with downtown Houston in the background, 27 November 2007, mid-morning, looking west.

Ship Channel, Houston

The Houston Ship Channel—530 feet wide by 45 feet deep by 50 miles long—connects the city of Houston to the sea and is one of the busiest waterways in the nation. The original watercourse for the channel was Buffalo Bayou, which has its headwaters thirty miles to the west of Houston.

Buffalo Bayou had been used to move goods to the sea since the 1830s. John Kirby Allen and his brother Augustus Chapman Allen laid out the town of Houston at the head of navigation on the bayou in 1836. A robust trading industry developed, prompting the town's fathers to establish the Port of Houston in 1842 and to assume the authority to remove obstructions from the bayou. Early on, goods from the interior of Texas were shipped on the bayou to Galveston where they would be transshipped around the country and even abroad. However, after the Civil War, Houston leaders disagreed with the policies of the Galveston Wharf Company, and sought a way to reach the sea without going through Galveston.

Permission to build the channel came in fits and starts as Houston sought federal funding to develop it. After early efforts by private individuals such as Charles Morgan, the "Father of the Houston Ship Channel," the U.S. government in 1890 accepted primary responsibility for developing the channel, though its progress was slow and funding often inadequate. In 1909, Houston mayor Horace Baldwin Rice, impatient with the slow progress, presented the "Houston Plan" to Congress, which offered to pay one half of the cost of dredging the channel from 18.5 to 25 feet

deep, as recommended by the United States Army Corps of Engineers. Congress accepted the plan and completed the dredging with great fanfare in 1914.

The Houston Ship Channel is responsible for Houston's development into one of the busiest ports in the country. As the aerial photograph of the circuitous channel suggests, many of the products shipped along the channel fall into two areas—agricultural (note the grain warehouses in the foreground) and petrochemical (note the industrial plant on the left side of the photograph). By the 1970s, more than 4,500 ships from sixty-one nations used the channel yearly.

R. M. Farrar. *The Story of Buffalo Bayou and the Houston Ship Channel.* Houston, Tex.: Chamber of Commerce, 1926.

Marilyn M. Sibley. *The Port of Houston: A History.* Austin: University of Texas Press, 1968.

Photograph of the turning basin of the Houston Ship Channel after it had been deepened and widened, May 1928. Photograph Collection, UTA Library.

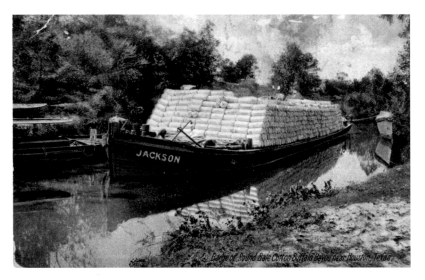

Postcard showing cotton exports at Houston, 1908. Garrett Postcards, UTA Library.

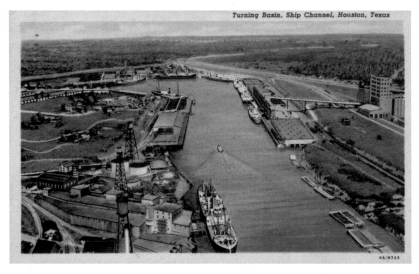

Postcard showing the turning basin, ca. 1936. Garrett Postcards, UTA Library.

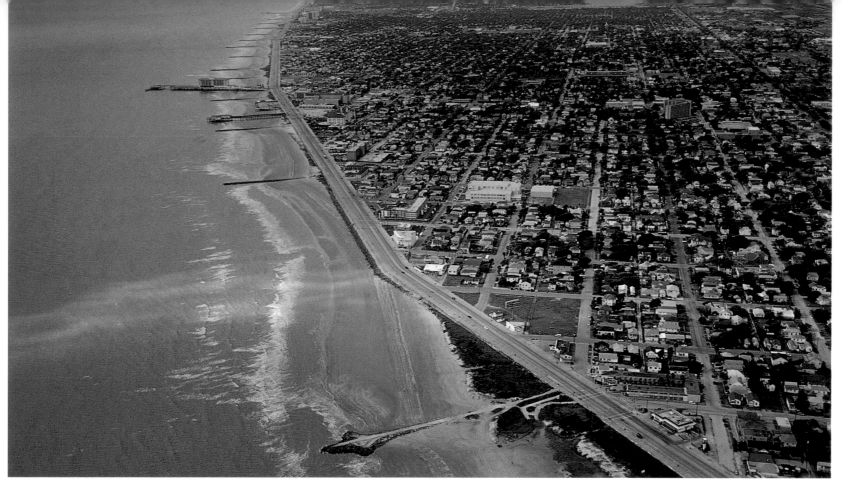

Aerial photograph of the Galveston Seawall, 27 November 2007, mid-morning, looking southwest from the Gulf of Mexico.

Seawall, Galveston

On 8 September 1900, a deadly hurricane struck Galveston, then the fourth largest city in Texas with a population of 38,000, leaving devastation and death in its path. Hurricane winds gusted to an estimated 120 miles per hour and submerged the entire city under a maximum of fifteen feet of water. After the hurricane, the city lay in shambles, with an estimated 6,000–8,000 people dead and a third of the city's buildings destroyed, including 2,636 homes. Even though costlier hur-

ricanes have struck the United States since 1900, the Galveston storm is still considered to be the worst natural disaster to hit the country in terms of its high death rate. Early storm warning systems were not yet in place and the relatively primitive modes of communication at the time prevented Galveston residents from knowing the location and path of the storm. As a result, no one had evacuated the city.

After the hurricane, city leaders rallied to rebuild the island community, and to implement safeguards to prevent similar devastation from future storms. Protection from the sea was the first priority, so in 1902,

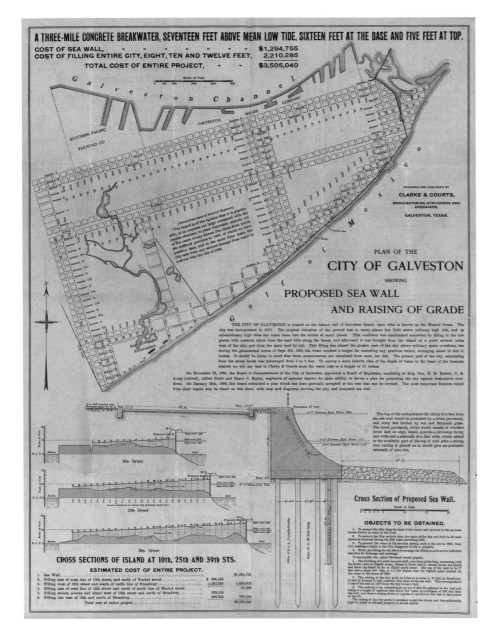

authorities began construction of a seven-mile seawall to stand seventeen feet above the mean low tide. The wall was completed in 1962 for a total of $14.5 million dollars, and today has been extended to run ten miles along the coast, parallel to Seawall Boulevard. The seawall has never been overtopped by a storm surge and is on the National Register of Historic Places.

At the same time as the construction of the seawall, Galveston underwent an ambitious project to increase the grade of the city by raising more than 2,000 buildings, streetcar tracks, water pipes, and other infrastructure. Work crews would jack up homes in order to pour four to six feet of sand underneath. They poured fill dirt around the foundations of buildings that could not be raised. Galveston also developed a commission form of government to more effectively respond to the disaster.

Galveston gained notoriety for coping with the disaster through planning, efficiency, and dedication. Today the seawall stands as a testament to the city's spirit and commitment to rebuild.

Howard Barnstone. *The Galveston That Was.* New York: Macmillan, 1966.

Erik Larson. *Isaac's Storm: A Man, a Time, and the Deadliest Hurricane in History.* New York: Crown Publishers, 1999.

David G. McComb. *Galveston: A History.* Austin: University of Texas Press, 1986.

John Edward Weems. *A Weekend in September.* New York: Holt, 1957.

1902 broadside, "Plan of the City of Galveston Showing Proposed Sea Wall and Raising of Grade." Garrett Maps, UTA Library.

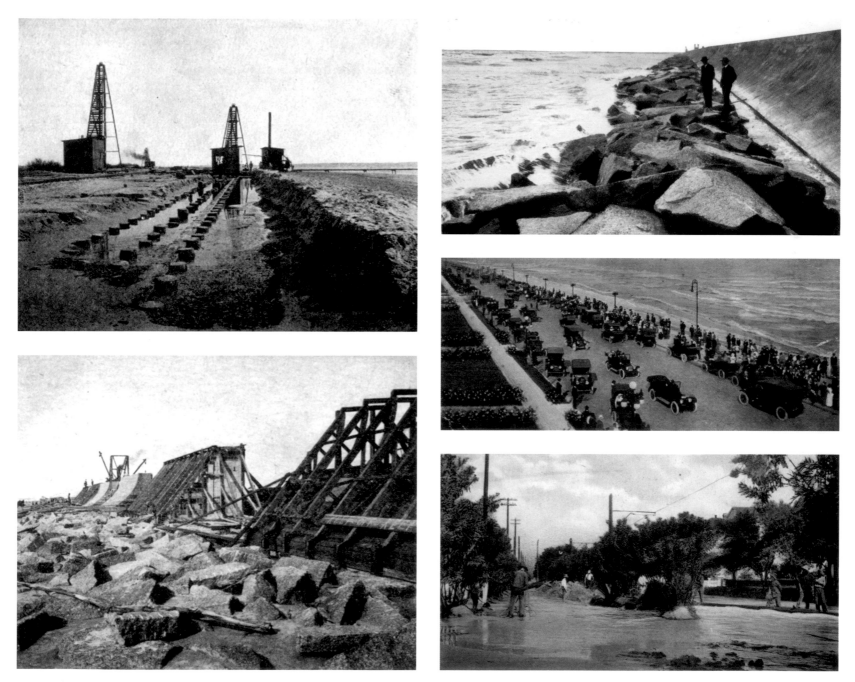

A series of five postcards showing the sea wall under construction and its completion. Garrett Postcards, UTA Library.

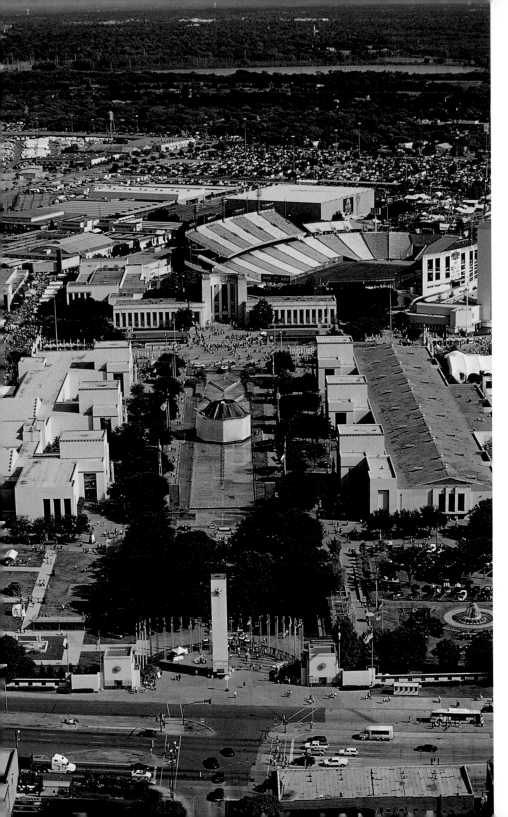

Aerial photograph of Fair Park, 9 March 2005, late afternoon, looking south.

Fair Park, Dallas

The sprawling Fair Park complex east of downtown Dallas is the largest intact concentration of 1930s art deco architecture and art in the United States. In 1986, Fair Park was entered on the National Register of Historic Places as a national landmark. Fair Park, as we know it today, was mostly the creation of Dallas architect George Dahl and consulting architect Paul Cret.

In 1936 Fair Park became the location of the Texas Centennial Exposition after intense lobbying by Dallas business leaders and a commitment of $5.5 million of public and private money to attract the statewide celebration marking the one hundredth anniversary of Texas independence from Mexico. Beating out such cities as San Antonio, Austin, and Houston for the celebration, Dallas expanded what had been the site of the annual Texas State Fair since 1886. Dahl was hired as the chief architect and technical director of the exposition and oversaw the spending of some $25 million to construct fifty buildings at Fair Park, twenty-one of them permanent. All of this feverish construction happened between October 1935 and the opening of the exposition on 6 June 1936.

Every building followed Dahl's architectural theme, which he labeled "Texanic." His designs featured low buildings painted in light earthtone hues brightened with boldly colored murals and striking sculptures. The main entry gate opened onto an esplanade, flanked by exhibit buildings on both sides of a manmade lagoon. At the terminus of the esplanade stood the striking Hall of State that had been built by the State of Texas to celebrate its rich history. The 1936 exposition attracted more than seven million visitors and helped Dallas rebound from the Great Depression.

Today Fair Park is a 277-acre venue owned by the City of Dallas. For three weeks every year, the city leases the park to the State Fair of Texas Association for the Texas State Fair, an event that attracts more than 3.5 million visitors a year. In the 1980s the city began an effort to preserve the architecture of the park, and organized the Friends of Fair Park support group to ensure that the restoration continued. Fair Park is currently home to museums, exhibit and sports facilities, and year-round cultural and recreational activities.

Maxine Holmes and Gerald D. Saxon, eds. *The WPA Dallas Guide and History.* Dallas, Tex.: Dallas Public Library, Texas Center for the Book and Denton, Tex.: University of North Texas Press, 1992.

Darwin Payne. *Dallas: An Illustrated History.* Woodland Hills, Calif.: Windsor Publications, 1982.

Nancy Wiley. *The Great State Fair of Texas: An Illustrated History.* Dallas: Taylor Pub. Co., 1985.

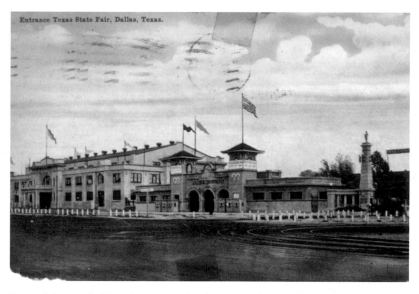

Postcard showing the Texas State Fair before the centennial renovations, ca. 1910. Garrett Postcards, UTA Library.

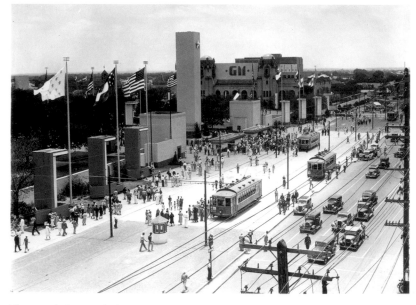

Photograph showing the bustling entrance to the Texas Centennial Exposition held at the state fairgrounds, 1936. Photograph Collection, UTA Library.

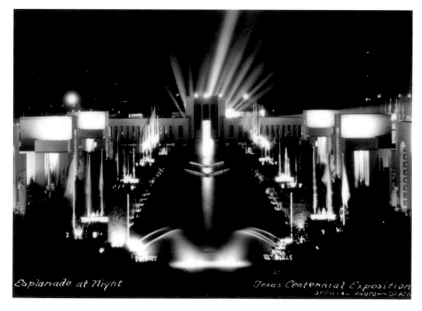

Postcard showing the Texas State Fair after the centennial renovations, 1936. Garrett Postcards, UTA Library.

Dealey Plaza, Dallas

Our aerial photograph shows the original site of Dallas, where John Neely Bryan, founder of the city, established his trading cabin in 1841 at a favorable point above the Trinity River. Later, this site would hold the "Old Red" Courthouse, to the right in our image, and later still, the Triple Underpass would be constructed here in 1936, to combine Elm, Main, and Commerce Streets, so that they might ingeniously pass together under the railroad bridge maintained by the Union Terminal Company. The postcard shows the underpass shortly after its completion, before the Works Progress Administration had added the art deco peristyles and other features visible on the aerial photograph.

The Elm Street portion of the road was, of course, where President John F. Kennedy and Governor John Connally were shot in November 1963, as their motorcade traveled westward along the curve toward the underpass. President Kennedy was killed and Governor Connally seriously wounded by a gunman apparently perched in the Book Depository, the large redbrick building on the extreme left of our aerial photograph.

Since the construction of the interstate highway system that runs north-south nearby, Dealey Plaza has lost most of its significance in a planning sense. But at the time of its construction it must have seemed a technical marvel, offering rapid access to the city from the west without disrupting the already very complex system of railroad lines.

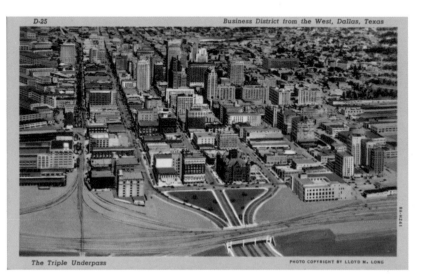

Postcard of the Triple Underpass to the west of downtown Dallas, ca. 1936. Garrett Postcards, UTA Library.

Jerry T. Dealey and George Bannerman Dealey. *D in the Heart of Texas*. Dallas: JEDI Management Group, 2002.

Conover Hunt Jones. *A Visitor's Guide to Dealey Plaza National Historic Landmark, Dallas, Texas*. Dallas: The Sixth Floor Museum, 1995.

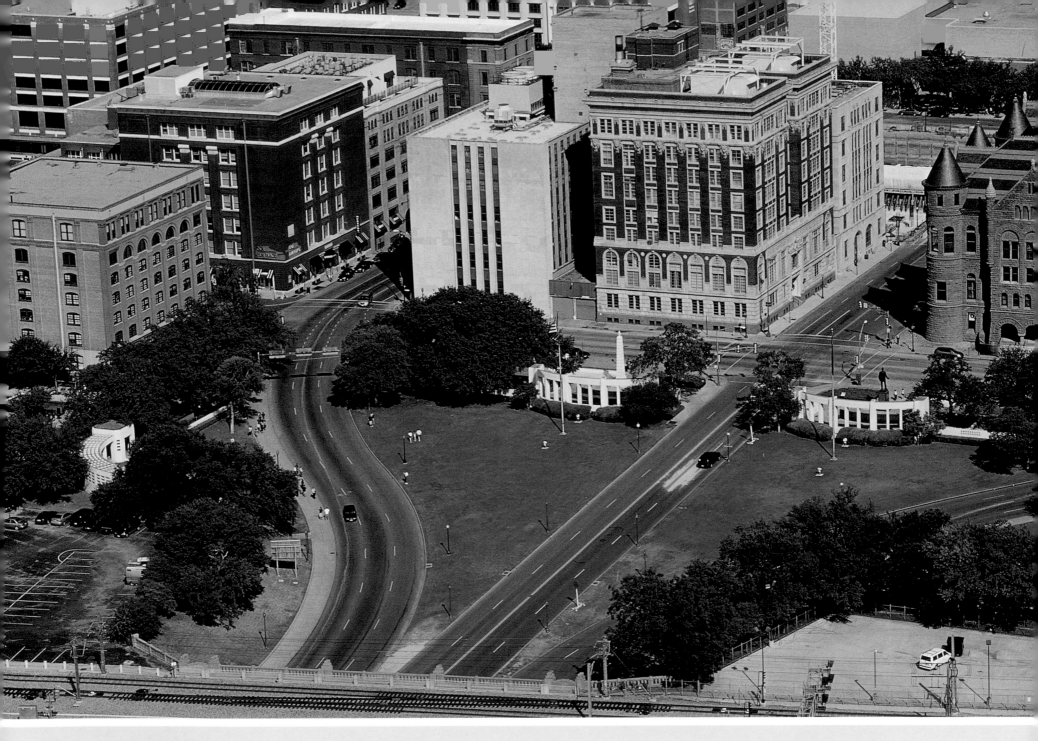

Aerial photograph of Dealey Plaza, 9 March 2005, late afternoon, looking northeast.

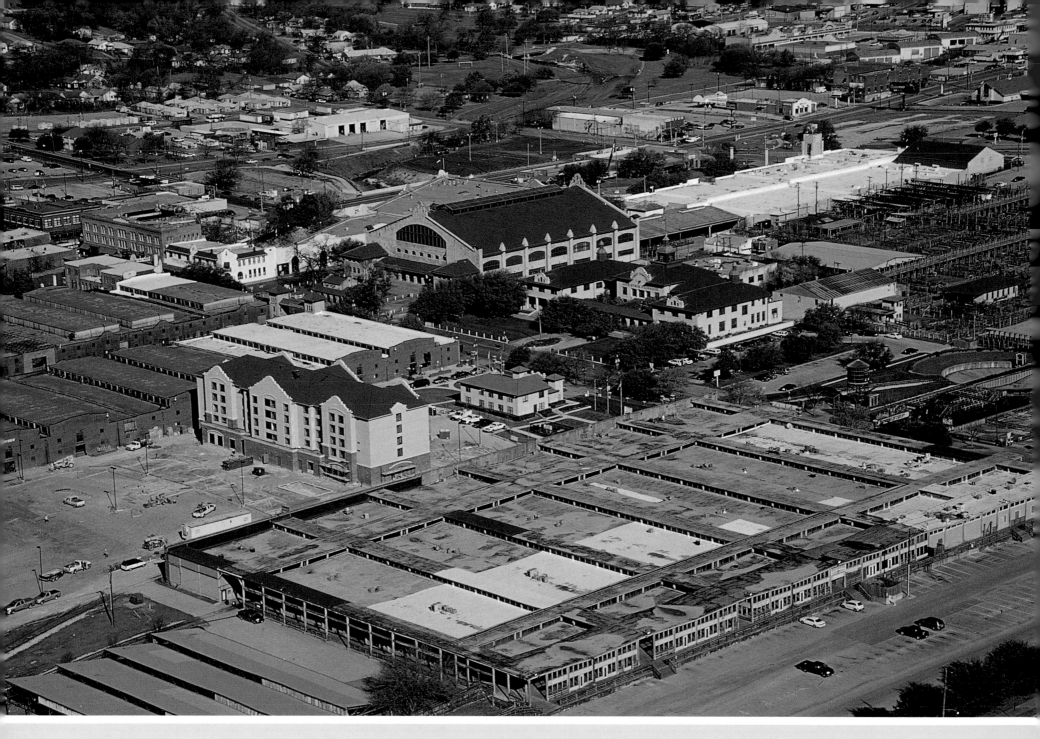

Aerial photograph of Fort Worth Stockyards (north side), 9 March 2005, midday, looking northwest.

Stockyards, Fort Worth

Soon after the Civil War, Texans labeled Fort Worth a "Cowtown." The appellation recognized the town's importance as a supply stop for drovers moving cattle north from South Texas to markets along the Chisholm Trail. After the Texas and Pacific Railway arrived in Fort Worth in 1876, promoters began building pens to hold cattle before they were shipped to market by the railroad. Fort Worth business leaders envisioned adding meatpacking plants in hopes of making the town an important cattle center. In 1889, the Union Stock Yards opened a 258-acre facility north of the Trinity River where the current Fort Worth Stockyards began. A series of local and national investors developed and promoted the stockyards. In 1896 they started the Southwestern Exposition and Livestock Show, still an annual tradition today.

The stockyards rapidly grew and then declined in the twentieth century. A 1902 agreement prompted corporate giants Armour and Swift to build modern plants adjacent to the stock pens. Fort Worth and the stockyards grew rapidly as Cowtown became an increasingly important center for the cattle and sheep industry. In 1905 the Fort Worth livestock market was fifth largest in the nation, and by 1937 the city was the top market, a development fueled by Texas's growth as the largest cattle and sheep producer in the nation; 1944 was the largest, most productive year ever for the stockyards. By the next decade, however, the decentralization of the cattle industry due to the development of feedlots across the state and the increasing prevalence of the trucking industry made the stockyards largely irrelevant and unprofitable.

The Armour and Swift plants closed in the 1960s and 1970s, and the

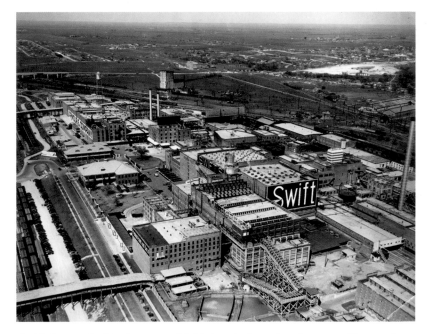

Aerial photograph of the Armour and Swift plants in the stockyards, ca. 1930. Photograph Collection, UTA Library.

city and private interests began redeveloping the stockyards as a tourist destination. The yards held their last cattle auction in December 1992. Today the Fort Worth Stockyards are a National Historic District that includes 125 acres and fifteen square blocks of historic sites, restaurants, clubs, hotels, and shops.

E. C. Barksdale. *The Meat Packers Come to Texas*. Austin: Bureau of Business Research, University of Texas, 1959.

Horace Craig. *The Fort Worth Stockyards National Historic District: An Illustrated History and Guide*. Kearney, Neb.: Morris Publishing, 1994.

J'Nell Pate. *Livestock Legacy: The Fort Worth Stockyards, 1887–1987*. College Station: Texas A&M University Press, 1988.

J'Nell Pate. *North of the River: A Brief History of North Fort Worth*. Fort Worth, Tex.: Texas Christian University Press, 1994.

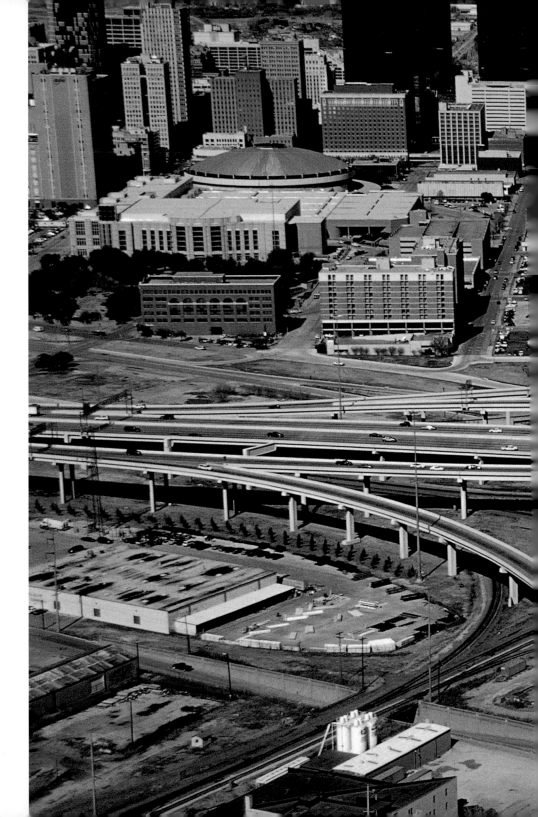

The Mixmaster, Fort Worth

An aerial view of modern downtown Fort Worth reveals the massive infrastructure that sustains today's automobile. At the southeastern edge of the city's central business district, I-30 and I-35W meet in intersecting ribbons of concrete. Locals call this location the "Mixmaster." Look more closely, however, and you will see the predecessor of today's Mixmaster nearly hidden under the maze of highway ramps. There, at ground level, a redbrick tower stands at the nexus where several major railroad lines cross at right angles. Tower 55 was so named because it was the 55th tower in Texas designated to protect the movement of trains at locations where railroads crossed—in this case, the Texas and Pacific running east-west, and the Missouri-Kansas-Texas running north-south; others like the Gulf Colorado and Santa Fe also funneled through this junction. Since 1881, this railroad junction has been an important bottleneck for a good reason: unlike the interstate highway, the rail lines here cross each other *at grade*—that is, on the *same* level, though future plans call for a separation of the tracks by overpasses to avoid congestion. The tower's purpose was straightforward enough: to house the workers and equipment that keep trains from colliding with each other. However, in recent years the tower operators have been superseded by an automatic control center housed elsewhere, leaving the tower vacant. The junction's function is complex, because trains can still take different routes by curving from one line to another in any direction, just as motorists today can change freeways at an interchange. All switches here need to be carefully orchestrated to keep the trains of several railroads moving efficiently. Deactivated in 1995, Tower 55 was one of the last

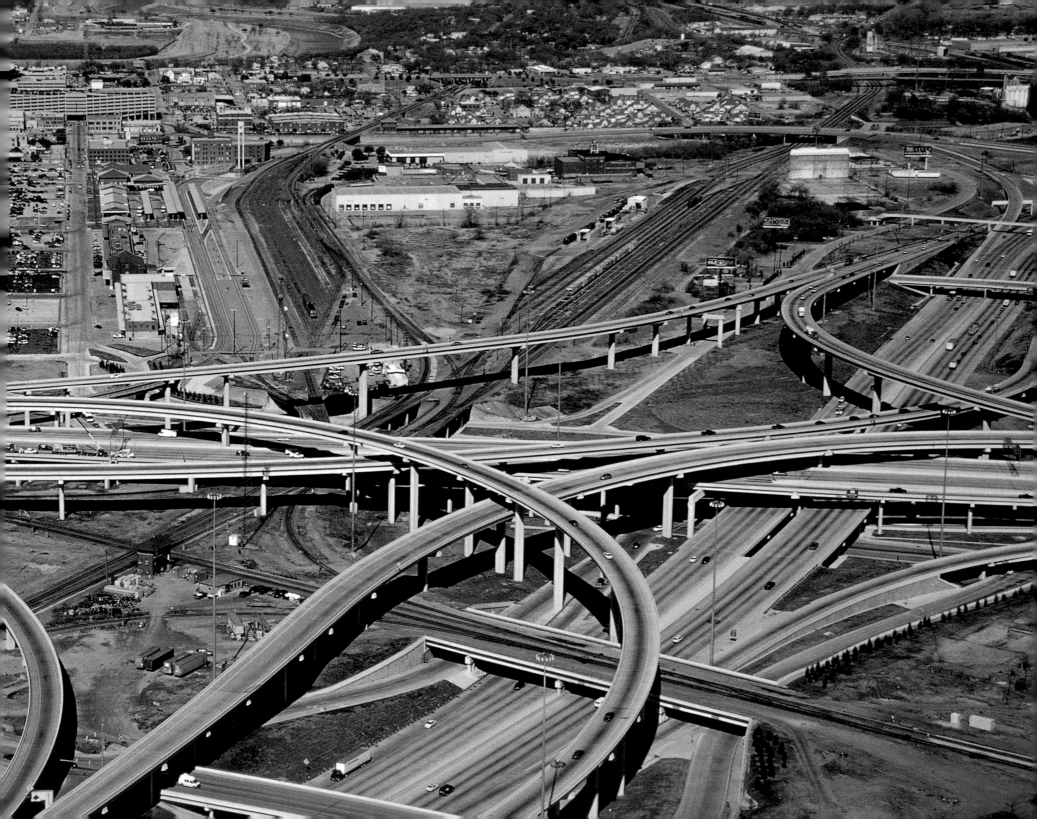

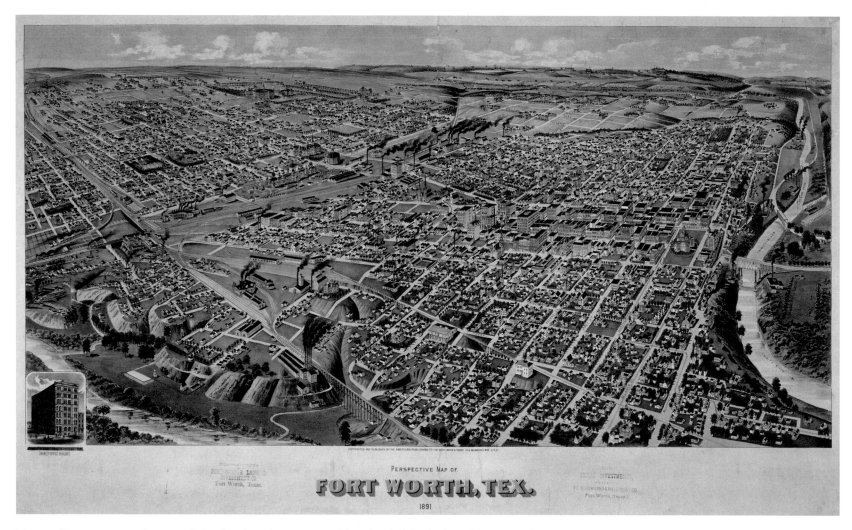

PERSPECTIVE MAP OF.

FORT WORTH, TEX.

1891

This 1891 "Perspective Map of Fort Worth, Tex." confirms the importance of the railroads (left side of image) in shaping the city. Courtesy the Amon Carter Museum, Fort Worth, Texas.

interlocking towers in Texas and the nation. At such interlocking plants, trains are not permitted to enter tracks occupied by other trains. Today dispatchers can control trains' movements from miles away, making towers like Tower 55 obsolete.

Just north of Tower 55, the Santa Fe line curves to the left, opening into a small railroad yard and the Santa Fe Union Station. This red brick building served Amtrak until the 2002 opening of Fort Worth's intermodal transportation center a few blocks to the north.

The 1891 bird's-eye view of Fort Worth was drawn by earth-bound mapmakers, who speculated how the city would look from an elevated perch. It reveals the presence of the railroad lines and their crucial junction at the southeastern edge of the city's booming central business district. This view confirms Fort Worth's early role as a crossroads of transportation lines. The railroads from six separate railroad companies are labeled on this map. Throughout its history, Fort Worth has been served by a total of twenty-six separate companies; today only two major railroads, the Union Pacific and the Burlington Northern–Santa Fe, serve the city and most of Texas. Additionally, Amtrak and the Trinity Railway Express provide passenger service. The railroads met in Fort Worth partly because of the efforts of B. B. Paddock, one of the city's greatest boosters. In 1873, Paddock created the "Tarantula Map," which showed numerous railroad lines intersecting here. Paddock's map is all the more remarkable because he drew it *before* any railroads actually converged on the city! The nineteenth-century bird's-eye view was fairly accurate, while Paddock's map involved wishful thinking. Yet, as all these images confirm, Fort Worth became, and remains, the major crossroads that Paddock had envisioned.

Jeffrey A. Harwell. "Tower Wars in the Lone Star State: Life Before and After Fort Worth's Tower 55." *Trains* 59, no. 7 (July 1999): 38–45.

J. David Ingles. "The View From Tower 55: First Trick, May 30, 1984, At the Rail Crossroads of Fort Worth." *Trains* 45, no. 4 (February 1985): 36–43.

Charles Zlatkovich. *Texas Railroads: A Record of Construction and Abandonment.* Austin: Bureau of Business Research, University of Texas at Austin; Texas State Historical Association, 1981.

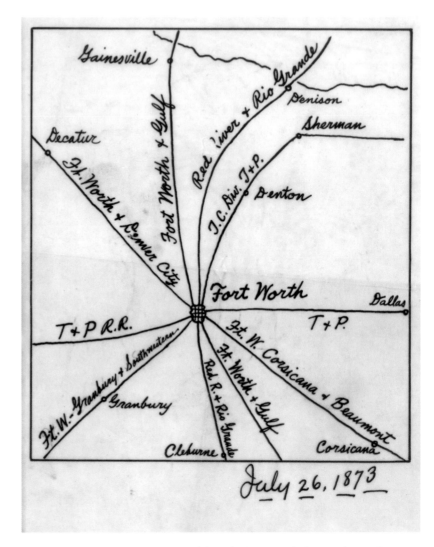

Railroad map of Fort Worth by B. B. Paddock, also known as the "Tarantula Map," 1873. In fact, this map shows railroad lines before they had been built. Garrett Maps, UTA Library.

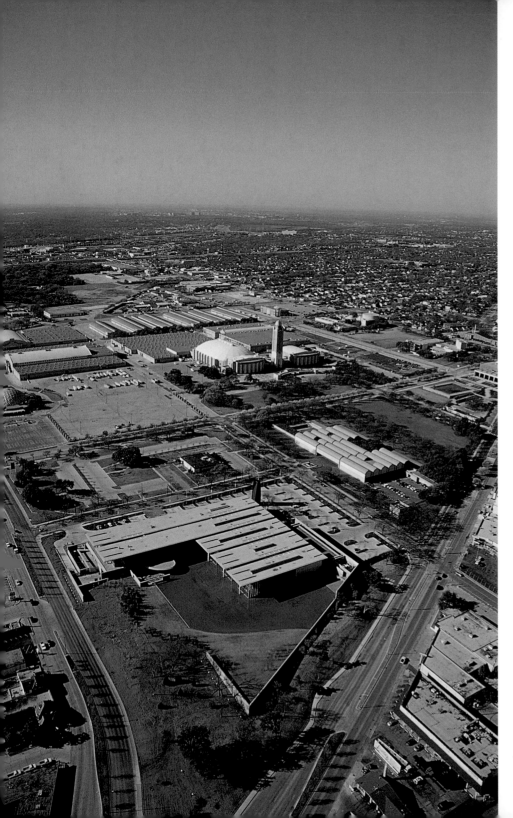

Aerial photograph of the Fort Worth Cultural District, 11 February 2003, midday, looking south.

Cultural District, Fort Worth

In city planning, the idea of a "cultural district" is relatively new, and the one at Fort Worth is a fine example of it. Our aerial photograph shows it from the northeast, with the Museum of Modern Art in the foreground, the Kimbell Art Museum to its right, and part of the Amon Carter Museum on the far right. The tower in the photo marks the Will Rogers Coliseum, and in the distance you can see the woods of the Fort Worth Botanic Garden. This cluster of attractions is convenient for the visitor, and probably draws more visitors than each institution would individually if they were scattered across town.

It is curious to think that this whole area was once part of the great military camp, Camp Bowie, constructed in six months in the second half of 1917. ("Arlington Heights Road" on our military map is now called Fort Bowie Boulevard.) The camp could hold as many as 35,000 men, and the 36th Division trained here before it left for France in July 1918. The modern-day museums lie in what was once the eastern part of the camp, marked on the military map as "Ammunition and supply trains." The "Remount Station" (not visible on the map) is now part of Trinity Park and the Fort Worth Botanic Garden, where visitors can still see traces of the old military railroad.

Camp Bowie was rapidly dismantled after World War I was over and many of the buildings were cannibalized for building materials. But residents of areas such as Hulen Street and Pershing Street still sometimes find military relics while digging in their gardens.

Ben F. Chastaine. *Story of the 36th: The Experiences of the 36th Division in the World War*. Oklahoma City: Harlow Publishing Co., 1920.

Bernice Maxfield. *Camp Bowie, Fort Worth, 1917–1918*. Edited by William E. Jary, Jr. Fort Worth, Tex.: B. B. Maxfield Foundation, 1975.

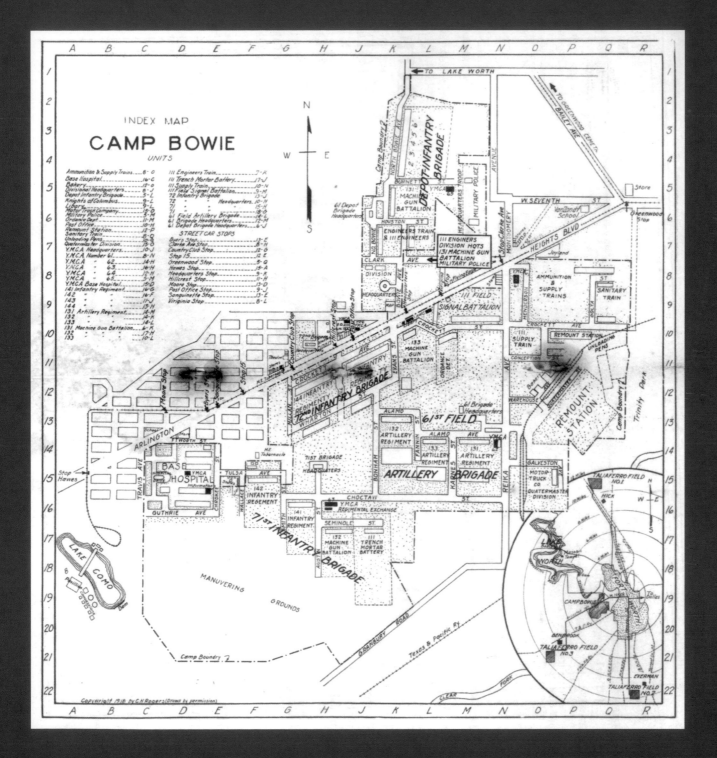

Baker Hotel, Mineral Wells

The Baker Hotel dominates the Mineral Wells skyline and towers above smaller commercial buildings downtown. The Baker, as locals call it, is a brick and mortar testament to the heady days of the 1920s when people from around the country came to town to partake of the local mineral water's curative and restorative powers. Vacant since 1972, the building now looms like an albatross over this town some fifty miles west of Fort Worth. The hotel is too big to demolish and too expensive to restore, so it sits waiting for neglect and nature to do their work. Once gushed over as the "Grand Old Lady of Mineral Wells," the Baker Hotel gets no respect these days, as evidenced by architectural historian Jay Henry's characterization of it as "essentially a slab of guest rooms with public spaces at the base."

It was not always this way. A product of the Roaring Twenties, the Baker opened to tremendous fanfare and celebration in 1929, only two weeks after the stock market crash ushered in the Great Depression. It was built by, and named after, hotel magnate Theodore B. Baker. The Baker was magnificent for its time and place. Built at a cost of $1.25 million, the fourteen-story hotel had 400 rooms, 50 apartment-size suites above the main roofline, ballrooms, an Olympic-size swimming pool, air conditioning, ice water in every room, ceiling fans, and all the modern conveniences. The brick hotel was the first Texas skyscraper built outside of a major city, and it rivaled hotels in New York and elsewhere in elegance. Designed by Wyatt C. Hedrick, who had designed the Arlington Hotel in Hot Springs, Arkansas (a building that the Baker strongly resembles), the Mineral Wells hotel is said to be a "Spanish Colonial Revival commercial high rise." When it opened, the hotel could accommodate 2,500 people in a town of 6,000, and its prospects appeared bright.

Why build such a large hotel in such a small town, you might ask? The answer was simple—water! In 1877 James Lynch brought his family to settle in the area and laid out the town four years later. When digging for drinking water, he discovered a foul-smelling and foul-tasting mineral water instead. The local water became famous for its medicinal

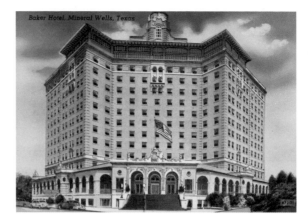

Postcard enumerating the rooms and bathing facilities at the Baker Hotel, ca. 1930. Garrett Postcards, UTA Library.

qualities and soon the town, named Mineral Wells, began to boom as a health resort. The railroad reached the town in 1891, and the first of several resort hotels was built in 1897. Townspeople bottled and shipped the local water, called "Crazy Water," throughout the country and built hotels and bathhouses to cater to the people flocking to town to partake of its healing properties. By 1920, the town had 400 wells and was billed as "the South's greatest health resort."

After its completion, the Baker Hotel survived the uncertain years of the Great Depression and World War II. In 1952, Theodore Baker retired, leaving his hotel empire to his nephew, Earl Baker, who closed the hotel in 1963. Two years later, a group of local businessmen reopened the hotel, but had to close it for good in 1972 because of sagging profits. The hotel sits empty today in the heart of downtown Mineral Wells. Locals say the hotel is haunted, but even with its broken windows, pigeons, and leaky roof, it is easy to imagine the building several decades ago bustling with life and business, catering to thousands of people each year wanting cures for everything that ailed them.

Gene Fowler. *Crazy Water: The Story of Mineral Wells and Other Texas Health Resorts.* Fort Worth, Tex.: Texas Christian University Press, 1991.

Janet Valenza. *Taking the Waters in Texas: Springs, Spas, and Fountains of Youth.* Austin: University of Texas Press, 2000.

A. F. Weaver, ed. *Time Was in Mineral Wells: A Crazy Story But True.* Mineral Wells, Tex.: Houghton-Bennett Print. Co., 1975.

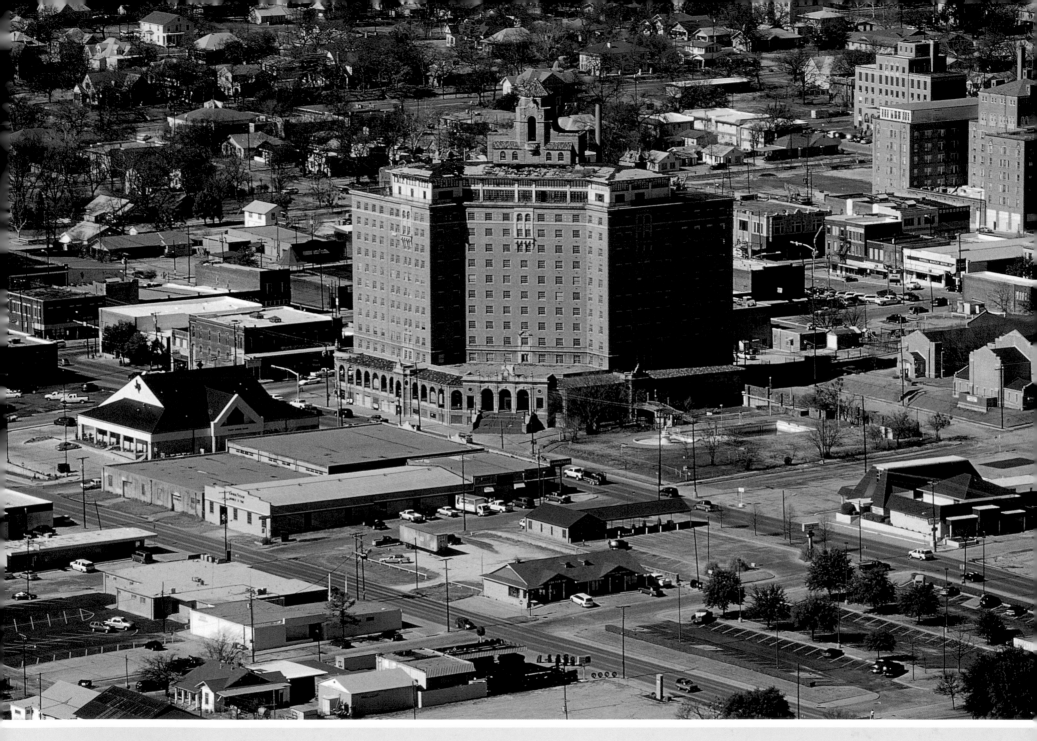

Aerial photograph of the Baker Hotel, 4 February 2003, midday, looking northwest.

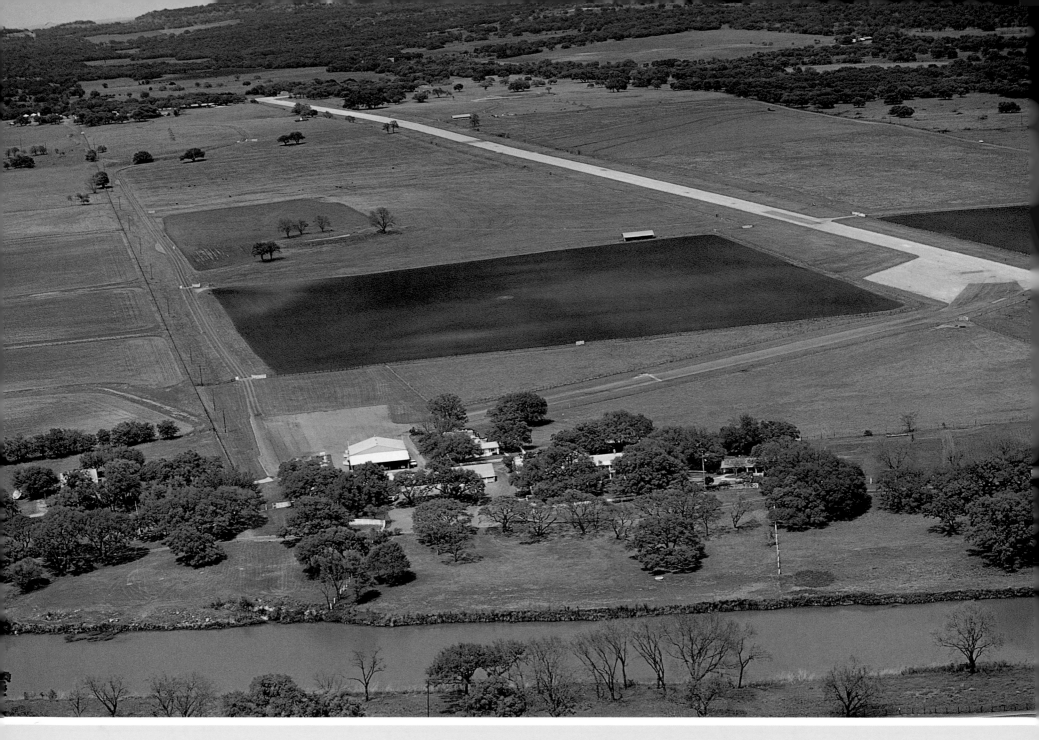

Aerial photograph of the Johnson Ranch, 10 April 2006, midday, looking north across the Pedernales River.

Johnson Ranch, Stonewall

President Lyndon Baines Johnson's national reputation suffered for many years because of the low esteem in which the Kennedy family held him. Many people at first subscribed to the idea that he was a loud, vulgar, bullying provincial who had unhappily and undeservedly succeeded to the elegant court of Camelot in 1963, after the untimely passing of its prince. With the passage of time, though, people began to understand that LBJ's rustic Texan origins and education did not prevent his exuberant manner, grasp of possibilities, and long political experience from enabling him to push through legislation (for the Great Society) which John F. Kennedy had envisioned but might not have been able to implement so effectively.

The tragedy of LBJ's presidency was that he became engulfed by the Vietnam War—a conflict that could neither be won nor terminated with honor. It is curious to imagine him conferring with his aides—Robert McNamara, MacGeorge Bundy, General Westmoreland, and the rest—under the trees at this relatively modest ranch house by the Pedernales River, which he had bought in 1951. Nothing suggests that this home was for a while the center of great power, except perhaps for the long runway in the background of our photograph. Although it could not bear the weight of Air Force One, it held other jets that whisked LBJ to and from Washington.

This was the country of Johnson's infancy and ancestors, and he lived here in retreat until he died in 1973. He was long survived by his wife, Lady Bird, an elegant and powerful character responsible, among other things, for the wildflowers liberally planted along the roadsides of Texas that are so remarkable in the spring. The Johnsons gave their "Texas White House" to the National Park Service in 1972, and it is now part of a museum that allows visitors to understand the nature of Johnson's achievements.

John Barnett. *LBJ Country*. Fresno, Calif.: Awani Press, 1970.

Hal K. Rothman. *LBJ's Texas White House: "Our Heart's Home."* College Station: Texas A&M University Press, 2001.

Historic photograph of President Lyndon Baines Johnson's birthplace, 1897. Courtesy National Park Service.

USS *Lexington*, Corpus Christi

The USS *Lexington*, an *Essex*-class aircraft carrier, now floats majestically in Corpus Christi Bay as a museum and testament to the U.S. naval campaign during World War II. Known as the "Blue Ghost" because of her dark blue paint (in fact, she was the only carrier during the war not to wear camouflage), the aircraft carrier is the fifth ship named in honor of the Battle of Lexington fought during the American Revolution.

The *Lexington* was built by Bethlehem Steel Company in Quincy, Massachusetts, in the early 1940s and commissioned on 17 February 1943. She measures 872 feet long, her beam rises 93 feet above the waterline, and she displaces 27,100 tons. She could travel at a maximum speed of 33 knots and held a complement of 3,748 crewmen and 103 aircraft. During the latter part of 1943, the *Lexington* saw service in the Pacific against the Japanese at Tarawa, Wake, and the Gilbert Islands before a Japanese torpedo hit her in early December off the coast of Kwajalein, forcing her to return to the United States for repairs.

After repairs in 1944, she joined Task Force 58, operating against major centers of resistance in Japan's outer empire, including Truk, Saipan, the Marianas, Guam, Palau, Okinawa, Formosa, and Leyte Gulf. A *kamikaze* crashed into her during this last engagement, forcing her to retreat to Ulithi for repairs. She rejoined the task force in December and became its flagship. In 1945 the *Lexington* entered the China Sea to strike Japanese shipping and air installations. After her service in the China Sea she sailed north to strike Formosa and Okinawa in late January and hit Tokyo and Iwo Jima in February, then returned to the United States for overhaul.

In May she was combat ready and joined Rear Admiral Thomas Sprague's task force for the last round of air strikes on the Japanese home islands until August, when word was received that the Japanese had surrendered. She supported the occupation of Japan until December 1945, when she was ordered back to the United States. The *Lexington* received the Presidential Unit Citation and 11 battle stars for her war service. The

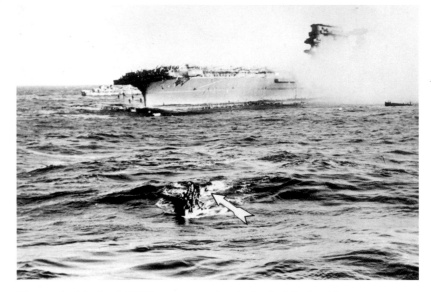

Photograph of the fourth USS Lexington, *sunk in the Battle of the Coral Sea, 1942. Photograph Collection, UTA Library.*

Japanese wrongly reported on three separate occasions that their navy had sunk her.

In the postwar years, the modernized *Lexington* served intermittently as an attack carrier and aviation training carrier. In the 1960s she operated out of her home port of Pensacola as well as New Orleans and Corpus Christi. In 1969 she was redesignated *CVT-16* and continued as a training carrier until she was decommissioned in November 1991. At the time, the ship had served longer on active duty than any aircraft carrier.

On 15 June 1992, the navy donated her as a museum and now she is formally known as the USS *Lexington* Museum on the Bay.

"Lexington." In Department of the Navy, Naval Historical Center. *Dictionary of American Naval Fighting Ships.* http://www.history.navy.mil/danfs/16/lexington-v.htm (accessed July 2, 2008).

Hugh Irvin Power. *Carrier Lexington.* College Station: Texas A&M University Press, 1996.

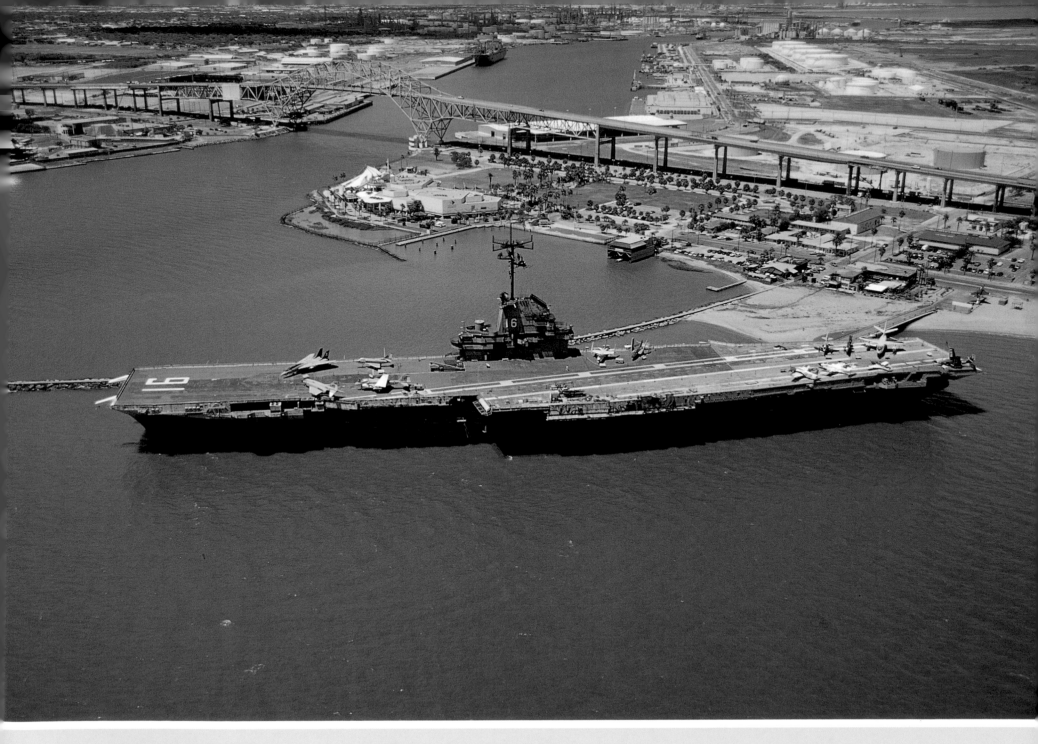

Aerial photograph of the USS Lexington, 24 August 2005, midday, looking west from Corpus Christi Bay.

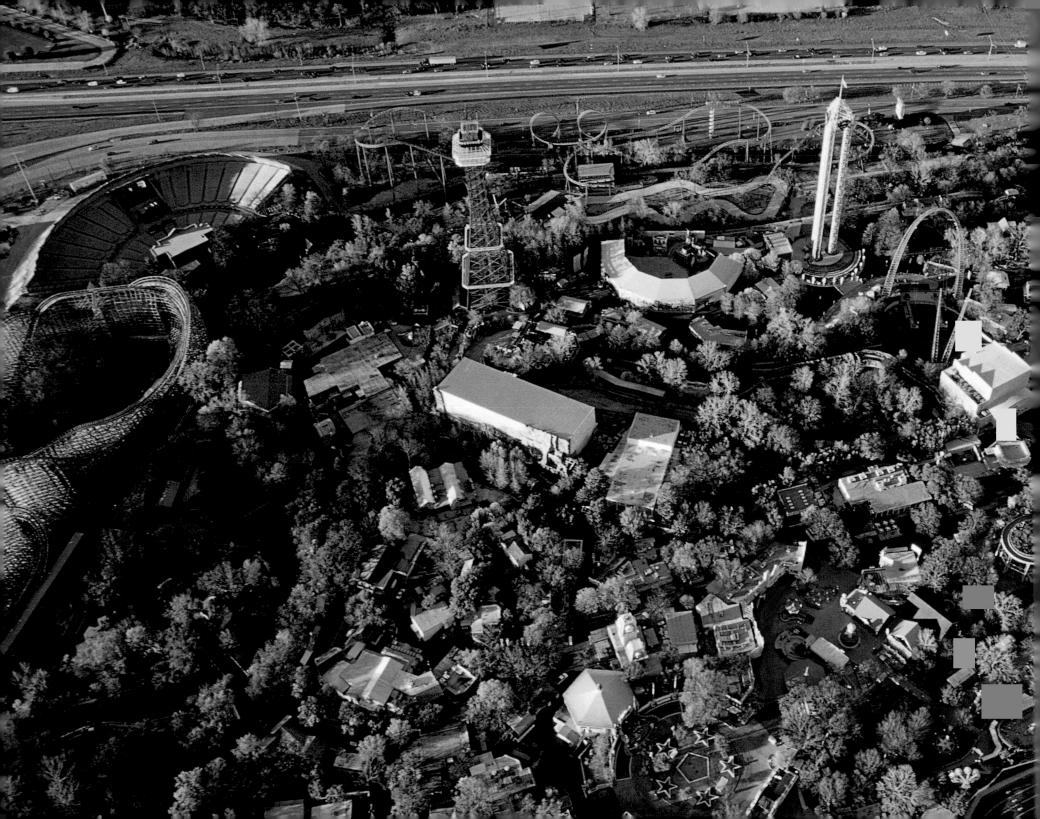

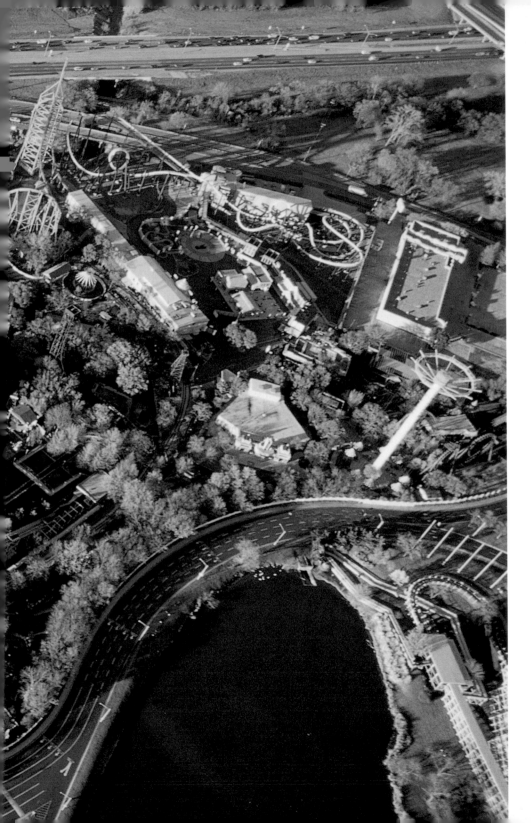

Six Flags Over Texas, Arlington

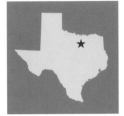

Six Flags Over Texas was the Lone Star State's first "edu-tainment" environment—a theme park designed to encourage people of all ages, and especially children, to learn while having fun. Our photo of Six Flags may remind you a bit of Disneyland, for good reason. Six Flags was designed by Randal Duell, who also helped design portions of that famous California theme park in the mid-1950s. In this north-facing photograph taken in 2005, Six Flags appears as clusters of buildings huddled in a forest, but when the park first opened in 1961, it was considerably less crowded-looking. As envisioned by Arlington businessman Angus Wynne, Six Flags would re-create the six political entities that have at one time claimed sovereignty over Texas: Spain, France, Mexico, the Republic of Texas, the Confederate States of America, and the United States of America. Each section of Six Flags featured a setting meant to transport the visitor to that time and place.

For example, the Spanish section featured a Spanish-style fort, while the French section contained a ride called the LaSalle River Adventure. Visitors to the original Six Flags could travel by canoe or stagecoach, but these rides (like the real things) were fairly hazardous as well as slow-paced. Over the years, these historic portions of the park diminished in the face of the public demand for more exciting rides. One of the earliest forms of transportation in the park, however, still remains—a steam-powered, narrow gauge train very similar to the train that circles Disneyland. In our 2005 photo you can see the vestiges of the historic regions, such as the Republic of Texas pond outlined by lone stars in the lower center.

An early 1960s aerial photograph of Six Flags Over Texas. Special Collections, UTA Library.

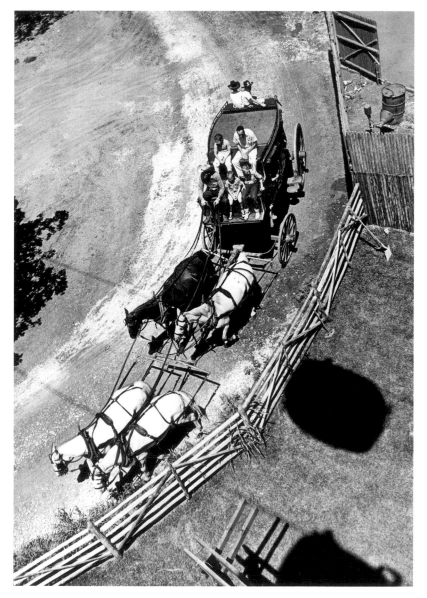

A stagecoach in operation during the early years of Six Flags Over Texas, ca. 1965. Special Collections, UTA Library.

Also note the numerous roller coasters—including the legendary "Texas Giant" (far left), which is still considered one of the finest coasters in the nation—and other modern rides that tower above the park. The large orange tower, which has become a North Texas landmark, looks like a replica of the Eiffel Tower, but is actually meant to represent something more Texan—an oil well. Significantly, Interstate 30 (top) borders the park, as does Highway 360 (out of the picture to the right)—reminders of the automobile's importance to theme park location by the mid to late twentieth century. Just north of I-30, at the very top of the photo, motels and restaurants line up to serve the traveling public and, of course, visitors to Six Flags.

Richard Francaviglia. "Texas History in Texas Theme Parks." *Legacies* VII, no. 2 (Fall 1995): 34–42.

Arista Joyner. *Arlington, Texas: Birthplace of the Metroplex.* Arlington, Tex.: Arlington Bicentennial/Centennial Celebration Committee, 1976.

Cameron Wallace. *The Early Success of Six Flags Over Texas, 1957–1970.* Arlington, Tex.: Arlington Hill Publications, 2006.

Aerial photograph of the Houston Astrodome with Reliant Stadium in the background, 27 November 2006, mid-morning, looking west.

Astrodome, Houston

Heralded as the "Eighth Wonder of the World" when it opened in 1965, the Houston Astrodome, officially named Harris County Domed Stadium, was the first fully air-conditioned domed stadium in the world. "The Dome," as locals call this multipurpose covered stadium, was conceived by former Houston mayor Roy Hofheinz to accommodate baseball, football, and other sports games and special events.

The construction of the Astrodome, funded primarily by Harris County general obligation bonds, lasted from the groundbreaking ceremony on 3 January 1962, until the Houston Astros National League baseball team opened the stadium on 9 April 1965, with an exhibition game against the New York Yankees. The stadium cost more than $40 million to build.

In Texas, size matters, and the Astrodome does not disappoint. The 9 ½-acre building stands eighteen stories high; its dome is 710 feet in diameter, and the ceiling is 208 feet above the playing surface, which itself sits twenty-five feet below street level. The temperature is a constant 73 degrees Fahrenheit with fifty percent humidity. Originally, transparent plastic panels covered the roof of the stadium, but the bright sunlight coming through them made it difficult for baseball players to see and catch fly balls. To remedy the glare, officials painted the roof panels after the stadium opened. Bermuda grass originally covered the playing surface, but the painted ceiling panels blocked the sunlight and the grass died, prompting the development and installation of an artificial surface, now known as Astroturf.

As our aerial photograph shows, the Astrodome is nearly circular, like a flying saucer. Inside the dome, movable lower seating areas accommodate the stadium's multiple uses. When it opened, the stadium could seat 52,000 for baseball games, 62,000 for football games, and 66,000 for special events. The stadium underwent a $60 million renovation in 1989, sacrificing its original beloved scoreboard to increase seating capacity and add sixty-six luxury boxes.

The dome's glory days are behind it. The Houston Oilers professional football team moved to Tennessee after the 1996 season, and the Astros played their last game in the stadium on 9 October 1999, before moving to the newly constructed Enron Field (now Minute Maid Park). Today the stadium is called the "lonely landmark" by Houstonians. As the aerial photograph reveals, the still-impressive Astrodome now sits both metaphorically and physically in the shadow of the newer Reliant Stadium (which features a retractable roof)—home of the NFL team the Houston Texans—a reminder of a time now past when the first domed stadium was an engineering marvel.

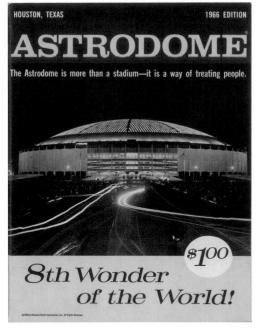

Promotional program using Texas hyperbole to tout the dome as the "8th Wonder of the World." Special Collections, UTA Library.

Houston Sports Association. *Inside the Astrodome, Eighth Wonder of the World!* Houston: Houston Sports Association, 1965.

Houston Sports Association. *Astrodome, 8th Wonder of the World!* Houston: n.p., 1966.

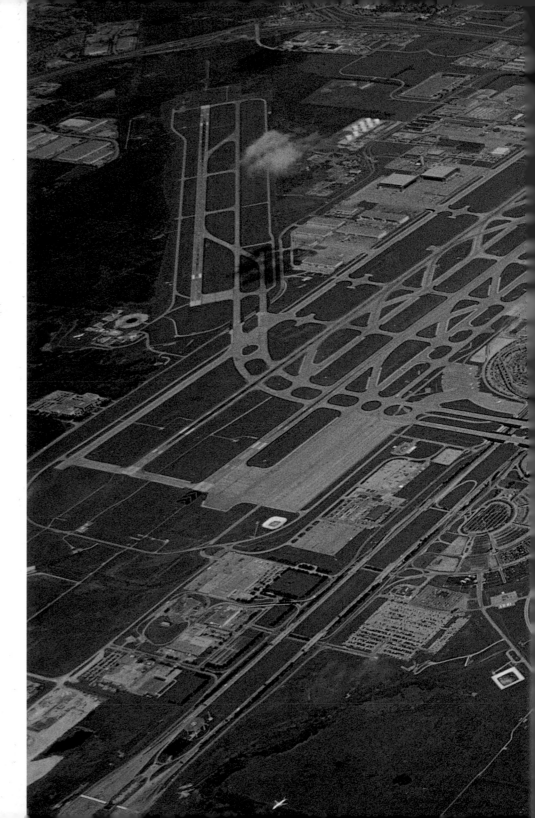

Aerial photograph of DFW airport, 13 April 2006, mid-morning, looking northwest from 11,000 feet.

Dallas/Fort Worth International Airport

The Dallas/Fort Worth International Airport, referred to by its International Air Transport Association (IATA) code as "DFW," was dedicated in September 1973 and opened to commercial traffic on 13 January 1974. When it opened, the 18,000-acre, $700 million airport was the largest and most expensive in the world. The joint airport, operated by the cities of Dallas and Fort Worth, was the result of pressure placed on both cities by the federal government to essentially "cooperate or else" lose federal funding for any airport operations in either city.

The history of aviation in the North Texas region has not exactly been a case study in local cooperation. As early as 1927, before the area had a commercial airport, Dallas proposed a joint airport with Fort Worth, but Fort Worth declined. This prompted both cities to open their own airports—Love Field in Dallas, a former U.S. Army facility purchased in 1928, and Meacham Field, constructed on the north side of Cowtown. In 1940, the Civil Aeronautics Administration (CAA) earmarked $1.9 million for the construction of a regional airport, but the cities could not agree on its construction, even after acquiring a site for it in Arlington, between the two cities. In the mid-1940s, Fort Worth annexed the site and developed it into Amon Carter Field with the assistance of American Airlines. Fort Worth transferred its commercial flights from Meacham Field to the new airport in 1953, naming it Greater Southwest International Airport to better compete with the developing Love Field in Dallas.

The joint airport idea arose again in 1961 when the chief of the Federal Aviation Administration, formerly the CAA, vowed not to "put another nickel" into either of the cities' independent airports. In 1964, the Civil

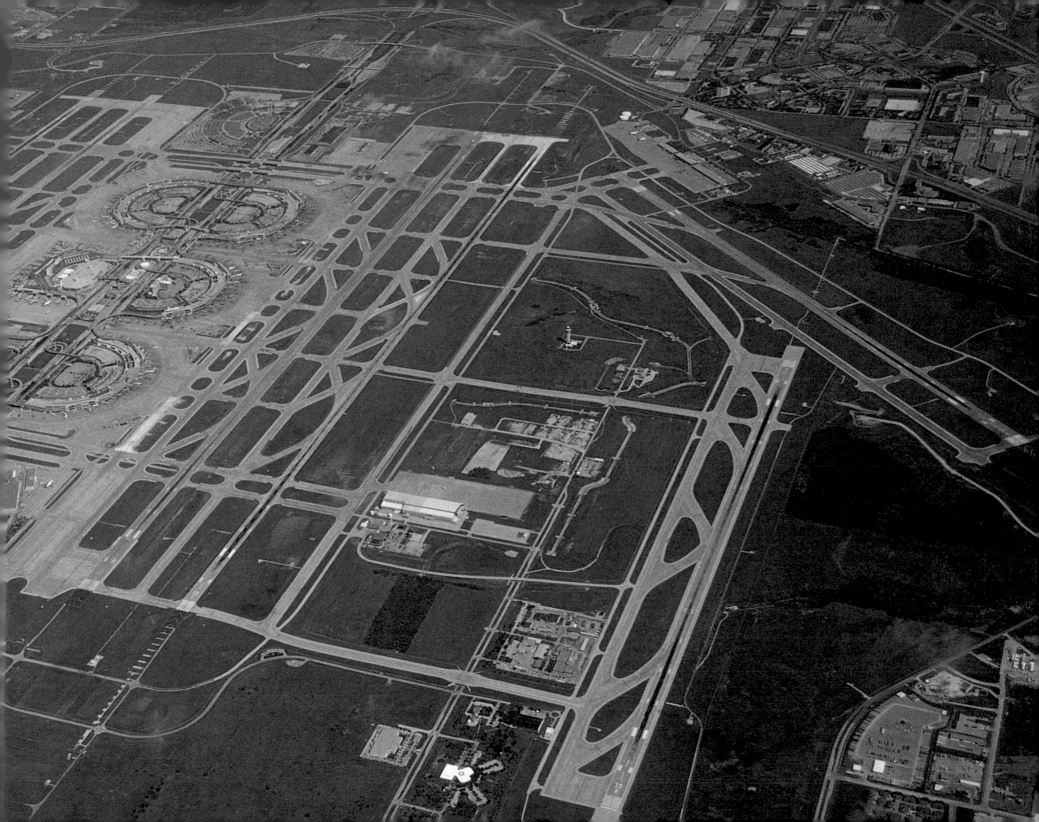

Officials at the groundbreaking ceremony for Dallas/Fort Worth Regional Airport, 1968. Photograph Collection, UTA Library.

Aeronautics Board ordered the two cities to come up with a "voluntary" agreement for a new joint airport or the federal government would do it for them. Both cities eventually agreed to appoint an eleven-member board (seven from Dallas and four from Fort Worth) to coordinate construction and operations. The site for the airport, to be called Dallas/Fort Worth Regional Airport, was chosen in 1965 at the intersection of the towns of Euless, Irving, and Grapevine, almost exactly seventeen miles from the central business districts of Dallas and Fort Worth, and just north of the Greater Southwest International Airport. The cities began acquiring land for the airport in 1966, and the airport opened eight years later.

DFW airport was built with expansion in mind and was designed to minimize the distance between a passenger's car and airline gate. The airport's five terminals are semi-circular, as you can see in the aerial photograph, and built around its central north-south arterial road, Texas Highway 97 (International Parkway). Unfortunately, this design forced connecting passengers to walk long distances between gates and terminals, prompting the airport to implement an automated people mover, which was redesigned in 2005 to become the largest such system in the world. DFW is the only airport in the world with four runways longer than 4,000 meters, and it is the sixth busiest airport in the world.

Darwin Payne and Kathy Fitzpatrick. *From Prairie to Planes: How Dallas and Fort Worth Overcame Politics and Personalities to Build One of the World's Biggest and Busiest Airports*. Dallas: Three Forks Press, 1999.

Stanley H. Scott and Levi H. Davis. *A Giant in Texas: A History of the Dallas-Fort Worth Regional Airport Controversy, 1911–1974*. Quanah, Tex.: Nortex Press, 1974.

Photograph of airport runways being constructed in 1972. Photograph Collection, UTA Library.

Photograph of the Airtrans people mover being tested at the airport in early 1973. Photograph Collection, UTA Library.

CONCLUSION

As we noted in the preface, the aerial photographs in this book document seventy-three historic sites in Texas from a unique perspective. When flying over and photographing these sites, Jack deliberately kept his altitude low—usually about 300 to 800 feet above the ground—in order to capture the texture of the places. We chose this "bird's-eye" perspective because we wanted to provide a rather intimate but unfamiliar look at the Lone Star State's history and geography. We feel that this perspective perfectly captures the details while also presenting the bigger picture.

In a way, these aerial photographs achieve the best compromise between two techniques commonly used to represent places: maps and pictures. Like maps, they reveal the spatial relationships of features—topography, buildings, trees, and so on—to each other. Unlike maps, though, the perspective captured in these photographs is oblique (that is, the earth's surface is seen at an angle) rather than planimetric (as if you were looking straight down). In the nineteenth century, mapmakers drew "bird's-eye view" maps, such as the one we used to compare the

Abilene of the early 1880s with Abilene today, because seeing places from this perspective helps people envision how they really are. A house, for example, is much more than a roof, so we elected to give our readers the added advantage of seeing sites from above and from the side.

The aerial photographs in this book are also pictures in the best sense of the word. The richness of detail in these photographs reminds us that a picture is still worth a thousand (or more) words. In some of the photographs, the landscape takes on the quality of a painting, sometimes even abstract or surreal. Consider, for example, the chimneys of the long-abandoned Fort Phantom Hill that stand like sentinels, the towering smokestack at Thurber that has been a regional landmark for nearly a century, or the remains of ten or more millennia of incessant human gnawing at the Alibates flint beds in the Texas Panhandle. All of this reminds us how intricately people have worked the land here in Texas. These patterns may be interesting and even beautiful, but more importantly they confirm that landscapes are also artifacts.

As records of human occupation, the sites that we photographed demand closer scrutiny. That is why we offered commentary on the individual places.

As we noted at the outset, some, like the Alamo, are extremely well-known, but others, like Shafter, Caddo Mounds, Hueco Tanks, and Sabal Palms, are rarely written about. Our essays accompanying each aerial photo were brief, but we hope that they confirm the rich texture of Texas's history and geography.

One last parting thought: although our photos and essays capture the essence of these places, so much more could and should be known about most of them that we encourage our readers to conduct additional research. Fieldwork and archival research are what we have in mind, but then again, what about places *not* included in this book—places that we live in, visit on trips, or read about in history books and online? They, too, deserve a close look, both from the ground and from the air.

Index